Happy birthday—

I've always found printmakers
to be pretty weird. If you find two
or three things in here of interest, then it's
money well spent.

Love,
from Glenn
7/20/03.

IMPRESSIONS OF THE 20TH CENTURY

IMPRESSIONS OF THE

20TH CENTURY

FINE ART PRINTS FROM THE V&A COLLECTION

Edited by MARGARET TIMMERS

V&A Publications
Distributed by Harry N. Abrams, Inc., Publishers

First published by V&A Publications, 2001

V&A Publications
© The Board of Trustees of the Victoria and Albert Museum 2001

Distributed in North America by Harry N. Abrams, Incorporated, New York
ISBN: 0-8109-6584-4 (Harry N. Abrams, Inc.)

Margaret Timmers and all the contributors to this book assert their moral right to be identified as the authors.

Designed by Roger Hammond
V&A photography by Sara Hodges,
V&A Photography Studio

A catalogue record for this book is available from the British Library.

Every effort has been made to seek permission to reproduce those images whose copyright does not reside with the V&A, and we are grateful to the individuals and institutions who have assisted in this task. Any omissions are entirely unintentional, and the details should be addressed to the publishers.

Printed in Hong Kong

Front jacket illustration: Detail from *Ice Hockey* (1933) by Lill Tschudi. V&A: Circ. 163-1933
Back jacket illustration: *Love* (1967) by Robert Indiana. V&A: Circ. 579-1968
© ARS, New York & DACS, London 2001

HARRY N. ABRAMS, Inc.
100 Fifth Avenue
New York, N.Y. 10011
www.abramsbooks.com

Picture Acknowledgements

Illustrations on the pages given are reproduced with the kind permission of the following: 8 © Tate, London 2001; 11 © Robert Rauschenberg/DACS, London/VAGA, New York 2001; 17 © Anne & Michael Yeats; 19 © Munch Museum/Munch – Ellingsen Group, BONO, Oslo, DACS, London 2001; 23 © Succession Picasso/DACS 2001; 24 © Courtesy of the artist's estate/Bridgeman Art Library; 26 & 27 © Succession H Matisse/DACS 2001; 28 © DACS 2001; 30 © Estate of Walter R. Sickert 2001. All Rights Reserved, DACS; 34, 44, 45 & 47 © DACS 2001; 49 © Tate, London 2001; 51 © Succession H Matisse/DACS 2001; 54 © Estate of Eric Ravilious 2001. All Rights Reserved, DACS; 55 © Angela Verren-Taunt 2001. All Rights Reserved, DACS; 63, 65 & 69 © ADAGP, Paris and DACS, London 2001; 76 © Succession Picasso/DACS 2001; 80 © DACS 2001; 81 © ADAGP, Paris and DACS, London 2001; 82 © DACS 2001; 84 © Man Ray Trust/ADAGP, Paris and DACS, London 2001; 91 © ADAGP, Paris and DACS, London 2001; 95 © Estate of Ben Shahn/VAGA, New York/DACS, London 2001; 97 © Estate of Edward Bawden 2001. All Rights Reserved, DACS; 98 © Eduardo Paolozzi 2001. All Rights Reserved, DACS; 101 & 102 © ADAGP, Paris and DACS, London 2001; 104 © Estate of Sam Francis/DACS, London 2001; 107 © David Hockney; 108 © Richard Hamilton 2001. All Rights Reserved, DACS; 111 © The Estate of Roy Lichtenstein/DACS 2001; 114 © ADAGP, Paris and DACS, London 2001; 117 © The Andy Warhol Foundation for the Visual Arts, Inc./ARS, NY and DACS, London 2001; 118 © Richard Hamilton 2001. All Rights Reserved, DACS; 120 © Patrick Caulfield 2001. All Rights Reserved, DACS; 123 © DACS 2001; 127 © ARS, NY and DACS, London 2001; 128 © Robert Rauschenberg/DACS, London/VAGA, New York 2001; 130 © DACS 2001; 136 © ADAGP, Paris and DACS, London 2001; 152 Reproduction permission courtesy Virgil Marti and Holly Solomon Gallery, New York; 156 Courtesy of the Victoria Miro Gallery and Chris Ofili.

The Contributors

Individual entries have been written by members of the V&A's Department of Prints, Drawings and Paintings, all of whom have played a major part in the creation of this book. They are identified at the end of each entry by the following abbreviations:

AH	Alison Hadfield
CN	Charles Newton
DG	David Giles
EM	Elizabeth Miller
FR	Frances Rankine
GS	Gill Saunders
JB	Julia Bigham
JS	Janet Skidmore
KC	Katherine Coombs
LN	Lesley Newman
LO	Lois Oliver
ME	Mark Evans
MG	Mary Guyatt
MH-B	Mark Haworth-Booth
MT	Margaret Timmers
NG	Nazek Ghaddar
RM	Rosemary Miles
RW	Ruth Walton
SC	Shaun Cole
SL	Susan Lambert
TT	Tim Travis

Contents

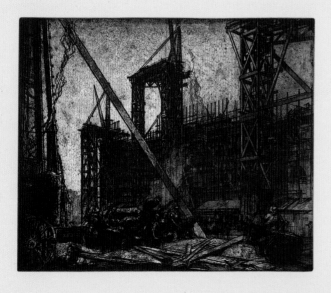

Frontispiece Frank Brangwyn (1867–1956), *Building the new Victoria and Albert Museum*, 1904, etching with aquatint. V&A: E.4288-1910; given by the artist through The Fine Art Society.

Introduction

THE WORD 'IMPRESSION' has many connotations from the imprint of a bare foot in crisp snow to a particular individual's feelings about a multitude of moments as time passes. This book is about impressions of a very particular kind: prints made deliberately by artists as statements of significance about the world. Such prints are made in a way very similar to footprints, but on paper from a variety of inked surfaces worked by artists. Each print is itself, however, also a vehicle for communicating the vision – or impressions – of the artist who made it, tempered inevitably by the experience of his or her life and times. The prints in this book, made in many different countries, date from each year of the twentieth century and so provide an international review of a particular kind of artistic endeavour throughout the century and to some extent also a visual chronicle of it. Because artists' prints had greater significance during the twentieth century than they have had in any other period, the book also provides an anthology of some of the greatest prints ever made.

Printmaking has a long history. In Europe images were first printed on paper late in the fourteenth century. These prints were made by intricately cutting away wood from a plank on both sides of the lines of a design and inking the wood left standing proud. The print was taken by pressing the inked surface of the block into a sheet of paper, thus creating an impression. The invention of woodcut was followed by many other printmaking techniques, all of which demanded considerable manual skill and technical expertise, supported in most cases by extensive specialist, and usually cumbersome, equipment. Engraving, a process in which the lines to hold the ink are incised in the printing surface with an instrument much like a chisel with a 'v'-shaped blade, was developed in the second quarter of the fifteenth century. Etching, a less arduous process, in which the lines are formed by the corroding action of acid, followed around 1500. In the mid-seventeenth and eighteenth centuries mezzotint and aquatint, forms of engraving and etching that give qualities of tone to an image, were introduced. Just before 1800 a new kind of process, lithography, dependent on the

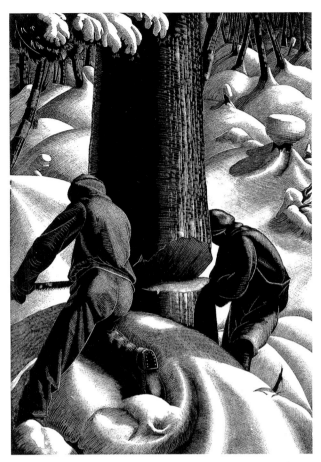

fig. 1 Clare Leighton (1898–1989), *Cutting*, 1931, no. 3 from *Lumber Camp* series, wood engraving.
V&A: E.3284-1931; purchased from the artist.

fact that oil and water do not mix, was invented. Its immediate attraction was that it was capable of producing an exact facsimile of the artist's design, but ironically its almost instantaneous spread throughout Europe and America reflected its adaptability to mass production. Printmaking developed thus over five centuries as a significant industry in the cultivated world, providing large numbers of highly skilled artisans as well as a wide range of business entrepreneurs with their livelihood.

However, in terms of the traditional hierarchy of the arts, printmaking did not rank highly until the twentieth century. Print-makers had been excluded from membership of the Royal Academy on its foundation in 1768 and did not gain admission on the same footing as artists in other media until 1928. The reason given was that engraving was wholly devoid of 'those intellectual qualities of invention and composition which painting, sculpture and architecture so eminently possess ... its

greatest praise consisting in translating with as little loss as possible the original arts of design'.[1] It was indeed true that most printmaking served the utilitarian functions of society, for before the invention of photography it was only by laboriously cutting blocks and plates by hand that repeatable visual images for publication could be made. Most printmakers were therefore engaged in supplying information of a more practical and mundane kind to a public that was, until the growth of popular education in the mid-nineteenth century, better able to read pictures than words. Of course, many high-status artists did make prints. The work of Rembrandt comes immediately to mind; indeed, his habit of touching and retouching the plate with drypoint, and printing from countless different bitings of the plate on papers that absorbed the ink differently, defied the basic multiple nature of printmaking and made clear his essentially uncommercial, 'artistic' approach to the medium. The making of prints tended, therefore, to be an experimental and private part of an artist's work, the results seldom being issued in the large numbers of which the medium was capable.

A pre-electronic invention, photography, announced to the world in 1839, was to set the traditional craft of printmaking on radically different trajectories. Dependent on the action of light on a suitably sensitized surface and described by William Fox Talbot, a lead player in its invention, as 'the pencil of nature',

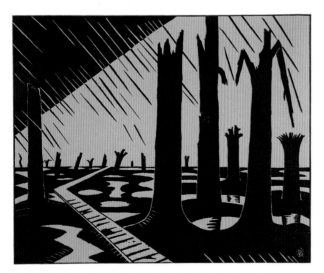

fig. 2 Paul Nash (1889–1946), *Void of War*, design for a poster for an exhibition at the Leicester Galleries, London, 1918, lithograph. V&A: E.4796-1960; given by Mrs Margaret Nash, widow of the artist.

photography was capable of creating images on paper without manual intervention. Once perfected, it became possible to achieve in moments what could take many weeks of work by hand. As a result photomechanical processes rapidly took over the hard graft of the more utilitarian end of printmaking, leading to widespread redundancy within the industry but also providing a spur to a more 'artistic' approach. Societies were set up all over Europe to encourage the creative development of the medium. In 1862 one such, the Société des Aquafortistes based in Paris, made this appeal to its public: 'In these times when photography fascinates the vulgar by the mechanical fidelity of its reproductions, it is necessary to assert an artistic tendency in favour of free fancy and picturesque mood'.[2]

By the beginning of the twentieth century the development of relatively cheap photomechanical printmaking processes had given artists the opportunity to distinguish their work in both subject matter and technique from the commercial end of the trade. Artists coming to maturity after 1900 were attracted to printmaking specifically for the visual effects the chosen medium brought to the image, such as the grain of the wood in Edvard Munch's *The Kiss* (1902),[3] Josef Albers's *Tlaloc* (1944) and Naum Gabo's *Opus 6* (1955); the fortuitous textures of inks when pulled from the soft linoleum block in Ben Nicholson's *Three Mugs and a Bowl* (1928) and Cyril Power's *The Tube Staircase* (1929); and the richness achieved through the virtuoso use of wood-engraving tools in Gertrude Hermes's *Autumn Fruits* (1935) and Clare Leighton's *Cutting* (1931, fig. 1) with its magical rendering of light on snow. The free wriggling line that etching encourages is exemplified in Walter Sickert's *La Belle Gâtée* (1908), Louis Marcoussis's *Rosemonde* (1934) and Anthony Gross's *La Maison du Poète* (1936), while the considerable graphic power that lithography offers is evident in Käthe Kollwitz's *Arbeiterfrau* (1903), Barnett Freedman's *People* (1947) and Michael Rothenstein's *The Cockerel* (1950). Indeed, the sheer variety of materials and tools that can be used in printmaking has in itself proved a constant spur to creativity.

Artists were also attracted to certain techniques because of their historic associations. German Expressionists, exemplified here in the work of Franz Marc (1912)[4] and Karl Schmidt-Rottluff (1907), were for quasi-political idealistic reasons drawn in particular to the

fig. 3 Henri Gaudier-Brzeska (1891–1915), *Wrestlers*, proof, c.1914, linocut. V&A: E.3210-1934; given by Horace Brodzky, 1934.

woodcut, the technique with the longest history of communicating with the largest number of people, and to lithography with its more recent involvement with mass communication. By contrast, British and American artists tended to be drawn rather to etching, as in the case of Augustus John (1905), F.L.Griggs (1914), Edward Hopper (1921) and Graham Sutherland (1931), and to drypoint, as in the case of David Jones (1930) and Martin Lewis (1939), largely because of their immediate responsiveness to the artist's gesture and because they were the techniques with which fine art printmaking, before the twentieth century, had been most associated.

Increasingly in the aftermath of the First World War a significant coterie of artists and connoisseurs felt that a special sensibility and acute powers of discernment were required to appreciate fully the aesthetic minutiae of prints. Such beliefs were common in the artistic and museum establishment in London in the 1920s, and in 1921 Martin Hardie, who was to become Head of the Department of Prints and Drawings at the V&A, accordingly said in his inaugural speech as President of the London-based Print Collectors' Club that he hoped the club would serve its members as a 'loophole of retreat from the insistent clamour of daily life'. The artists of this generation in Britain who did engage with the great and painful issues of war, like Joseph Pennell (1913), Edward Wadsworth (1915), Robert Gibbings (1916), C.R.W. Nevinson (1917, 1918) and Paul Nash (1918, fig. 2), tended, like the German Expressionists, to present their vision in the more 'popular' media of woodcut and lithography. The sculptor Gaudier-

fig. 4 Claude Flight (1881–1955), *Speed*, c.1922, colour linocut. V&A: E.3543-1923; given by F. Hoyland Mayor.

Brzeska, who was killed in action in the French army in 1915, was among the first to experiment with linoleum in place of wood (c.1914, fig. 3), a medium that was subsequently taken up in particular for subjects that conveyed the vitality of the modern world as in Claude Flight's *Speed* (c.1922, fig. 4).

Regardless of the technique involved, high value was placed in most circles on close manual involvement by the artist in the making of the printing surface, leading eventually to the formal definition of what constituted an original print. In 1960 the Third International Congress of Artists in Vienna stipulated that only prints 'for which the artist made the original plate, cut the wood block, worked on the stone or any other material' could be considered 'originals'.[5]

Such definitions were drawn up ostensibly to help tax inspectors and trading officers distinguish original work from reproductions and to protect the public from buying reproductions 'masquerading' as originals. That it was also a counter-movement by an old guard was clear from the fact that the period around 1960 coincided with that in which a new generation of artists including Robert Rauschenberg (1962, fig. 5), Roy Lichtenstein (1964) and Andy Warhol (1967) in America, and Richard Hamilton (1963), R.B. Kitaj (1970) and Eduardo Paolozzi (1957) in Britain turned deliberately to photomechanical techniques and mass-popular imagery as a way of refreshing the tired vocabulary of artistic expression. Photographic images were used in paintings and prints alike, and it was precisely at this time, when prints first became a significant part of every serious artist's output, that the market for them grew dramatically and they developed into big business.

The fact that manual skill was no longer required to

render life-like images of the world encouraged the exploration of a different kind of image in paint and print, in which the meaning of the work frequently became the handling of the medium itself, an essay in the sensation of 'facture', as for example in the work of Jean Dubuffet (1945), Joan Miró (1958) and Sam Francis (1960). Francis found that lithography in particular provided the same liberating immediacy as painting. Of his feeling of oneness with his medium, he said: 'I have found a way to get into that machine [the printing press]. When I am working with these prints, I *am* the paper, I *am* the print, I *am* the machine.'[6] More recently artists have become so intimately involved with the physical process of printmaking that in some instances their bodies have acted as both tool and image as in Richard Long's *Africa Footprints* (1986) and Antony Gormley's *Body and Soul* (1990). In the ultimate fusion of artist and medium Lee Wagstaff in *Shroud* (2000) screenprinted an impression of his own body using his own blood.

Art has also come to engage with many more of its own ingredients. In a sense the magical act of seeing is the subject of the simple screenprinted planes of flat colour of Victor Vasarely's *Zett-R.G* (1966), Robert Indiana's *Love* (1967, back cover) and the modulated colour of Bridget Riley's *Coloured Greys III* (1972). The support can also be part of the meaning of a print. All the prints discussed here are on paper except where stated otherwise; F.L. Griggs (1914) deliberately chose old laid paper for his etchings, evoking a pre-industrial age that contributed to his 'Arts and Crafts' vision. An outstandingly beautiful sheet of paper was selected by André Masson for his lithograph, *Couple aux fleurettes* (1959), which is embedded with flower heads and ferns. They introduce an element of chance that complements the free movement of Masson's so called 'automatic' line and are integral to the central image of a couple who embrace against this lovely background. Equally, the fact that Lee Wagstaff's *Shroud* (2000) is printed not on paper but on cloth, the material of which shrouds are made, reinforces the power of the image.

The work of Jenny Holzer (1982, fig. 6), Barbara Kruger (1993) and Simon Patterson (1992, fig. 7), whatever the medium, draws on the language of advertising and explores the interdependence of mass communication and art. The debate specifically surrounding medium has, however, been explored especially in prints. Hamilton's *The critic laughs* (1968) contains a dialogue on the nature of originality between the photographic basis of the image and its manual adaptation, while Marcel Broodthaer's *La Soupe de Daguerre* (1975) examines the relationship between the commercially printed photographic 'snap' and the *trompe l'oeil* capacities of neo-realist screenprinting. It was not, however, until the last quarter of the century that it became accepted that printmaking involved the 'choice of mind, not the cleverness of hand',[7] as Marcel Duchamp, the inventor of the ready-made, claimed in relation to painting and sculpture as long ago as 1914. Only then did it become acceptable for artists, even when working in traditional techniques as in Francesco Clemente's woodcut self-portrait (1984), to have the printing surfaces made by trained professionals.

Whatever the role in detail played by the artist in the production of prints, printmaking was throughout the twentieth century supported by a wide range of people with complementary skills. The energy of the entrepre-

fig. 5 Robert Rauschenberg (born 1925), *License*, 1962, lithograph. V&A: Circ.119-1964; purchased 1964.

neur that had been so important for the success of reproductive printmaking remained a driving force in the creation of artists' prints. The most important name in the first half of the century was probably Ambroise Vollard, tragically killed in a car accident in 1939. He played a major role in commissioning prints from the greatest painters of the period including Pablo Picasso (1942), Georges Braque (1932) and Marc Chagall (1952). Specialist printers, who showed artists how to achieve their aims with the different media, were also crucial, such as the Parisian intaglio printer, Roger Lacourière, who taught Picasso (1942) how to work with sugar aquatint, and the lithographer Fernand Mourlot, who introduced Dubuffet (1945) to the full potential of the stone. Chris Prater of Kelpra Press in London was probably more responsible than any of the artists with whom he collaborated, represented here by Richard Hamilton (1963), Patrick Caulfield (1969) and R.B. Kitaj (1970), for the refinement of screenprinting as an artist's medium.

Of particular significance in the second half of the century were three American women, Tatyana Grosman, June Wayne and Kathan Brown. Grosman founded Universal Limited Art Editions (ULAE) in 1957 and persuaded some of the greatest artists of the century, including Rauschenberg (fig. 5) and Jim Dine

fig. 6 Jenny Holzer (born 1950), *Don't Talk Down To Me ...*, one of twelve plates from the portfolio *Truisms and Essays* published by G.W.E. Partner, Hamburg, 1982, offset lithograph. V&A: E.I022-1989; purchased 1989.

(1965), to make their first lithographs. Wayne set up the influential Tamarind Lithography Workshop in 1960. It trained a generation of master printers who created a network of workshops across America, including Kenneth Tyler's Los Angeles-based Gemini G.E.L., represented here by Claes Oldenburg's huge gestural lithograph *Soft Screw in Waterfall* (1976) and Rauschenberg's *Pull* (1974), an even larger screenprint on layers of muslin and taffeta. The first woman to graduate from Tamarind was Judith Solodkin, who set up the New York-based Solo Press, where Howard Hodgkin's lithograph, *Bleeding* (1982), was printed. Brown was the founder of the Crown Point Press, which by contrast has been involved principally with etching, creating some of the finest intaglio prints in the last quarter of the century – for instance Anish Kapoor's untitled aquatint (1988). Perhaps even more importantly, the Press has also played a leading role in developing the potential of print in perform-ance art and in installation, as in Daniel Buren's *Framed/Exploded/Defaced* (1979), which consists of twenty-five pieces cut from a single print designed to be hung in a grid pattern under rules laid down by the artist. In John Cage's *Where R = Ryoanji* (1983, fig. 8) the creation involved the placing of stones, collected by the artist-composer from around the world, in varying positions determined by chance operations on the plate and drawing around them. The piece thus involved 'performance' in its creation and equally formed a record of a 'performance'.

In spite of the attempts to define and thus confine printmaking, what a review such as this brings out is the extent to which artists throughout the last hundred years have pushed out the boundaries of the fine art print. When does a 'photograph' become a print? Throughout the century 'traditional' photographs, like Frederick Evans's *Lincoln Cathedral: Stairway in Southwest Turret* (1900) or much more recently Hamish Fulton's less traditional *Humming Heart* (1983), relied on the seductive tones of photogravure to print suffi-cient numbers to reach a wide public. Can a poster be a print? The status of Spencer Pryse's Labour Party elec-tion poster *'Workless' / 'Landless' / 'Forward! The Day Is Breaking!'* (1910) was established by critical acclaim on its exhibition at the Royal Society of British Artists in 1914. What is the status of the carrier bag that carries on itself Kruger's untitled photo-collage exclaiming *'I*

fig. 7 Simon Patterson (born 1967), *The Great Bear*, 1992, colour lithograph. V&A: E.1842-1992; purchased 1992.

shop therefore I am' (1993)? Could linocut, once considered a medium only for children, become a medium for exhibitable art? Claude Flight and his pupils (1929 and 1933) proved it could and the medium has remained one of enduring interest. A notable recent example is Tayo Quaye's life-size *The Man* (1995). In recent years wallpaper has also become a vehicle for artists' statements as in Renée Green's screenprinted wall covering for the installation *Taste Venue* (1994), Virgil Marti's flocked *Bullies* (1997) and Sonia Boyce's embossed *Lover's Rock* (1998), potentially providing a total environment in print.

Arguably the definition of whether a work of art is or is not a print depends on its creator's act of choice. Helen Chadwick saw herself as a photographer. Much of her work, however, like *Vanitas* (1985), relied on photocopied prints, which, dependent on the deposit

of pigment on paper rather than a chemical reaction, are technically traditional not photographic prints. Daniel Buren's installation piece *Framed/Exploded/Defaced* (1979) was marketed as a print although it is not an exactly repeated image, for each set is printed in a different colourway and the appearance of any set changes with the space in which it is presented.

In summary, the century saw the ambition of printmaking move from the few square inches of the monochrome etching, via the scale and multicolour potential of the lithographic stone, to the unlimited square feet of the sometimes fluorescent screenprint and even the three-dimensional piece. Whatever the medium, prints have tended to get bigger. For example, Peter Howson's woodcut *The Heroic Dosser* (1987) is larger than life

fig. 8 John Cage (born 1912), *2R + 13.14* and *(R³)*, 1983, two prints
from a series of six entitled *Where R = Royoanji*, drypoint.
V&A: E.1488, E.1487-1984; purchased 1984.

size, the crude almost brutal incisions in the wood creating a visual parallel with the rough and cruel fate of its subject. Prints thus moved out of the connoisseur's 'private' portfolio on to the wall not only of private houses but also of corporate offices and important public buildings. Democratic initiatives like the series of prints issued by Contemporary Lithographs Ltd in the 1930s, represented here by Edward Ardizzone's *The Bus Stop* (1938), aimed precisely 'to introduce the work of living artists to the general public in the original'.[8] Artists like Joseph Beuys (1971), Gavin Jantjes (1977) and Conrad Atkinson (1978) were drawn to printmaking specifically as an egalitarian means of discourse. Prints attained the same public status as paintings, became the subject of major exhibitions and in some museums formed the primary focus for contemporary collecting.

All these points will emerge in greater detail from the entries that follow, contributed by the community of scholars of commercial and 'fine art' printmaking at the V&A. The works discussed here all form part of the permanent collection of the Museum and are only a small selection of the memorable twentieth-century prints that it has assembled. When the V&A was founded in the 1850s – at the very moment when the centuries-old dialectic within printmaking between the imaginative and the reproductive was poised on the verge of its modern synthesis – it was the nation's contemporary museum, in close touch with practising artists and leading-edge industrial design. As a result it houses, as well as commercial graphics of the epoch, an unrivalled collection of the 'modern' print from the 1850s to the present as it has been defined and redefined by the artists themselves.

Of the prints discussed here thirty-two were acquired within twelve months of production, and a further thirty-five within ten years. The remaining thirty-three have been acquired at various times in order to make the Museum's holdings match what subsequent critical scholarship has considered from time to time to be the canon.

It continues to be the Museum's policy to represent the work of printmakers as it rolls off the press or emerges from its electronic matrix. Artists' thinking is, however, taking them in new directions. The diversity and rich potential of the new image-making technologies for all artists put in question our traditional understanding of the print as an autonomous category of art. Possibly, in the years ahead the twentieth century may be seen as the time when printmaking reached its apogee, set free from the nineteenth-century anxieties about the hierarchy of the arts and able to take advantage of its practitioners' skilled understanding of what industrial image-making technology could offer them. The historic mission of the V&A as a museum of making, of all kinds of significant made objects whether fine or industrial, puts it in a better position than museums and galleries with narrower briefs to recognize the value of these new directions and to continue to compile its public record of this branch of human activity for the future.

SUSAN LAMBERT

Chief Curator, Department of Prints, Drawings and Paintings

Notes
1. Royal Academy General Assembly Minutes, 23 December 1812, 3, pp.90-91. Cited from Celina Fox, 'The Engravers' Battle for Professional Recognition in early Nineteenth Century London', *The London Journal*, vol. 2, no.1, 1975, p.8.
2. 'En ce temps où la Photographie charme le vulgaire par la fidélité mécanique de ses reproductions, il devait se déclarer dans l'art une tendence au libre caprice et à la fantaisie pittoresque.' Théophile Gautier, 'Un mot sur l'eau-forte', from the introduction to the first portfolio of the Société des Aqua-fortistes, A. Cadart & Luquet, Paris, 1862.
3. A single date in brackets after a title or an artist's name (unless accompanied by a reference to an illustration) indicates an entry for that year later in the book with a reproduction of the print or an example of the artist's work.
4. See previous note.
5. *The Definition of an Original Print Agreed at the Third International Congress of Artists, Vienna*, a pamphlet issued by the U.K. National Committee of the International Association of Painters, Sculptors and Engravers, 1966.
6. Quoted in Peter Selz, *Sam Francis*, New York 1982, p.269; cited in Connie W. Lembark, *The Prints of Sam Francis: A Catalogue Raisonné 1960–1990*, New York 1992, p.15.
7. Cited from an unpublished interview with Harriet, Sidney and Carroll Janis in 1953 in A. d'Harnoncourt and K. McShine (eds), *Marcel Duchamp*, Philadelphia, 1973, p.275.
8. Extract from *Original Prints by Living Artists*, London, c.1938, cited in Antony Griffiths, 'Contemporary Lithographs Ltd.', in *Print Quarterly*, vol. VIII, London, December 1991, p.399.

IMPRESSIONS

Frederick H. Evans (1853–1943)

Lincoln Cathedral: Stairway in Southwest Turret, 1900

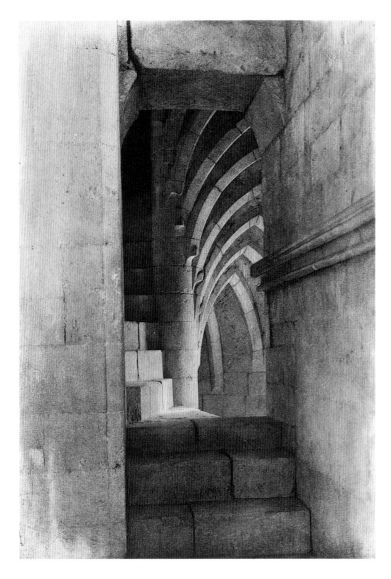

Blind stamped with photographer's monogram

Photogravure from a photograph taken in 1895

Size of platemark 25.3 x 15.6 cm; size of sheet 31 x 23.6 cm

595-1900. Given by the artist

FROM THE THRESHOLD and vantage point of this image printed in 1900 we can step into two centuries. The photograph simultaneously sums up nineteenth-century themes and opens onto preoccupations of the twentieth. Born in the same decade as Pre-Raphaelitism, Frederick Evans photographed medieval architecture from an uncompromising ethical and aesthetic standpoint. He was an ardent admirer of William Morris. However, he was also the friend and patron of Aubrey Beardsley. Evans looked both back and for-

wards. His photographs were admired by his fellows in the quaintly named English photographic group, the Brotherhood of the Linked Ring; also by the avant-garde circle around Alfred Stieglitz and his magazine *Camera Work* in New York. Evans's typical choice of subject – the spaces and details of English cathedrals – may seem purely Victorian. His concern for the dynamics of form, the validity of the 'straight' photograph (which he described as 'manifestly a photograph – something produced by camera and lens'[1]) and the subtle poise of his camera positions – all of these characteristics commended him to twentieth-century moderns.

The photograph shows us, at the left, the simple beauty of the Lincoln limestone from which the cathedral was built and the finesse with which it was cut and carved by masons. We enter the picture via the steps at their base and through the receding moulding at the right. Evans chose his camera position to give the clearest possible display of the Early English Gothic vaulting that supports the building. Each vault rib springs from a central newel post, around which the staircase spirals. The spiral was of particular significance for Evans. Using a glass-tipped pen suspended from a 'twin-elliptic pendulum', he made drawings that he called 'pendulum curves'.[2] Such drawings illustrated natural laws and an underlying order traceable from microscopic bacilli to spiral nebulae. The photograph displays the spiral motif in the context of sacred architecture (or sacred engineering).

Although Evans was a masterly printer of platinum photographs, this is an ink print, a photogravure. It was one of a group ('four of my finest things', he said[3]) by the Swan Electric Engraving Co. For much of the new century photography would be transmitted not in the form of silver or platinum-based prints but in ink. New technologies would challenge and transform all the graphic arts. Late in the century photography itself would be challenged and transformed by the arrival of newer media.

MH-B

Jack Butler Yeats (1871–1957)

The Pugilist, 1901

Signed and dated in watercolour *Jack B. Yeats, 1901*

Colour stencil

Size of printed surface 29.7 x 21.8 cm; size of sheet 38.3 x 30.5 cm

E.2141-1932. Given by Dr W.A. Propert

JACK BUTLER YEATS, son of the painter J.B. Yeats and brother of the poet W.B. Yeats, had a passion for sport. He attended sporting events of every kind throughout his life and many aspects of what he observed on these occasions were used as subject matter for his paintings and drawings, and for his work as a commercial artist. He particularly enjoyed boxing and attended matches in the East End of London. He described his experience of boxing in his book *Sligo*:

> By many ring sides I have sat. But still I am no hardened veteran. I still give and receive in imagination the blows, bobbing up and down, and wincing, and setting my teeth and crushing forward. But the picture was different under gas than under electric light, the Tawny gas was more blood-thirsty, more of action; I have, if not the vulgar tongue, at least the vulgar heart. I like the fight.[4]

Yeats loved to sketch the assembled spectators at these matches as well as the muscular athletes, delighting in the formality and the lively ritual of the gatherings. His diaries for 1901 record that he was going to matches in Whitechapel, and it is possible that Yeats made this stencil print from sketches taken there.

The Pugilist is a splendid abstract study of a gloved boxer resting in his corner of the ring. Between 1893 and 1909 Yeats produced several figure studies using cut-out stencils; these stencils were 'one-offs' and not generally intended for multiple impressions. They were produced by laying a stencil, made from cut-out paper or a thin metal sheet, over the surface to be painted and then brushing or spraying pigment onto the paper below. Here Yeats uses the technique to great effect to emphasize the solid form of the combatant, thereby suggesting his latent strength. The darkness of the background and the whiteness of the posts and ropes of the boxing ring focus the light on the lean, muscular figure of the boxer who dominates the space. The white cloth of the boxer's trousers is represented by leaving part of the paper un-inked, and a stripe of green, possibly a reference to the Irish nationality of the boxer, renders the sash around the boxer's waist. On the boxer's arm is a tattoo of a tombstone lettered 'In loving memory of Aggie'.

FR

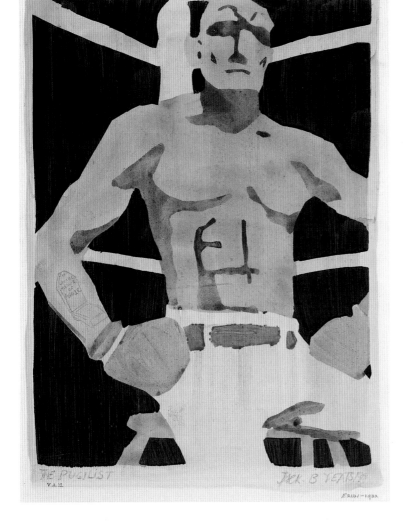

17

Edvard Munch (1863–1944)

The Kiss, fourth version, 1902

Signed bottom right in pencil and again on the back *Edv Munch.* Inscribed bottom left in pencil *Lashaly* (the printer Lassally)

Woodcut printed in grey and black from two woodblocks on Japanese paper

Size of printed surface 46.9 x 46.9 cm; size of sheet 58 x 56.9 cm

E.5067-1960. Purchased 1960

The kiss
Two burning lips against mine
heaven and earth vanished
and two black eyes looked
into mine –

from Edvard Munch, *The Tree of Knowledge of Good and Evil*[5]

LIKE MANY ARTISTS and writers at the turn of the century, the Norwegian artist Munch believed that significance lay beyond what was visible; he was intrigued by the unseen world of emotions, moods and ideas, the most intimate experiences of the human spirit. Taking the outer appearances of things as the basis of a common vocabulary for communication, he shaped his images to create signs for deeper experience: love, jealousy, anxiety and death.

In this woodcut Munch returned to a motif that he had first begun to explore in paintings, drawings and an etching of 1895. The etching shows a couple before a window, with the curtains open and lights on in the buildings opposite. Between 1897, when he cut the first woodblock version of *The Kiss,* and 1902, when this version was completed, Munch distilled the essence of the kiss from the more circumstantial narrative of the early etching to this iconic abstraction.

Arms encircling each other, the two lovers seem to have become one. With their features undefined, their faces merge in a single shape. The contours of the embracing couple mark the edge of one woodblock, which Munch cut out and printed over a background taken from another block – an uncut plank whose grain forms its only design. In an earlier version Munch printed the whole image from a single block, cutting out the figures in order to ink them in a different colour from the background before reassembling the pieces like a jigsaw to print the image. The use of two blocks brings new meaning to the image. The two colours and the two different woodgrains intermingle across the figures so that they seem to hover in and out of the plane of the uncut wood: it is as if they are seen through driving rain or insubstantially, as an idea or in a memory. In another of Munch's prints, *The Lonely Ones,* in which a man and woman are shown looking out to sea, the woman was printed from one block, and the man and beach from another, the different blocks symbolic of their spiritual separation. In contrast, the lovers in *The Kiss* have been united forever on a single block of wood. The independence of this block from the background perhaps symbolizes the lovers' oblivion to their surroundings: technique is fused with meaning.

LO

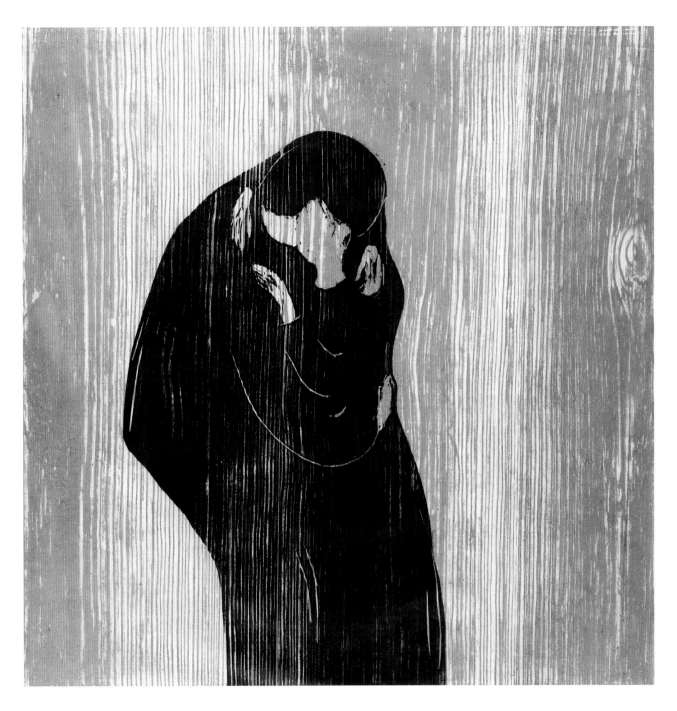

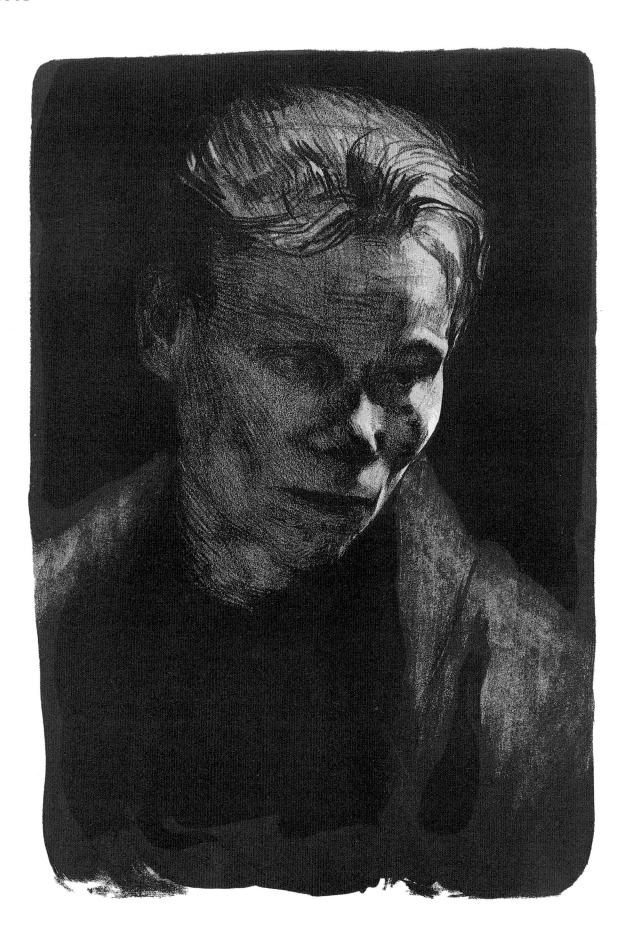

Käthe Kollwitz (1867–1945)

Arbeiterfrau (Working-Class Woman), 1903

Lettered with title and
Original-Lithographie
von Käthe Kollwitz.
Verlag der Gesellschaft
für Vervielfältigende
Kunst, Wien

Colour lithograph
Size of printed surface
35.4 x 24.5 cm; size of
sheet 56.2 x 45.1 cm

E.6208-1906.
Purchased 1906

KOLLWITZ (NÉE SCHMIDT) had originally intended to become a painter but soon realized that her real talents lay in drawing and printmaking. This decision was influenced by the great German etcher Max Klinger, and in particular his views on the respective applications of painting and printmaking. According to Klinger, painting is best suited to 'the glorification, the triumph of the world', whereas prints and drawings are better suited to the description of 'resignation ... misery ... the pitiful creature in his eternal struggle...'[6] Schmidt, who had been born into a politically radical family, was already drawn to subjects of this latter kind. Her marriage in 1891 to a doctor, Karl Kollwitz, brought her into close contact with the hardship and misery of life in one of the poorest working-class districts of East Berlin, where her husband had his practice. Over the next two decades she worked on two print series that addressed proletarian revolution: *A Weavers' Uprising* (1893–7) and *Peasants' War* (1903–8). She also established what were to be her characteristic themes: the struggles of the working class, the lives of proletarian women and pacifism.

Despite the socialist sympathies evident in her choice of subjects, Kollwitz disavowed overt political propaganda. She explained that 'the life of the workers ... provided me with what I found beautiful.'[7] But she also acknowledged that 'the fate of the proletariat ... took hold of [her] with great force' when she came to know 'the gravity and tragedy of the most miserable kind of proletarian existence' through her meetings with the women who came for consultations with her husband.[8] A number of her prints from this period represent these women. The focus is always on the face, with Kollwitz's spare but naturalistic style aptly describing the gaunt careworn features and the often dispirited demeanour of her sitters. This dispassionate portrait is all the more moving because it eschews any trace of the sentimentality that occasionally afflicted her later work. She made no more individual portraits of this kind after the First World War. She lost her younger son early in the war, and from then on, driven by her own loss and her anger at the waste and suffering she had seen, she took up universal themes, with archetypal images of motherhood, and of women in need, grief and despair.

GS

21

Pablo Ruiz Picasso (1881–1973)

Le Repas frugal (The Frugal Meal) or *L'Aveugle* (The Blind Man), first state, 1904

The plate later steel-faced and reprinted by Ambroise Vollard in an edition of 250 in the portfolio *Saltimbanques*, 1913

Etching

Size of platemark 46.3 x 37.6 cm; size of sheet 66 x 51 cm

E.2551-1930. Purchased 1930

PICASSO HAD NO formal training in printmaking and before *Le Repas frugal* had only ever made one other print, *El Zurdo*, in Barcelona in 1899. In his youthful inexperience Picasso had failed to recognize that his image of a picador would be reversed on printing. Although he cleverly disguised his mistake, titling the portrait *El Zurdo* ('the left-handed one'), it may have dissuaded him from further immediate experiment. However, in the contemporary art world in Paris dealers were anxious to spread the reputation of their particular artists, and actively encouraged them to make prints. The professional infrastructure of skilled printers, greatly expanded throughout the latter years of the nineteenth century, made printmaking not only relatively easy but also highly attractive to visual artists, both as a means of earning income and of broadcasting their ideas. Picasso chose one of the most highly regarded intaglio printers, Eugène Delâtre, to print up this plate, but he prepared it under the guidance of his friends, Joan Gonzales, who provided the plate, and Ricardo Canals, who had also helped him with *El Zurdo*. Gonzales had previously used the plate for a landscape, traces of which can be seen in earlier impressions, before it was steel-faced by Vollard.

For Picasso 1904 was a year of transition, in which he finally relinquished the comforts of Barcelona for the intellectual and artistic stimulus of Paris. Symbolically enough the image of *Le Repas frugal* was conceived in Barcelona, but drawn up as an etching in Paris. Despite his many friends and growing reputation, during his first months in the city Picasso was forced to live in the most humiliating poverty. His pictures at this time are characterized not only by a still powerful formal allegiance to his old Spanish masters, such as Goya, Luis de Morales and El Greco, but by a marked sympathy for the indigent and the social outcast. By 1905, when his own financial position was improving, he was already moving away from these images of compassion and pathos. In 1903–4, however, portrayals of the blind (an enduring metaphor relating to the struggle for inner vision and creativity for Picasso), the alcoholic and the penniless formed a significant element of his work.

RM

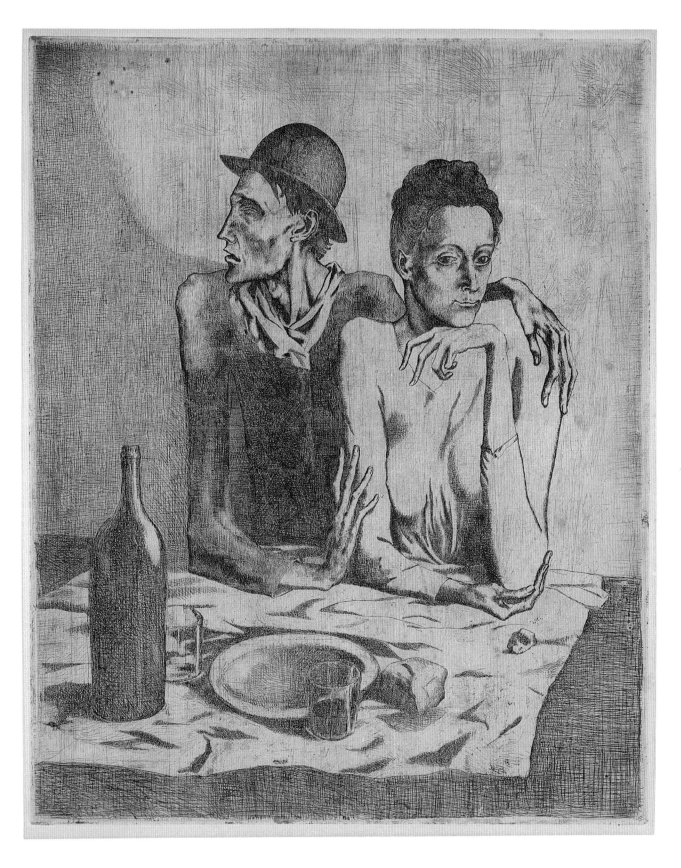

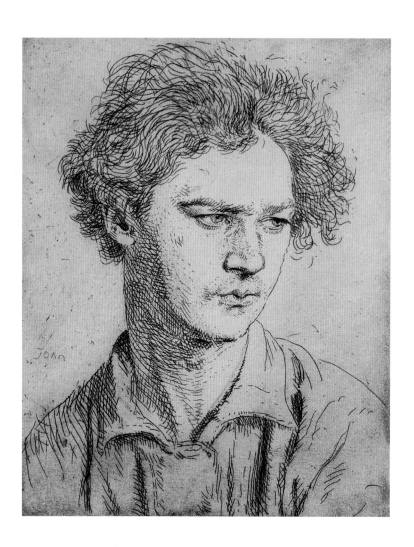

Augustus Edwin John (1878–1961)

Jacob Epstein, 1905–6

Signed *John* and in
pencil *Augustus E John*

Etching

Size of platemark
12.4 x 9.9 cm; size of
sheet 27.3 x 20 cm

Circ.79-1962.
Purchased 1962

DURING THE FIRST decade of the twentieth century Augustus John was thought to epitomize progressive British art; in 1913 a reviewer of the famous New York Armory Show cited him, together with Matisse and Jacob Epstein, as the three great talents of the European avant-garde. Although his reputation has been overshadowed in recent years by that of his sister Gwen, it has recently revived, and his early work, produced before the First World War, is highly prized.

While a student at the Slade School of Art in London, John was hugely impressed by J.M. Whistler and was also encouraged to study the old masters. Later in life he ridiculed young artists who failed to recognize 'the pre-eminence of Rembrandt as a draughtsman'.[9] Between 1899 and 1906 John produced a spectacular series of portrait etchings of friends and relations, frequently heavily worked, with dynamic line and dramatic lighting. Many were published in 1906 to accompany a major exhibition of his prints organized by the Chenil Gallery. They were subsequently catalogued by Campbell Dodgson, a leading authority on Rembrandt and old master printmakers, who considered that John had a 'power, unequalled among English etchers of to-day, of expressing individual character'.[10]

In 1905 the American sculptor Jacob Epstein (1880–1959) moved from Paris to London where he soon became acquainted with John and other members of the New English Art Club. At around the same time as the present work John executed a further etching of the sitter, full face, and Epstein returned the compliment with a bronze head of the painter's seventh child Romilly. Notwithstanding their friendship, John was equivocal about Epstein's primitivist style, describing a sculpture under way in 1907 as 'a monstrous thing – but of course it has its merits'.[11] In this portrait the sculptor is depicted glancing sideways, with pursed lips, as though musing, his forehead framed by a dense mass of wiry hair: a self-consciously 'Bohemian' image of a standard-bearer of international modernism.

ME

25

Henri Matisse (1868–1954)

Nu de profil sur une chaise longue (Le Grand Bois) – 'Nude in Profile on a Chaise Longue (The Large Woodcut)',[12] with the woodblock from which it was printed, 1906

Signed in ink *Henri Matisse* and numbered *10/50*. Blind stamped with the mark of H. Neuerburg (Lugt 1344a)

Woodcut on laid van Gelder paper

Size of printed surface 47.8 x 38 cm; size of sheet 57.5 x 46 cm; size of woodblock 49.5 x 40 cm

Woodcut: E.276-1994. Purchased 1994 with assistance from the National Art Collections Fund

MATISSE, RIVALLED IN reputation as a painter only by Picasso, is arguably the greatest French colourist of the twentieth century. It is surprising therefore that the majority of his prints were executed in black and white. This print was made shortly after Matisse's paintings caused a furore at the *Salon d'Automne*, Paris, in 1905, when the critic Louis Vauxcelles described a restrained sculpture in a room hung with paintings by Matisse, Rouault, Derain, Vlaminck and others as 'un Donatello parmi les fauves' (a Donatello among the wild beasts). The implication was that the sculpture was by a real artist and the paintings by animals, a reference to their violent execution and experimental colour. This woodcut, the largest and most arresting of three compositions in the medium by Matisse of the same period, translates the vigour of the colourful Fauve paintings into black and white in an astounding manner.

The block from which this image was printed consists of two thick joined planks of fruit-wood (probably pear-wood), from which Matisse cut away the wood around the design with knives, chisels and gouges leaving the stark lines, dashes and dots standing in relief. It is the only woodblock cut by Matisse known to have survived. It was acquired by art dealer, Frank Perls, from the French print publisher Ambroise Vollard, famous for his editions of fine prints by many leading artists.

Woodcut was the first printmaking technique to be used for printing on paper, the earliest dating from the fourteenth century. Throughout its long history woodcut was primarily used to communicate with the masses and it was just this demotic character combined with the direct simplicity of the medium that led a number of artists, especially some of the German Expressionists (see pp.29, 35), to revive its use early in the twentieth century. Matisse may also have been drawn to woodcut because of its sculptural affinities, for at the same period he was experimenting with sculpture as a vehicle for his vision. That Matisse chose to exhibit this woodcut alongside his paintings at the *Salon des Indépendants* in 1907 suggests that he considered it a work of considerable distinction and significance.

SL

Woodblock: E.609-1975. Purchased 1975 with the assistance of the Lumley Cazalet Gallery, whose gift was made in memory of Frank Perls

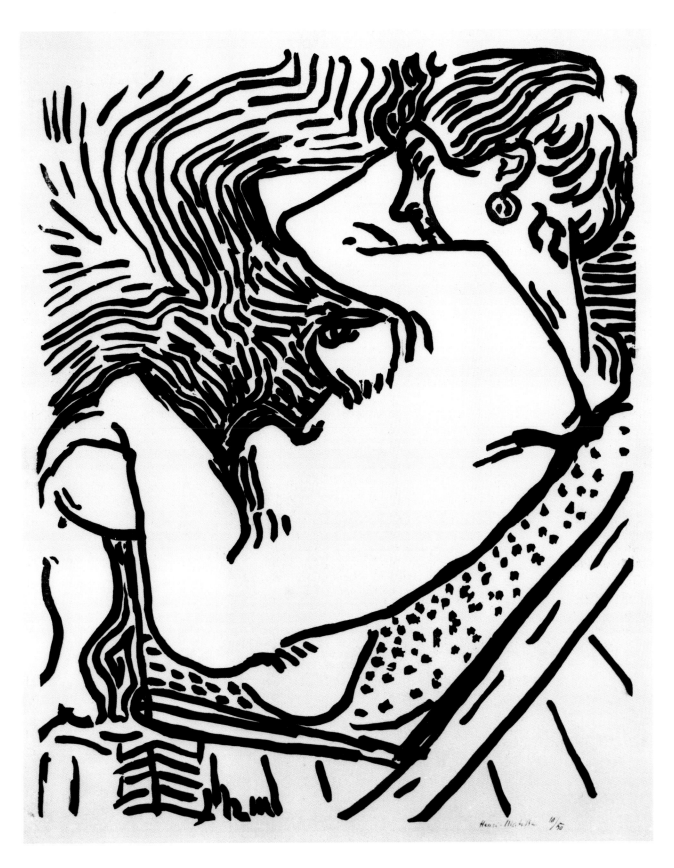

27

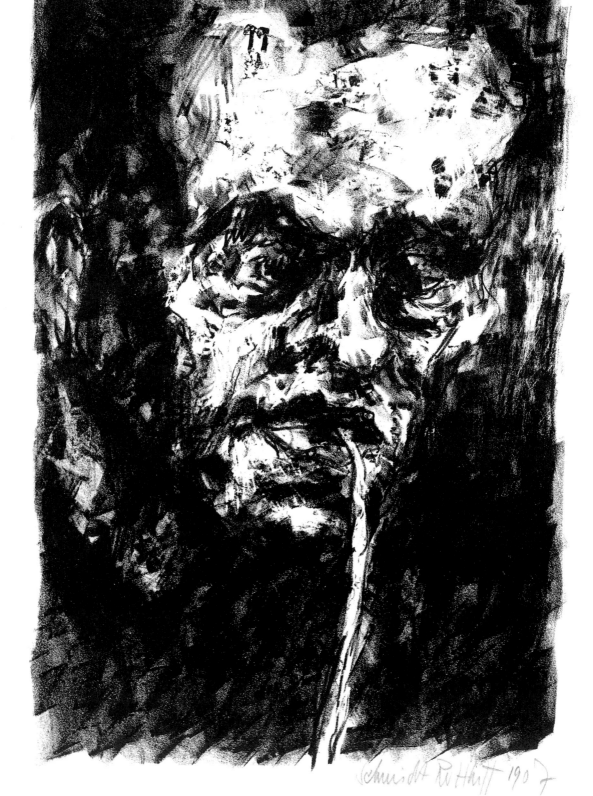

Schmidt Rottluff 1907

Karl Schmidt-Rottluff (1884–1976)

Man with Pipe (Self-Portrait), 1907

Signed and dated in pencil *Schmidt Rottluff 1907*. Inscribed in pencil *Mann mit Pfeife* [Man with Pipe] *Pr*[obedrucke = proof] and numbered *15*

Lithograph

Size of printed surface 34.x 22.5 cm; size of sheet 45 x 31.3 cm

E.703-1955. Bequeathed by Dr Rosa Schapire

THIS IS JUST one of the many fine prints by Karl Schmidt-Rottluff bequeathed to the V&A by Dr Rosa Schapire, a close friend of the artist and author of the standard *catalogue raisonné* of his work up to 1923. She originally proposed this bequest in 1946 and ultimately her almost complete collection was split between thirteen museums in Germany, and the V&A and the Leicester County Museum in the UK. Those that came to the V&A, along with the gift of Dr Schapire's executor, Geoffrey Delbanco, considerably augmented the representation of Expressionist prints in the collections of both the Prints and Drawings and the Circulation Departments. Work by Paul Klee and one or two others, such as Emil Nolde and Otto Mueller, was acquired in 1938 after the first significant London exhibition of Expressionism, the radical art movement that developed in Germany in the first decades of the twentieth century. Until the time of Dr Schapire's remarkable bequest there were very few works from modern Germany in the V&A's collection. Her act of generosity represented an extraordinary prelude to the Museum's more serious consideration of such work that began with acquisitions in the 1960s.

Karl Schmidt-Rottluff, Eric Heckel and Ernst Ludwig Kirchner were the founding members of a group called 'Die Brücke' (The Bridge), which was set up in Dresden in 1905. The name, intended to convey the idea of a link between the members, later came to signify a crossing into the 'new' or the future. Together with 'Der Blaue Reiter' (The Blue Rider), Die Brücke formed the backbone of the German Expressionist movement; Der Blaue Reiter, named after a painting by Kandinsky, was established in Munich in 1911 and its members were linked in their search for a greater spiritual reality through a new approach to colour and form. In an unprecedented way printmaking was vital to their aesthetic, and their experiments in the medium were uninhibited and dynamic. Schmidt-Rottluff made his first lithographs in 1906, and although by 1908, through the encouragement of Kirchner and Heckel, he was printing the stones himself, in 1907 he was still using the services of an art institute, the Dresden Kunstanstalt. Nevertheless, even such early work shows a remarkable affinity with and appreciation of the medium. So much so that the great Edvard Munch, shown some of these lithographs, was excited enough to declare Schmidt-Rottluff 'insane', as he himself had sometimes been described.

RM

29

Walter Richard Sickert (1860–1942)

La Belle Gâtée (The Spoilt Beauty) or *The Camden Town Murder*, second state, 1908

Signed and dated within the plate *Sickert. 1908.* Inscribed in pencil below *'Qui qu'est la belle gâtée à son Mimir?'*

Etching and aquatint on wove paper

Size of platemark 29.6 x 21.9 cm; size of sheet 34.5 x 24.3 cm

Circ.130-1971. Purchased 1971

THE MURDER OF a prostitute in his own neigh-bourhood of Camden Town in September 1907 provided Sickert with a conveniently evocative generic title for a series of studies of a man and a woman in an interior. In *La Belle Gâtée* the nature of the pair's relationship is ambiguous. Are the cou-ple – the man clothed, the woman nude – in an amorous embrace or are we witnessing the macabre prelude to murder? Both scenarios are possible, although the former seems more likely. The bareness, even seediness, of the setting and

the starkness of the single iron bedstead, point clearly to an illicit encounter between a prostitute and her client. At the same time the woman, in the encircling/threatening grasp of her lover, is obvi-ously vulnerable. The ambiguous inscription could be a quotation of the man's rhetorical question, freely translated as 'So who's Mimir's spoilt beauty, then?' (The name Mimir is possibly an abbreviation of Casimir.)

The Camden Town Murder series (paintings, drawings and prints) was executed while Sickert was a member of the Fitzroy Street group of urban realist painters. The studies prefigure work by the Camden Town Group, formed by Sickert between 1911 and 1913. Their unifying principle was the treatment of 'real-life subjects' – the acute obser-vation of mundane scenes in contemporary set-tings. At the same time, in *La Belle Gâtée*, Sickert exploits the dramatic potential of his lowlife sub-ject. The figures are revealed in explicit juxtaposi-tion, and there is a sense of uncomfortable enclo-sure as the bed and the floorboards recede sharply to the peeling backdrop of the rear wall. Shadows of the man's face and form, and of the bedstead, are rendered in heavy cross-hatching, in contrast to the smooth highlights of the woman's naked torso.

Sickert loved to experiment with etching, enjoying its freedom of line and the tonal effects that could be achieved through varied hatching patterns and the subtle application of aquatint. In the early 1880s he had been a pupil and admirer of James McNeill Whistler but later rejected his mas-ter's prints as 'a feast of facile and dainty sketching on copper'.[13] Through the later influence of Degas he began to place greater emphasis on form, out-line and structured composition. *La Belle Gâtée* went through three states of printing: this, the sec-ond state, is lightly aquatinted, with some burnish-ing and erasure of original lines and very faint high-lighting of the figures and bedclothes.

MT

Theodore Casimir Roussel (1847–1926)

The Snow. My front garden, March 2nd 1909

Signed within the plate *Theodore Roussel* and below in pencil *Theodore Roussel Imp.*

Soft-ground etching and aquatint

Cut to platemark 22.8 x 17.7 cm

E.370-1922. Purchased from the artist, 1922

Roussel was born in France but settled in England in the late 1870s and married an Englishwoman, Frances Amelia Smithson Bull. In 1890 the family moved from the King's Road, Chelsea, to Belfield House on Parson's Green in Fulham. This print shows the view from the front of this house looking towards the Green. The actress Billie Burke who lived with the family for a time described the new residence in her memoirs as a 'charming Adams [*sic*] house which had been designed for a king's mistress. It had beautiful gardens and a mysterious, shadowy studio, and the Roussels' had beautiful afternoon parties there.'[14]

Roussel's printing technique was initially influenced by the work of James McNeill Whistler but, as he began to experiment with printmaking, he became preoccupied with exploring the differing tonal effects of intaglio techniques and particularly colour printing. After his move to Parson's Green Roussel started to work on more ambitious print projects. In 1899 he produced a series of nine colour etchings for which, innovatively, he also designed and printed frames and mounts. The only known surviving complete framed set is held in the Department of Prints Drawings & Paintings at the V&A. It came from 'a house in Parson's Green' and is likely to have been the set from Roussel's own house.

Each print by Roussel was the result of considerable experimentation. *The Snow* is a wonderfully atmospheric print and demonstrates Roussel's painterly skill in handling aquatint and soft-ground etching to depict light and the qualities of snow. Exploiting a variety of tone and texture, Roussel creates a muffled landscape with a cold, grey sky above and, below, the blurred outlines of the trees, fence and ironwork of the street lamp. The crisp, fallen snow is represented by leaving parts of the paper un-inked. This print is one of about forty impressions from a fourth and final reworking of the original plate, and testifies to the diligent care that Roussel took to achieve the exact effects he wanted.

FR

31

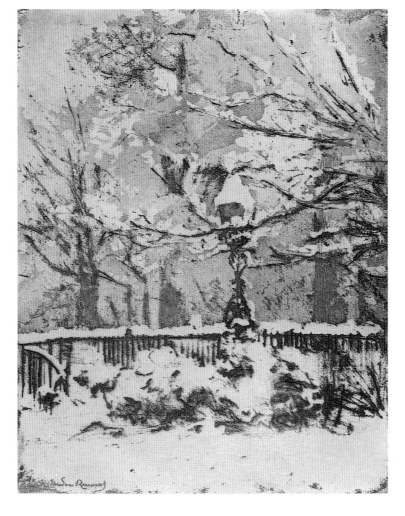

Gerald Eric Spencer Pryse (1882–1956)

'Workless' / 'Landless' / 'Forward! The Day Is Breaking!' 1910

Election poster in three panels, published by the Labour Party, 1910

Colour lithograph

Size of sheets respectively 101.4 x 70.8 cm, 101.4 x 71.1 cm, 101.4 x 148.6 cm

E.3141-1913, E.3140-1913, E.3139-1913. Given by the Labour Party at the request of the artist

SPENCER PRYSE WAS little known in 1910 when he drew this poster for the Labour Party's election campaign; the commission probably came about through his friendship with Beatrice and Sydney Webb and his association with the Fabian Society. It was the first of several posters he designed for the Labour Party.

Although these images were conceived more in the manner of fine art than poster design, their power to communicate the political message lay in the expressiveness and sensitivity of the artist's draughtsmanship. His fluid and delicate lines, which in the first two panels poignantly capture the attitudes of resignation and despair, deliberately focus on the humanity of these men and women. They are presented as universal symbols of suffering. The dark shading and restrained use of colour convey the grey hopelessness of life for those affected by the widespread strikes in the mining, cotton and shipbuilding industries. In contrast, the third panel symbolizes the optimistic prospect for working people under a possible Labour government. They look forward joyously, if a little apprehensively, towards the dawn of the new era; a young man strides resolutely forward to embrace its challenges and opportunities.

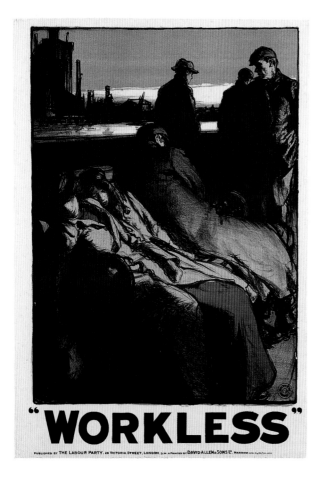

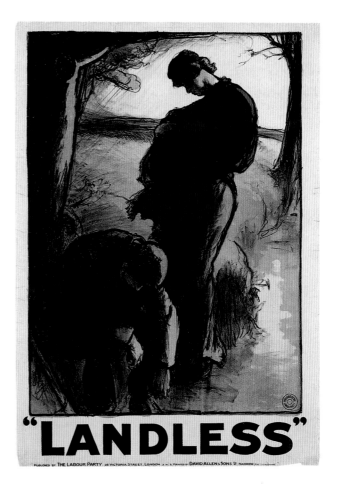

The poster was praised in the Labour Party's 1911 Annual Conference Report: 'To this poster we beg to draw special attention, as both from the symbolical and artistic point of view it will be of permanent value.' Its status as a work of art was positively established when it was exhibited in the 1914 exhibition of the Royal Society of British Artists, creating a precedent for a poster. Critical opinion varied from 'dignified, impressive and very beautiful' (*The Times*) to 'too sentimental, too romantic' (*Evening Standard*). The poster was re-issued for the 1929 election, when the Labour Party won its first outright majority, and then again in 1971 as commercial stock.

Spencer Pryse's artistic reputation developed out of his talent as a lithographer. He was a founder member of the Senefelder Club (see p.36) and relished the sensitivity of lithography to reproduce on paper any mark exactly as made on the stone. This gave every print the immediacy of the original drawing. Although he also found recognition as a painter, he is best remembered for his lithographs.

RW

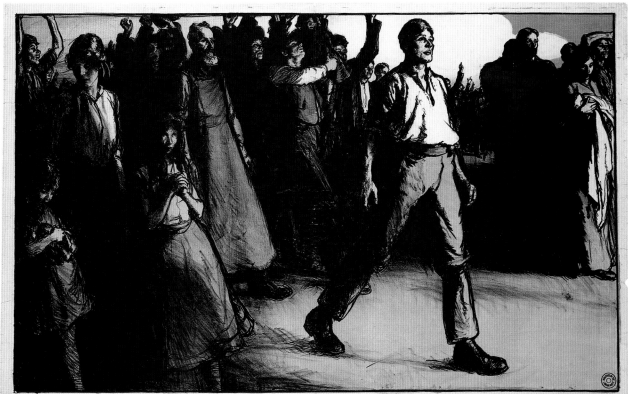

"FORWARD! THE DAY IS BREAKING!"

PUBLISHED BY THE LABOUR PARTY 28 VICTORIA STREET, LONDON,S.W. & PRINTED BY DAVID ALLEN & SONS L.^D HARROW

Paul Klee (1879–1940)

Bahnhof (Railway Station), artist's proof, 1911

Signed in pencil *Klee*. Inscribed with title in pencil. Dated *1911* and numbered with the artist's own inventory number *26*

Drypoint on celluloid

Size of platemark 15 x 19.8 cm; size of sheet 27.2 x 36.2 cm

Circ.216-1938. Purchased 1938

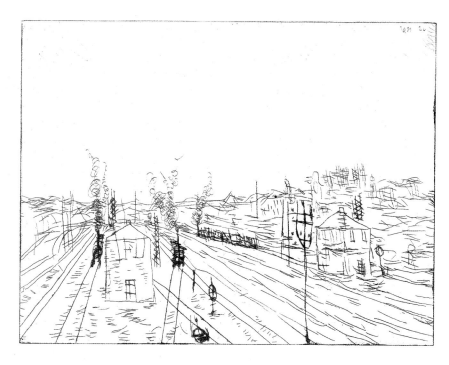

P AUL KLEE WAS born in Berne, Switzerland, where he also grew up. In 1898 he went to Munich to study at Heinrich Knirr's school of drawing and later at the Munich Academy under Franz von Stuck. On completion of his studies he returned in 1901 to Berne to live with his parents. The years spent in Berne, following on from his apprenticeship in Munich, were a period of great experimentation and innovation. He wrote in his Journal in June 1902, 'I want to be like a newborn child, knowing nothing about Europe, nothing at all. To know no poets, to be totally passive; to almost return to the source.' The work produced during this period illustrates Klee's evolution from a traditionalist to one of the most original and fascinating artists of the twentieth century. In 1906 Klee returned to live in Munich, where he became an active participant in modern art movements. The year that this print was made was the year that Klee joined Der Blaue Reiter (The Blue Rider), the group of Expressionist artists with radical aims and ideas whose members included Vassily Kandinsky, Franz Marc (see p.35) and August Macke.

Bahnhof is characteristic of Klee's work at the time in its looseness and simplicity of line; it is very similar in style to a series of drawings of Munich

Station he made in the same year as this print. For the plate Klee used a sheet of celluloid, a synthetic material more conventionally associated with the manufacture of film and domestic items. Klee's preoccupation with line as a pictorial element may have drawn him to use celluloid: of all the intaglio printing techniques, drypoint (see p.72) allows the most spontaneous drawing, and celluloid, a comparatively soft material, allowed an even freer line than the more usual copper or zinc. Klee experimented with a number of different techniques, one of which was drawing and painting on glass. In 1905 he recorded in his diary that he was etching with a needle on a blackened pane of glass and that dabbling on a porcelain plate had given him the idea. In this instance Klee has used the sharp, pointed drypoint tool to score the image into the smooth printing surface. Klee made a number of drypoints in this way. Through the immediacy and nervous energy of these finely scratched lines Klee evokes the bustle and shifting movement of the railway station he portrays. The print was purchased at the time of the exhibition of German Expressionist Art held at the New Burlington Galleries in July 1938.

FR

Franz Marc (1880–1916)

Schlafende Hirtin (Sleeping Shepherdess), 1912

Signed with initial *M.* within the block. Inscribed on the reverse in pencil *druck vom Originalholzstock bestätigt Maria Marc*

Woodcut on Japan paper

Size of printed surface 19.9 x 23.9 cm; size of sheet 27.5 x 39.2 cm

Circ.906-1967. Purchased 1967

FRANZ MARC AND Vassily Kandinsky were the driving forces behind the circle of revolutionary artists known as Der Blaue Reiter (The Blue Rider). Seeking a higher dimension in art, they expressed universal emotional and spiritual truths rather than external appearances, and used the abstract elements of pictorial language (line and colour) in a way that opposed material reality. The new vision was expressed in *Almanach der Blaue Reiter* (Blue Rider Almanac) compiled and edited by Marc and Kandinsky during the latter half of 1911; this illustrated and explained the correspondences not only between different art forms but also between the arts of different countries, drawing attention to the expressive power of naïve and primitive cultures.

Marc sought through his art to restore spiritual harmony to a restless world. Both in his art and in his writings he emphasized the primacy of intuition and instinct over reason, and the need for a harmonious union with nature for humanity's spiritual welfare; he rejected industrial technology and modern urban life, and preferred animals, spiritually pure creatures, to man (unless depicted in naked innocence among nature) as vehicles for his artistic expression.

Impressed by the woodcuts of Die Brücke (The Bridge) artists, Marc insisted on their inclusion in the second Blaue Reiter exhibition (1912) and, though primarily a painter and colourist, he began himself to experiment with the technique. *Schlafende Hirtin*, which is more intricate than the simple massed forms of his first few attempts, displays a growing confidence and markedly improved technical facility. The horizontal line exactly halfway across the image suggests that the block comprised two pieces of wood clamped together. This woodcut was widely publicized when it was printed from the block on the front page of the avant-garde magazine *Der Sturm*,[15] and signed impressions printed on Japan paper were advertised for sale in a later edition.[16]

Marc sought a purified vision, a way of seeing restored to primitive simplicity and directness. In *Schlafende Hirtin* consciousness is filled by the calm contemplation of the natural object, the reclining nude in a pastoral scene. The dominant human form is unusual, but here the woman becomes part of nature. The body of the shepherdess harmonizes rhythmically with both the undulating landscape and the animal forms; it curves protectively over the lamb and is, in turn, contained between the two sheep; the rays of light playing on her shoulder add a religious intensity to the atmosphere and emphasize her purity. Marc's use of thick black outlines to convey her voluptuous sensuality in defiance of the flat picture plane endows the shepherdess with essential vitality and suggests his own facility as a sculptor.

NG and RW

35

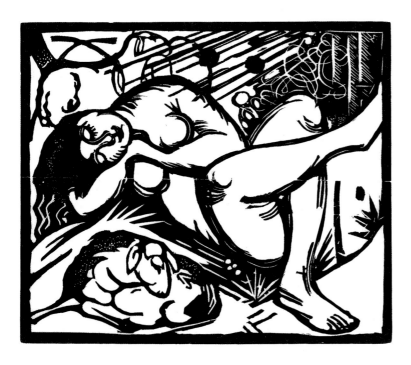

Joseph Pennell (1857–1926)

The New Bay of Baiae, 1913

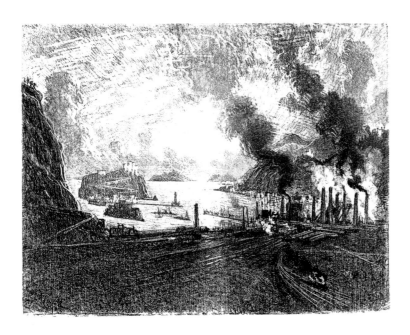

Printed by F. Vincent Brooks, printer to the Senefelder Club

Inscribed in pencil with title and *2nd Trial Proof of First Plate issued by the Senefelder Club, offered to the Victoria & Albert Museum by the President, Joseph Pennell, on behalf of the Club October 1913. Unfinished trial proof. J.Pennell del. Sc.*

Lithograph

Size of printed surface 42.5 x 55.2 cm; size of sheet 46 x 58.1 cm

E.3498-1913. Given by the Senefelder Club

Tʜɪs ᴘʀɪɴᴛ ɪs a sardonic commentary on the unthinking desecration of one of the most beautiful bays in the world. The ancient city of Baiae was situated about 16 km (10 miles) west of Naples, and at the height of the Roman Empire it was one of the most popular places for a rich man to build a villa, almost proverbial for its desirability. It was famous for its sulphur springs and baths, and many eminent or notorious Romans, including Julius Caesar and the Emperors Tiberius, Nero, Hadrian and Severus, had villas there. Ancient writers frequently mention the luxury and immorality of the life of Baiae. The city was devastated by the Saracens in the eighth century and was entirely deserted by 1500 on account of the spread of malaria. The melancholy ruins remained isolated until the late nineteenth century. Then they were overshadowed by the monstrous industrial development of modern Naples, whose urban sprawl crept along the coast in both directions from its ancient boundaries.

Born in Philadelphia, Pennell was an illustrator, printmaker and writer. In 1880 he opened his own studio and started to supply illustrations for magazines. He specialized in drawings of American cities, and in 1883 he also illustrated a series of articles on cities in Tuscany. That same year he married and came to London where he became part of a literary and artistic circle that included Robert Louis Stevenson, George Bernard Shaw and James McNeill Whistler. At first Pennell was noted for his skill as an etcher, but influenced by French lithographers such as Toulouse-Lautrec and Odilon Redon and by Whistler, he took up lithography. He published various works on printmaking and illustration, and eventually a biography of his friend Whistler. The Senefelder Club, formed in 1908 by Pennell, F.E. Jackson, A.S. Hartrick, G.E. Spencer Pryse and others, was named after the inventor of lithography. It celebrated and promoted the artistic potential of this form of printmaking and by 1914 had organized forty-five touring exhibitions.

Pennell himself travelled widely, depicting cityscapes, the elegance of tall American buildings and other images of the modern world. His incisive style suited his images of skyscrapers and machinery. However, he became acutely conscious of the contrast between the old and the new, between the glory of nature and the darker side of modernism, as the industrial revolution, by now the age of steel, transformed the modern world at breakneck speed. In *The New Bay of Baiae* the cranes, chimneys, railways and industrial plant of a modern port are unflinchingly shown, the artist utilizing the heavy graininess of the chalk on the stone to emphasize the smokiness and gritty atmosphere of the subject.

CN

Frederick Landseer Maur Griggs (1876–1938)

Ashwell, second state, 1914

Signed in pencil below
the platemark
F.L. Griggs

Etching on laid paper

Size of platemark
20.9 x 14.9 cm; size of
sheet 26.3 x 20 cm

E.1187-1920.
Purchased 1920

GRIGGS'S LYRICAL ETCHING *Ashwell* was made in early spring 1914. With hindsight it can be seen as a poetic evocation of a golden world, whose idyll was about to be shattered by the onset of the Great War. In fact, Griggs had first made a pen drawing of St Mary's Church, Ashwell, for an illustration to *Highways and Byways in Hertfordshire*, published by Macmillan in 1902. In that drawing, as in a subsequent painting and a pencil drawing of 1909 for the *Highways and Byways in Cambridge and Ely*, Griggs portrayed the church's glorious fourteenth-century west tower, its soaring height crowned by an octagonal lantern with a leaded spike.

Griggs's visionary art was inspired by among others Wenceslaus Hollar, J.M.W. Turner and Samuel Palmer. Trained as a perspective artist for architects, he established himself by the early 1900s as a supreme illustrator of architecture, sensitive to the form of buildings and meticulous in their portrayal. Like Palmer, he had a special reverence for the Gothic and the vernacular. Through his work as an illustrator he built up a vast stock of topographical imagery which he later explored, enriched and transformed into new architectural visions.

Although similar to his 1909 illustration of Ashwell, this elegiac composition has a heightened atmosphere: birds wheel around the tower, the road is dramatized into a rutted lane with sweeping shadows, and a solitary female figure stands dwarfed by the tower. The artist uses etching, the medium of his imagination ('those etchings which are to embody the best my poor head & heart can yield'[17]), to render the architecture in exquisite detail, particularly the limestone masonry of the church. The print was made on old laid paper, which in the drawn areas shines through the mesh of fine lines and in the open areas gives the soft flat glow of evening light.

The church at Ashwell had a special significance for Griggs, for it bore a Latin inscription on the tower wall describing how a mighty wind thundered on St Maur's Day in 1361, marking the end of the plague. When Griggs became a Roman Catholic in 1912, he added the name 'Maur' to his own.

MT

37

Edward Alexander Wadsworth (1889–1949)

Façade, 1914–15

Signed in pencil
Edward Wadsworth.
Inscribed in pencil
(perhaps with framing
instructions) *1/205
22x16*

Woodcut on thin laid
paper

Size of printed surface
17.2 cm x 9.5 cm; size
of sheet 21.3 x 13.5 cm

E.448-1965.
Purchased 1965

IN JULY 1914 the Vorticists burst onto the scene with the publication of a manifesto in their journal *Blast*. One of the signatories was Edward Wadsworth and this print epitomizes his Vorticist work. Announcing a desire to engage directly with the modern industrial world, the Vorticists declared 'machinery is the greatest earth medium', and although the title of this print sounds architectural, the image suggests powerful interlocking machinery, perhaps the looms with which Wadsworth was familiar from the Wadsworth family mill at Cleckheaton in Yorkshire.

The bold black-and-white shapes of the print display Wadsworth's gift for abstract design, a talent that was later to be employed in the dazzle-camouflage of ships. From 1918 he supervised work on over 2,000 ships, mostly at Bristol and Liverpool, covering them with extraordinarily bold diagonal patterns and zigzag bands intended to confuse the enemy.

Wadsworth's affinity with the woodcut is apparent here: the flat impersonal quality of the medium suited the machine-like character of his art and he cut the intricate interlocking designs with remarkable precision. Responding to a letter from the New York collector John Quinn, Wadsworth wrote:

You seem to like the woodcuts best. To a certain extent I agree with you: I think they are probably best in that they are most complete – that is to say, the means of expression is in a more complete accordance with the thing expressed in them ...[18]

Wadsworth's woodcuts won the admiration of the artist Henri Gaudier-Brzeska, who carried some with him as a soldier on the Western Front. Writing to Wadsworth from the trenches, he made a special request:

I have your letter with the woodcuts ... When you send me some more, as I am greedy to see much vorticism just now, just print them on the thin paper. The reason is this, I have room for them in my knapsack and the less weighty the individuals are, the more I shall be able to stuff in.[19]

Gaudier was among Wadsworth's friends killed in the Great War, and like many artists, Wadsworth found his attitude to mechanization changed after the appalling carnage of those years. When he returned to portraying the northern industrial scenes that had inspired his early pictures, his vision was bleaker: the machine age had shown a darker side. Wadsworth abandoned the woodcut, the medium that had been central to his Vorticist work. This print represents that brief period of innocent untarnished enthusiasm for machines that preceded the First World War.

LO

Robert John Gibbings (1889–1958)

The Retreat from Serbia, 1916

Signed within the block *R G*. Signed and dated in pencil *Robert Gibbings 1916* and inscribed with title

Colour woodcut

Size of printed surface 17.8 x 17.9 cm; size of sheet 25.9 x 22.6 cm

E.1832-1919. Purchased 1919

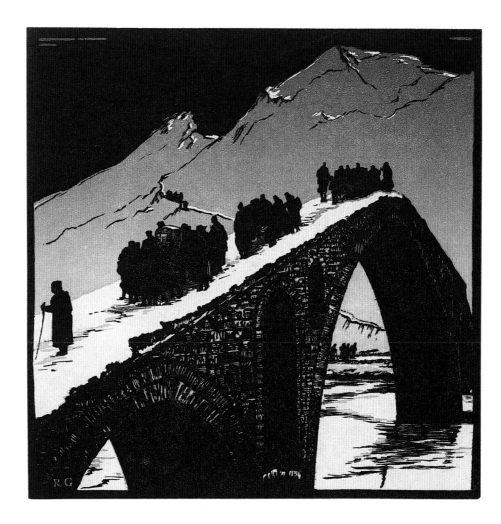

THIS PRINT IS based on a remarkable photograph taken by a war correspondent, published in *The Illustrated London News* on 15 January 1916. The Serbian commander-in-chief, Marshall Putnik, was heading the retreat from the Germans through Albania. His soldiers carried him in a sedan chair over the Bridge of the Viziers, which crossed a river, the White Drin. The artist's eye of Gibbings was caught by the stark but beautiful lines of the stonework of the sixteenth-century Ottoman bridge. Its distinctive parabola form, without any parapet, was characteristic of many bridges adapted from Roman architecture by Ottoman military engineers throughout the Turkish Empire. (There are now few such bridges left after the ravages of time, conflict and the modernization of the twentieth century, and the most famous example, a favourite subject for artists and printmakers, was the bridge at Mostar in Bosnia-Herzegovina, deliberately destroyed by shellfire in 1993.)

As subject matter for his early prints, Gibbings often used the silhouetted forms of architecture, as they were peculiarly suited to the hard-edged patterns rendered by the woodcut block. The subtle hand-colouring enhances the melancholy nature of the subject. The image in the newspaper was striking enough, but the printmaker has made something even more haunting from this tragic episode of the First World War. Gibbings himself served in the army and was wounded at Gallipoli, but although he produced several prints of the buildings he had seen while abroad, he did not otherwise make images of the war.

CN

Christopher Richard Wynne Nevinson (1889–1946)

Banking at 4,000 Feet, 1917

Plate 41 from the set 'Building Aircraft' in the series of 66 lithographs entitled *The Great War: Britain's Efforts and Ideals*, first published by the Department (later Ministry) of Information through the Fine Art Society

Blind stamped with government stamp

Lithograph with scratched highlights

Size of printed surface 40.3 x 31.7 cm; size of sheet 47.4 x 39.3 cm

Circ.240-1919. Given by the Imperial War Museum, 1919

NEVINSON CLAIMED TO be the first person to paint in the air and wrote in his autobiography, 'in all modesty I still think my aeroplane pictures are the finest work I have done. The whole newness of vision, and the excitement of it, infected my work and gave it an enthusiasm which can be felt.'[20]

Here, he draws the viewer into the aeroplane to share his experience of being in the air. The excitement derives not only from the sensation of flight itself, of man as part of machine, close to the engine and the whirring propeller, but also in the completely new vision of the world below. The juxtaposition of the sharply defined bulk of the plane with the diminutive, misted features of the landscape below emphasizes the distance between them, while the strong diagonal tilt of the wings set against the grid of the distant fields, and the contrasting circular action of the propeller, convey the feeling of movement. Nevinson later depicted the same subject as an oil painting; he frequently executed images as both prints and paintings, more often the painting first.

Contributing six images of aircraft manufacture and flight to the *Efforts and Ideals* propaganda series was Nevinson's first commission on being appointed an official war artist in 1917. He was sent to visit various aircraft factories and was also taken up in an aeroplane, describing his first flight as a 'momentous occasion';[21] he subsequently flew many times, often witnessing air combat and even, once, experiencing an enemy attack. The complete *Efforts and Ideals* series was exhibited at the Fine Art Society in July 1917, where signed impressions were sold either individually or in sets, and were available afterwards from the printers, the Avenue Press; unsigned prints were later distributed to national institutions. Nevinson's prints were among the most popular, and after the war he was to develop his reputation as a printmaker in a variety of techniques.

Nevinson's earlier war paintings, uncompromisingly modernist in their geometric structure and stylized forms, and Futuristic in their aggressive dynamism, had thrust him to fame at the Leicester Galleries in 1916. These images, from his time at the Front as a Red Cross ambulance driver, were powerful evocations of the ordinary soldier's experience of war rather than attempts to capture appearances. This lithograph, in contrast, is primarily naturalistic but retains his obvious enjoyment in the interplay of geometric forms. His earlier experiments with geometric abstraction as a compositional discipline had formed, and would remain throughout the variations in his style, the foundation of his structural approach.

RW

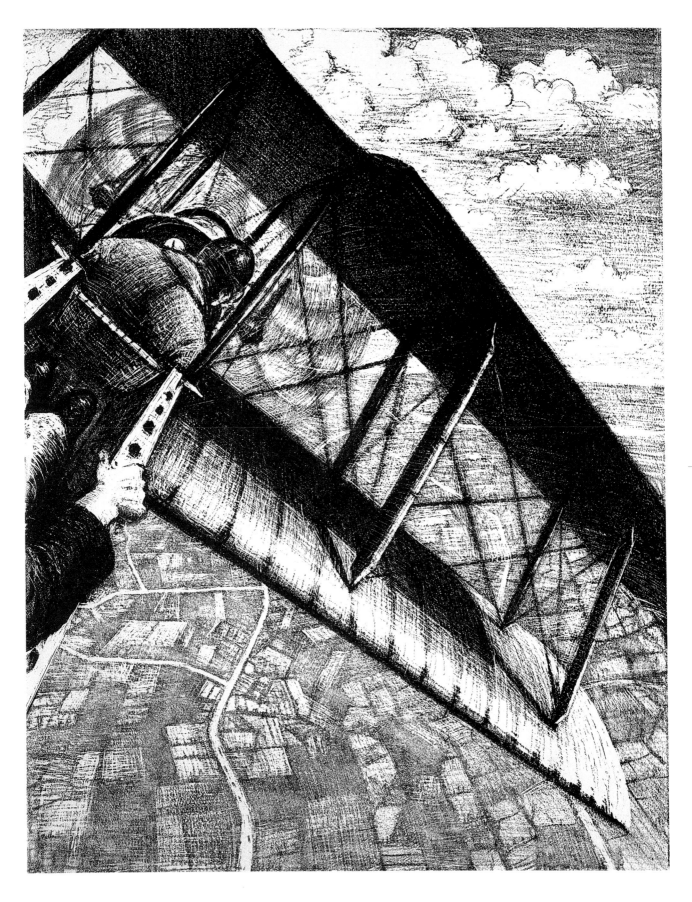

Christopher Richard Wynne Nevinson (1889–1946)

From an Office Window, 1918

**Signed and dated in
black chalk *C.R.W.
Nevinson 1918***

Mezzotint

**Size of printed surface
25.3 x 17.7 cm; size of
sheet 29.2 x 23.3 cm**

**E.2972-1962. Purchased
1962**

*F*ROM AN OFFICE *Window*, executed in 1918 at
the end of the First World War, evolved out of a
painting made by Nevinson in 1917 of the same
subject. The painting was purchased by Sir Osbert
Sitwell, the author and aesthete. The print repeats
the 'cubist' composition of the painting but with
some minor changes – it is much darker and more
oppressive in tone. Nevinson was fascinated with
the form of the modern city. In a review in *The
Sunday Times* in February 1911 Nevinson was
described as 'obviously in love with his selected
subjects, feeling the charm of form and colour in
unexpected industrial settings ... he is a painter
who sees beauty in what the world condemns as
ugly'.[22] The device of looking outside from an inte-
rior is one that Nevinson used on a number of
occasions. The window that frames the view looks
out onto a pattern of roofs and chimneys
enveloped in smoke. The artist uses the texture of
the printed surface to evoke the impression of a
metropolis choked by grime and soot. It is an
incredibly powerful image and the oppressive,
brooding atmosphere possibly hints at a darker
mood – Nevinson suffered a nervous breakdown
in 1918.

Mezzotint had virtually ceased to be used in
printmaking at this time and it is not known why
Nevinson took up this particular medium or who
taught him the technique. He made two other
mezzotints in the same year, *Limehouse* and *Wind*,
and two American subjects a year or two later. The
use of this medium was ideally suited to capture
the tones of the painting that Nevinson was repro-
ducing. In mezzotint this effect is achieved by
working a copper plate with a rocker – a serrated,
chisel-like tool – until the surface is covered in a
uniform burr. The design is formed by smoothing
the burr so that different areas of the plate will
hold different quantities of ink and therefore print
different tones. Highlights are created by making
the plate quite smooth so that when it is wiped no
ink remains on these areas.

This print has been described by Frances Carey
and Antony Griffiths in *Avant-Garde British
Printmaking 1914-1960* (1990) as one of the finest
British mezzotints of this century. The V&A's
impression was purchased in 1962 from the
Leicester Galleries, where Nevinson frequently
exhibited his work.

FR

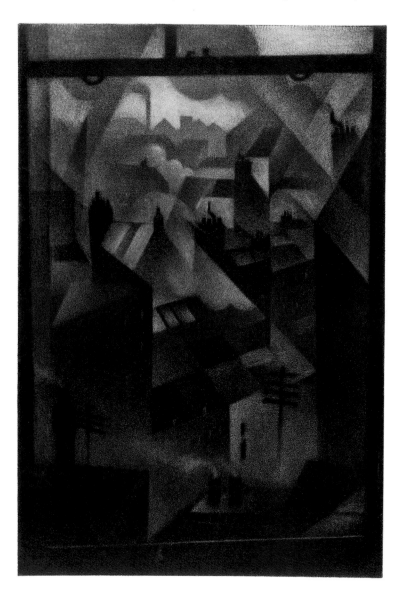

Margarete Berger Hamerschlag (1902–58)

Raskolnikoff in Dialogue with the Judge, 1919

Signed (very faintly)
with the artist's initials
MH. Inscribed in pencil
on the support sheet
with title and
Woodcut. Dated in
what appears to be a
later hand *1919*

Woodcut on Japanese
paper, pasted to pink
support sheet

Size of printed surface
23.5 x 22.6 cm; size of
sheet (irregular)
24.2 x 23.4 cm

E.1127-1988. Purchased
from the widower and
the son of the artist in
1988

MARGARETE HAMERSCHLAG WAS just seventeen when she made this print. Her talent is all the more interesting when we know she had been a pupil of Franz Čizek, a pioneer of modern child education who, from 1904 until the outbreak of the Second World War, ran Saturday morning art classes in Vienna for children from the ages of six to sixteen. Čizek's teaching methods recognized the inherent creativity of children's work and did not use the conventional approach of trying to make children work like adults. In 1923 an exhibition of his pupils' work toured Britain and was subsequently acquired as an archive by the Centre for Child Education at Bretton Hall in Yorkshire. At the same time Čizek donated a further forty-six linocuts by his pupils to the V&A; these included a print by Margarete depicting Red Cross nurses, made in 1916.

This print, made just three years later, evidently illustrates a scene from Dostoyevsky's *Crime and Punishment* and is inscribed with notes about the novel's protagonist, Raskolnikov. It looks almost like a sheet of studies, yet the dramatic shift in scale from the foreground figures to the scene set for interrogation behind them implies a direct psychological connection between the two. A sense of entrapment is conveyed with striking economy. The 'criminal' Raskolnikov's mental state is visualized in the black space above his hollow face and above his tormentor (probably the inscrutable magistrate Porfiry). For all her youth Hamerschlag seems to have been keenly aware of Dostoyevsky's intense psychological insight into deranged morality, with its implications beyond the society of his time.

Hamerschlag later came to live in England where, although never acquiring fame as an artist, she practised as an illustrator and teacher. Some of her most engaging drawings were of Teddy Boys, which she made while working with teenagers in an East End youth club. An exhibition celebrating the achievements of Čizek and his pupils, including Hamerschlag, was held at the Bethnal Green Museum of Childhood in 1989.

RM

43

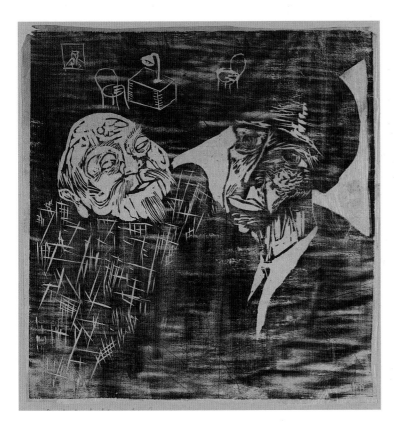

DIE SILBERGÄULE

MERZ

Aus feindlichen
Trümmern zu=
gefaßt.

Vorsicht: ANTi=

»dada

DIE

KATHEDRALE

8 LiTHoS von
KURt SCHWiTTERS

PAUL STEEgEMANn VERLAG HANNOVer

Kurt Schwitters (1887–1948)

Merz 8 – Die Kathedrale (Merz 8 – The Cathedral), 1920

Front cover and first plate (unnumbered) of a volume of 16 pages stapled into thin card covers with 8 plates, including the back cover, and broken paper seal pasted to front and back covers. Printed by Edler & Krische, Hanover and Berlin, and published by Paul Steegemann, Hanover, as volume 41/42 of the periodical *Die Silbergäule* (The Silver Nag)

Lettered on the front cover with title, etc. and on the seal on the back *K.S. Merz. 1920*, etc. Lettered inside the front and back covers and on the last 2 pages with details of other publications by Steegemann, including other works by Schwitters and other *Silbergäule* titles

Lithograph and letterpress on paper and brown card

Size of volume 22.4 x 14.4 cm, opening to 22.4 x 28.8 cm

E.191 & E.191(1)-1986. Purchased 1986

THOUGH HE BEGAN his career as a painter, Schwitters very soon adopted collage and assemblage as his primary strategies for making art. He created collages from discarded paper fragments of all kinds – sweet wrappers, tram tickets, packaging, fragments of newsprint and illustrations from magazines. In his collage compositions these abject materials are simply themselves – they do not aspire to the status of the illusionist tricks found in Cubist collages. Schwitters was associated with Dada, the radical anti-stylistic movement that encompassed a range of art forms and practices, but he worked in relative isolation from the movement's political manifestations. In 1920 he had fallen out with fellow Dada artists when he was refused permission to exhibit in the Berlin Dada Fair at the Burchard Gallery, and was also snubbed by George Grosz. In retaliation he had stickers printed for the cover of *Die Kathedrale*, which was already in the press. They read 'Vorsicht [Beware]: Anti-Dada'.

The term 'Merz' was itself arrived at through the collage method. It first appeared as a word fragment, taken from an advertisement for a 'Kommerz und Privatbank' (commercial and private bank) in a painting of 1919. Schwitters adopted it as a collective noun for all his work, including painting, poetry, his three-dimensional architectural assemblages (the 'Merzbau') and his publications. The lithograph plates in *Die Kathedrale* are a mix of drawing and collage processes. It appears that Schwitters nailed fragments of embossed papers and pieces of shoe leather to wooden blocks, used transfer papers to take rubbings from these, added drawn elements and transferred the resulting image to lithographic stones. As a whole the volume is a compendium of Schwitters' various artistic practices and concerns, incorporating oblique references to his allegiances within the art world and quoting the title of his famous poem *An Anna Blume*.

GS

Edward Hopper (1882–1967)

The Evening Wind, 1921

Signed in pencil
Edward Hopper and
numbered [8]*30.*
Inscribed in pencil
with title and *3 Wash
Square New York*

Etching

Size of platemark
17.6 cm x 21.1cm;
size of sheet
33.5cm x 39.3cm

E.2689-1929.
Purchased 1929

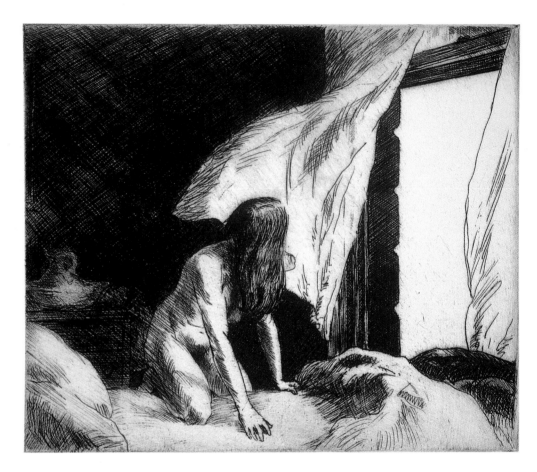

ALTHOUGH THESE DAYS it is Edward Hopper's oil paintings that are endlessly reproduced on calendars and posters, in 1921 the artist was better known as a printmaker, having concentrated his efforts on etchings and drypoints since 1915. Indeed, by the time he abandoned printmaking for painting in the mid-1920s he had made some seventy-six printed images, the majority of which can now be found in public collections across Europe and America. Like many of these early works, *The Evening Wind* demonstrates qualities that were later to make Hopper one of the most celebrated of American artists, noted as much for his technical skill as for his unfailing ability to evoke the darker side of modern urban life.

In *The Evening Wind* a simple interior scene takes on a disturbing resonance that strangely anticipates Alfred Hitchcock's later cinematography. Reworking the timeless subject of a lone female nude, Hopper subverts the familiar and the comfortable to create an image that denies as much as it gives. Poised tensely on the edge of the bed, the woman hides her face behind her hair, transfixed by we know not what. The cramped room remains as anonymous as its occupant, hidden in shadow and home to little more than a commode and an unmade bed. But above all, it is the vast open window that dictates the mood, letting in the cold wind while simultaneously revealing nothing about the world beyond. As is the case with many of Hopper's works, we are invited to observe a private moment, but at the same time rebuked for looking too hard.

With its understated tonal contrasts and half-told story, *The Evening Wind* is a deeply memorable print. Significantly, like a conjurer who must guard his magic with absolute secrecy, Hopper chose to remain silent about the narrative content of his work, preferring instead to grant us the pleasure of our own multifarious readings.

MG

Otto Dix (1891–1969)

Dompteuse (Lion-Tamer), 1922

Signed in pencil *Dix*.
Inscribed in pencil
with title and
numbered *43/50*

Etching

Size of platemark
39.8 x 29.5 cm; size of
sheet 49.1 x 39.2 cm

Circ.146-1966.
Purchased 1966

OTTO DIX, A contemporary and associate of George Grosz, was a social realist and satirist. The defining experience for Dix was the First World War, which he experienced at first hand as a soldier in the trenches. He was moved to anger and revulsion by the pointless suffering of ordinary soldiers and the moral vacancy of the generals and governments. He subsequently addressed – in print and in paint – the corruption of modern society, its facades and pretences. With Grosz, Dix became a leading exponent of the 'Neue Sachlichkeit' (New Objectivity) movement. They turned an unflinching gaze on the world around them, refusing to flatter or finesse their sitters and subjects.

This etching is from the period when Dix was living in Düsseldorf, studying intaglio techniques with the master printer William Eberholz, as he prepared to produce his graphic series *Der Krieg* (War), published in 1924. In 1922 and 1923 he made several etchings of less overtly political subjects, including a portfolio, *Circus*. This was a series of portraits of circus performers – acrobats, bareback riders and trapeze artists as well as the lion-tamer. Dix was drawn to the circus and the fairground because the people who worked there lived on the fringes of society, and were thus free from many of the moral constraints that governed the everyday life of the majority. The lives of these artistes and performers were inherently dangerous; he hinted at this with small details such as the skull-and-crossbones tattoos on the shoulders of the high-wire walkers, the 'death despisers' as he called them.[23] The lion-tamer is a voluptuous monster, her features metamorphosing into those of a lion, indicating that she shares the animal nature of her charges. Rather than taming these dangerous wild animals, she is in fact becoming a feral creature herself, sensual, predatory, amoral. In the circus prints Dix seems to suggest that danger liberates men and women from established social structures and conventional moral codes. He saw these performers, risking their lives daily, as a model for the way everyone should live. In this he was drawing on the ideas of Nietzsche, who had used the allegory of the circus and fairground in his philosophical writings.

GS

47

Lazar (El) Lissitzky (1890–1941)

Proun III, 1923

Signed in pencil
El Lissitzky

Lithograph

**Size of printed
surface and sheet
59.4 x 43.2 cm**

**E.757-1976.
Purchased 1976**

TRAINED AS AN engineer and architect, El Lissitzky began painting his *Prouns* in 1919, inspired by the Suprematist paintings of Kasimir Malevich in the Tenth State Exhibition in Moscow that year. The word *Proun* is an acronym of a Russian phrase meaning 'Project for the Affirmation of the New', and the artist explained the concept in a lecture at 'Inkhuk' (The Institute of Artistic Culture) in September 1921 as 'a changing-station between painting and architecture'.[24] It was also in 1921 that Lissitzky taught architecture at Vhkutemas, the Russian Bauhaus, where Vladimir Tatlin was among his colleagues. Lissitzky developed Suprematism's visual language of pure geometric abstraction and applied it to the Constructivist aim to recreate the world along rational lines, transforming the disciplines of the propaganda poster, book illustration, architecture and exhibition design in the process.

After a successful exhibition of *Prouns* in Hanover in 1922, organized by the Kestner-Gesellschaft, a society founded in 1916 to promote new art, Lissitzky was commissioned to produce a portfolio of six lithographs which the society published in an edition of fifty in 1923; this print is from that portfolio. Exploiting the properties of the lithographic process, he adds texture and extends the monochromatic tonal range, heightening the tension and spatial ambiguity of the floating Suprematist forms in the composition.

TT

Paul Nash (1889–1946)

Genesis, The Void, 1924

Plate 1 of *Genesis*,
published by the
Nonesuch Press,
London, 1924

Signed and dated in
pencil *Paul Nash 1924*.
Inscribed by the artist
with title and *edition
12. set 5*. Inscribed in
another hand *Set 5 of
5 sets*

Wood engraving

Size of printed surface
9.3 x 8.2 cm; size of
sheet 26.6 x 18.1 cm

E.4756-1960. Given by
Mrs Margaret Nash,
widow of the artist

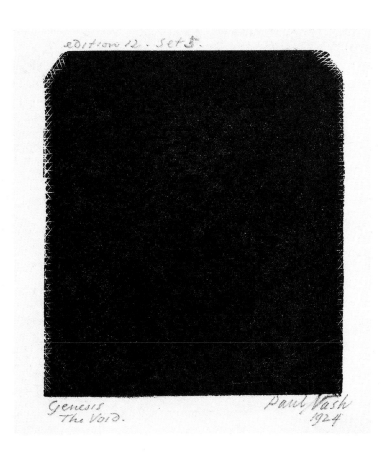

*In the beginning God created the heaven and
the earth. And the earth was without form and
void; and darkness was upon the face of the
deep. And the Spirit of God moved upon the
face of the waters.*

Genesis 1: 1

CONSIDER THE QUESTION 'What was here
before the world was born?', for this is the
very subject that Paul Nash addresses in *The Void*,
a wood engraving intended as the first plate to the
Nonesuch Press's 1924 edition of the *Book of
Genesis*. In this abstract, inky print Nash embodies
the opening words of the Old Testament, power-
fully conveying the darkness and emptiness of
earth at the moment of Creation. With further acts
of Creation soon to follow, *The Void* is the doorway
through which this nascent world will flow.
Grounded as we are in a physical dimension, we
have little choice but to express the primordial vac-
uum in terms of the dark and the empty. As the
opposites of light and matter, the elements most

often used to describe the extant world, they
remain the closest approximations to that state of
non-existence that we are forever incapable of
knowing.

By the time Paul Nash was first commissioned
to illustrate a book in 1918, he had already made
his name as a painter of visionary landscapes, con-
ceived while he was an official war artist in the First
World War. Most of the books he went on to illus-
trate were published during the 1920s, and in the
Nonesuch *Genesis* Nash scaled new heights of
poetic interpretation. The V&A's impression of *The
Void* is one of only two proofs taken, and it is the
working proof (the final state is in the British
Museum); the V&A also possesses the original
woodblock of the subject. In the published work
the biblical texts that accompany Nash's twelve
magnificent wood engravings are set throughout
in the dark, distinctive capitals of Rudolf Koch's
Neuland typeface.

MG

Henri Matisse (1868–1954)

Odalisque à la coupe de fruits (Odalisque with a dish of fruit), 1925[25]

Printed by M. Duchâtel
under the supervision
of Matisse or his
daughter, and
published by Matisse

Signed in pencil
Henri-Matisse.
Numbered *2/50*

Lithograph on chine

Size of printed surface
33.2 x 26 cm; size of
sheet 47.1 x 32.6 cm

E.319-1935. Given by
the National Art
Collections Fund

'TO TELL THE truth, M. Matisse is an innovator, but he renovates rather than innovates,' wrote Apollinaire in 1909.[26] This statement is particularly true of Matisse's attitude to lithography. When he made his first lithographs in 1906 he was in close touch with Paul Signac and Henri Edmond Cross, two of the greatest exponents of the colour lithograph, and a year or two earlier his paintings had been influenced by their pointillist doctrine. Yet, in spite of his love for resonant colours, he chose to remain faithful to the nineteenth-century tradition of chalk lithographs printed in black, except in a few examples towards the end of his life.

Matisse made a total of well over three hundred lithographs, ninety-five of which are in the Museum's collection, thanks to the National Art Collections Fund which bought ninety-one from his daughter on a visit to London in 1935 and donated them to the V&A. They vary from works in line to rich chiaroscuro compositions like this. In an article on his drawing style Matisse said that he believed his line drawings, mistaken by some as mere sketches, to be the purest and most direct translation of his emotion. But he stressed the importance of the drawings built up with shading. Finding this a less demanding way of drawing, he was able 'to consider simultaneously, the character of the model, her human expression, the quality of the surrounding light, the atmosphere and all that can be expressed by drawing'.[27]

The subject matter of his lithographs is close to that of his paintings. This example, executed during the hot summer months in Nice, relates to a number of vibrantly coloured odalisque paintings of the same period. Yet Matisse believed that composition 'alters itself according to the surface to be covered'.[28] Normally, Matisse worked on related compositions in different media concurrently: the lithographs were parallel developments to his paintings rather than studies for them or copies after them. Matisse stressed that it was the relationship between his colours as much as their individual brilliance that caused their impact. It is as if the discipline of lithography provided an opportunity for a monochromatic analysis of the relationships between colours. Finding the black and white equivalents of the surrounding colours, he achieved with his subtle balance of light and shade the 'living harmony of tones, a harmony not unlike that of a musical composition' that he so desired.[29]

SL

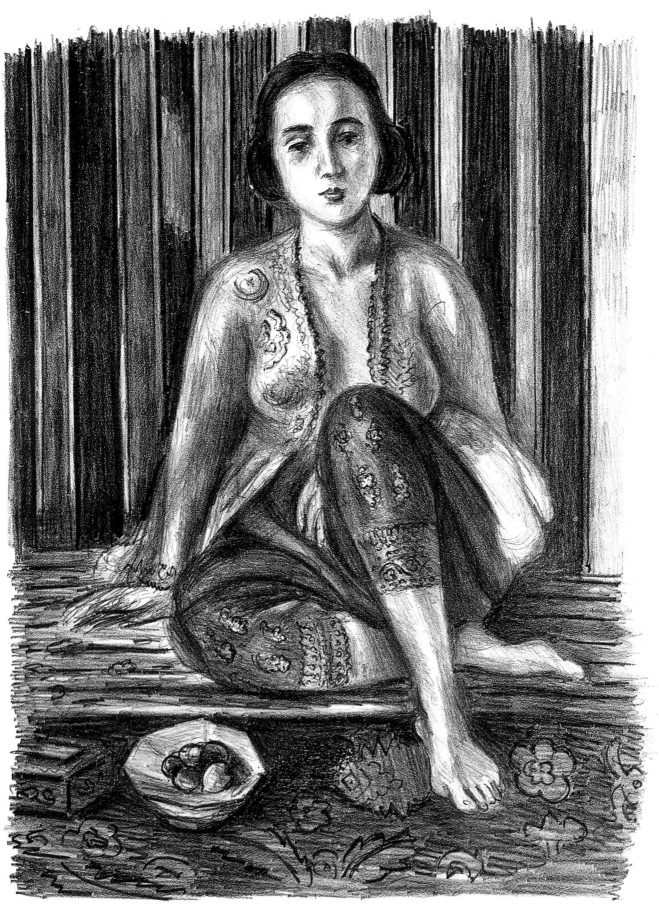

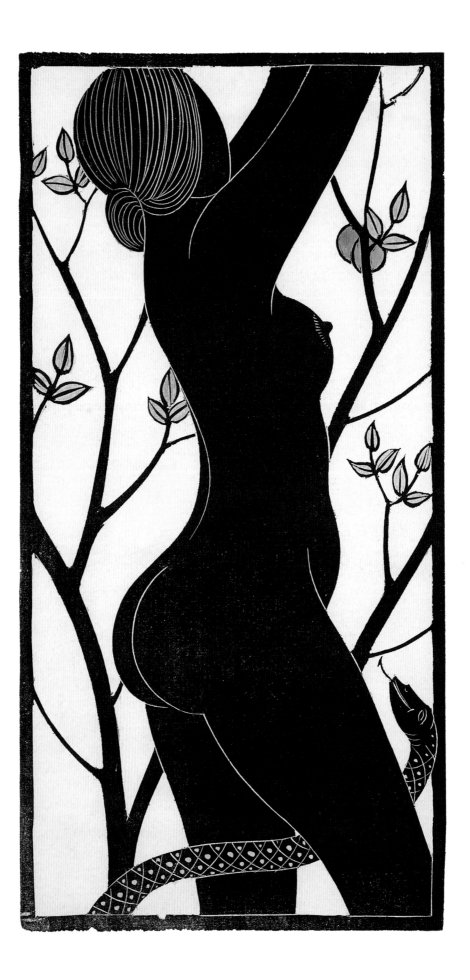

(Arthur) Eric Rowton Gill (1882–1940)

Eve, 1926

Proof, inscribed in ink on the mount by the artist with title and *Ed.50 £1.10.0*

Wood engraving, coloured by hand

Size of printed surface 23.8 x 11.8 cm; size of sheet 25.4 x 13.5 cm

E.1227-1952. Given by Mrs Mary Gill, widow of the artist

ERIC GILL, SCULPTOR, engraver, typographer and polemicist, is as famous today, or more accurately notorious, for his sexual proclivities as for his creative output. Gill was not coy in his own lifetime about his sexual interests and expressed them with great force in much of his work. For Gill there was a strong spiritual aspect to the sexual and he wrote and created work that challenged Victorian Christian divisions between the body and the spirit. These were forceful expressions of his belief that the body and the soul formed a beautiful unity. One notable set of works illustrated the *Song of Songs*, the erotic love poems in the Bible supposedly written by Solomon. These express the relationship between Christ and his church through the metaphor of the love of a man and a woman, which Gill portrayed as an uncompromisingly robust sexual relationship. Recent research, however, has revealed the full extent of Gill's experimental rebellion against the sexual repression he experienced growing up at the end of the Victorian era. The reality of, for example, his incest has exposed Gill and his beliefs to accusations of hypocritical self-justification and has sadly cast a shadow of distaste over many of Gill's most beautiful works.

Gill's two abiding interests, the biblical and the erotic, both seem to find expression in this provocative image of Eve. However, on balance, this image is probably an unproblematic piece of erotica, produced as a one-off rather than forming part of a narrative series. It is executed in the cool, spare medium of wood engraving, a technique in which there had been a revival of interest from the late nineteenth century, encouraged by, among others, William Morris. Gill noted in his diary in 1906, 'tried wood-engraving a little in the evening'.[30] His initial interest was in typography, but he quickly appreciated the wider creative possibilities and began engraving Christmas cards and small illustrations. In 1920 he became a founder member of the Society of Wood Engravers. This image was subsequently used for illustration as plate 89 of *Engravings by Eric Gill*, with a preface by the artist, published by Douglas Cleverdon, Bristol, in 1929.

KC

53

Eric William Ravilious (1903–42)

Boy Birdsnesting, 1927

Signed in pencil
E Ravilious and
inscribed with title
and price. Inscribed in
pencil on the back
with title, price and
Eric Ravilious
46 Charleston Road
Eastbourne

Wood engraving

Size of printed surface
8.8 x 13.2 cm; size of
sheet 18.6 x 25 cm

E.582-1972.
Purchased 1972

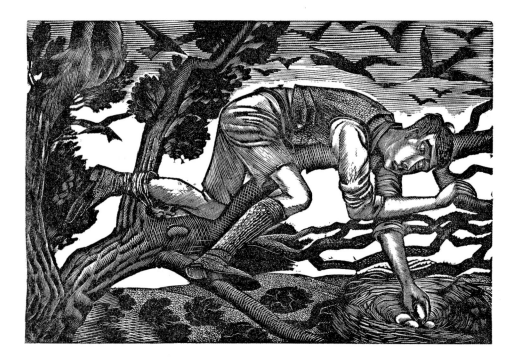

ALTHOUGH RAVILIOUS'S CAREER was cut short by the Second World War, his reputation as a watercolourist and mural painter, designer and printmaker was by then already established. He was a prolific artist, who first became known for his wood engravings. At the Royal College of Art he had enrolled in the School of Design, but under the tuition of the artist Paul Nash, who worked in both art and design, he was inspired in particular to learn wood engraving. While admiring his tutor's work, Eric Ravilious also looked at the work of other engravers, such as Thomas Bewick and the fifteenth-century German and Flemish masters, who influenced him in their use of a variety of tool marks to create tones. Their work was accessible to Ravilious through the Victoria and Albert Museum. In 1925, after Ravilious had been working in the medium for only a year, Paul Nash proposed him as a member of the Society of Wood Engravers. There he met Robert Gibbings (see p.39), owner of the famous Golden Cockerel Press, and was soon undertaking commissions for illustration.

The second book Ravilious illustrated was *The Twelve Moneths* (*sic*) by Nicholas Breton, published in 1927; it was for this book that *Boy Birdsnesting* was first designed. *The Twelve Moneths* consisted of pages of text containing a countryman's thoughts on each month, facing a calendar with wood engravings above and below illustrating the text. Within this strict format and small space Ravilious designed scenes reflecting his passionate observation of the English countryside and his skill in design and wood engraving, as well as his characteristic sense of humour. The print shown here is, however, an alternative version to the book illustration. Liberated from the constraints of book design, it is larger in scale, with slight variations in composition and printed in reverse.

Ravilious travelled widely around Britain sketching and painting landscapes, which he depicted from his own individual, almost eccentric viewpoint. It is in his wood engravings that his extraordinary enthusiasm and exuberance for life is particularly apparent. His skill in creating pattern and his strong sense of design result in a seemingly effortless lightness of touch. His prints were then given further richness by a great variety of tonal effects – a technique that he was to develop still further in his later wood engravings. *Boy Birdsnesting* thus becomes an unforgettable image in 'praise of a perpetual English April'.[31]

JB

Ben Nicholson (1894–1982)

Three Mugs and a Bowl, 1928

Signed and dated in
pencil *Ben Nicholson
1928* and inscribed
for R B F April 44

Linocut

Size of printed surface
25 x 32 cm; size of
sheet 28.1 x 38 cm

Circ. 655-1967.
Purchased 1967

WHILE HE WAS growing up, Nicholson recalled, the house was always full of 'very beautiful striped and spotted jugs and mugs and goblets, and octagonal and hexagonal glass objects' collected by his father, the painter William Nicholson.[32] The impression such things made became a powerful influence on Nicholson's chosen subject matter. Although he was also to become a landscape painter and one of the most important abstract artists in Britain, he remained more or less faithful to the construct of still life for the rest of his life.

In his linocuts, which he made throughout the later 1920s and early 1930s, Nicholson used various arrangements of jugs, mugs and bowls as a format for exploring and developing flattened space and geometric line. These experiments at first precluded, then ran in tandem with, the concerns of his abstract and carved reliefs of the 1930s. In some of the lino-prints the objects depicted retain vestigial decoration; the omission of such motifs in *Three Mugs and a Bowl* is significant in indicating a concentration on pure form. Linocut also provided the means of achieving a strong line within a very painterly surface. Interested in the textures it could offer, Nicholson

deliberately varied the thickness and number of applications of ink from one impression to the next. Sometimes, as in this plate, there is a 'crumbly' feeling achieved by using very dry and gummy ink; in others the ink is thinner and smoother.

Although he had begun making his linocuts before he first met the Cornish painter Alfred Wallis (1855–1942) in 1928, Nicholson found the latter's resourceful use of any old piece of card and ordinary house paints refreshingly direct. Linoleum, commonplace and cheap, could be 'picked up' in much the same way as Wallis's cardboard. This immediacy seems to have been particularly appealing to Nicholson, who is apocryphally said to have made his first print from lino taken from the floor of his father's house. Despite the modesty of the medium, Nicholson was obviously taken by the results. Printed by his own hand, in very small editions, approved linocuts were presented to friends, while others that he disliked were destroyed. However, an impression of *Three Mugs and a Bowl* was still in his possession at his death, so it must have been something of a favourite.

RM

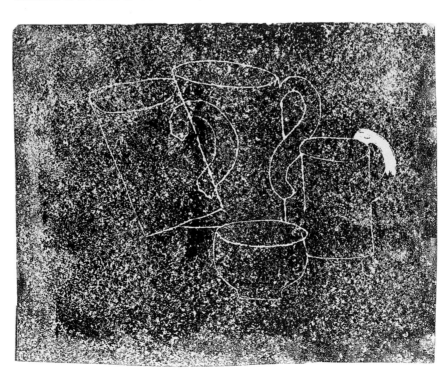

Cyril Edward Power (1872–1951)

The Tube Staircase, 1929

Signed in pencil *Cyril
E. Power*. Inscribed in
pencil with title and
numbered *22/50*

Colour linocut on laid
Japanese paper

Size of printed surface
48.3 x 29.5 cm; size of
sheet 49.1 x 30 cm

E.76-1981.
Purchased 1981

CYRIL POWER WAS one among an influential group of artists directly responsible for the promotion of linocut as a medium for fine art prints. Having pursued a career as an architect (he lectured on the subject and wrote a book on English medieval architecture in 1912), Power enrolled at Heatherley's School of Fine Art in 1922 as a mature student at the age of fifty. In 1925 he joined the newly formed Grosvenor School of Modern Art as a lecturer on architectural ornament; a year later, when Claude Flight (see p.10) came to the school to teach linocutting, Power attended his classes. Through Flight he learnt to appreciate the expressive qualities of the linocut and its potential to capture the forms and spirit of the modern age. Power's subjects often derive from metropolitan life and pursuits, and when Flight organized exhibitions of his pupils' work between 1929 and 1937, the work of Power and his artist colleague Sybil Andrews attracted particular attention. The pair, who formed a close working relationship until 1938, also collaborated on a series of bold and colourful posters for the London Underground.

Power's vision transforms the spiral staircase at Russell Square Underground Station into a dynamic structure of the machine age, expressed in terms of rhythm and movement. In its counter-thrusting energy it evokes the work of the Italian Futurists and the English Vorticists. At the same time there is a strong influence from the contemporary fashion for things Japanese: the staircase unfolds like the swirl of a Japanese fan and the newel post recalls the form of a bamboo pole. The composition, with its black outlines and flat areas of colour, is cut at the margins in the manner of Japanese woodblock prints. Similar elements appear, for example, in the contemporary posters of Edward McKnight Kauffer. Power exploits the particular quality of linocut to the full, revelling in the free energy of the cut line and the spontaneous textures of the coloured inks as they are pulled from the soft linoleum block.

MT

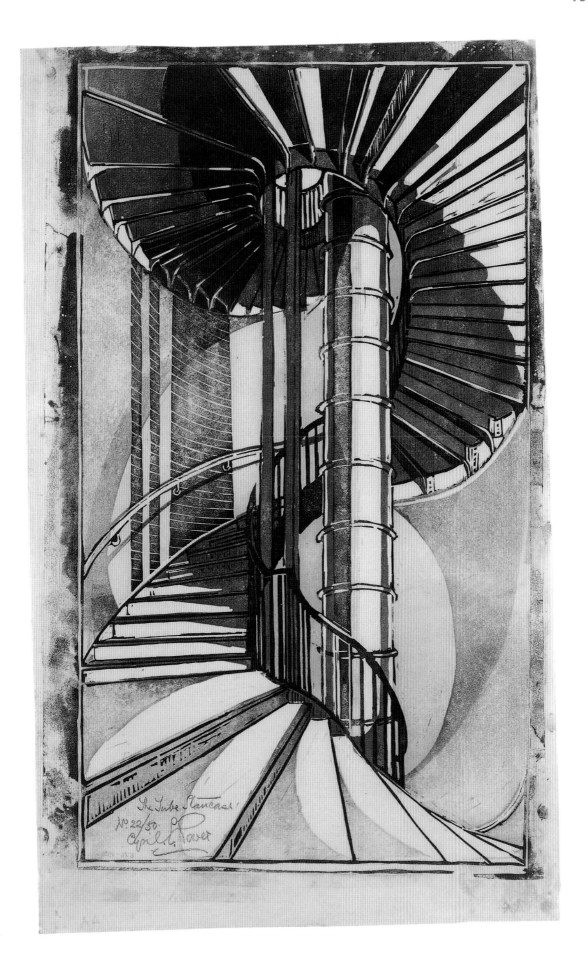

The Tube Staircase
No 22/50
Cyril E. Power

David Jones (1895–1974)

The Wounded Knight, 1930

Signed and dated in pencil *David Jones '30*

Drypoint

Size of platemark 20.1 x 15.7 cm; size of sheet 29.3 x 23.2 cm

Circ.520-1948. Purchased 1948

MANY WORKS BY the Welsh artist and poet David Jones are richly layered with allusions to medieval legends. Motifs from works such as Malory's Arthurian epic *Morte d'Arthur* and the Welsh *Y Gododdin* run like threads through his art and writings, bringing Jones's deeply felt consciousness of an age-old cultural inheritance into his response to the modern world, and showing in tragic juxtaposition the extent to which this continuum had been broken by the events of the twentieth century.

In this case Malory's work was itself the starting point: the print, intended as an illustration to the *Morte d'Arthur*, shows Jones's deeply personal response to Malory's work. Through the simplified contours of the central figures the artist focuses on the points at which they touch; the viewer's sensory awareness is heightened by details such as the knight's hair against the lady's arm. David Jones had been engaged to Eric Gill's daughter, Petra, but she broke off the engagement in 1927 and in 1930 married another man: the image of the knight lying wounded in his lady's arms and the way she sits up, unattainable, perhaps carry with them something of the shadow of this experience. Certainly the wounded knight lying in the arms of his lady recalls *Pietà* images of Mary cradling Christ, an image central to Jones's strong Catholic faith.

Two years earlier Jones had begun the writings which became *In Parenthesis* (published 1937), a novel in prose and poetry about the experiences of a soldier in the First World War. Jones had himself fought as a private with the Royal Welsh Fusiliers on the Western Front, and this had affected him profoundly. *In Parenthesis* contains many allusions to the *Morte d'Arthur*. The Great War had shattered the heroic ideal of medieval Romance, and Jones often ends quotations abruptly or literally breaks them up across the page. In the book, too, soldiers are linked with Christ. The frontispiece shows a soldier with his arms hung out as if on a cross, his helmet strap a kind of halo. Men were no longer to be the heroes of medieval chivalry; instead they were to be sent to their deaths, betrayed by their officers as Judas betrayed Christ. And so, in this illustration of an Arthurian legend, we might likewise read echoes of the death of a soldier at the Somme, or perhaps the death of the chivalric ideal itself: riderless horses are scattered beside the shore as the sun sets on the Arthurian legend.

LO

Graham Vivian Sutherland (1903–80)

The Garden, 1931

Signed in pencil
Graham Sutherland.
Numbered in pencil *3/6*
and inscribed *own
proof*

Etching

Size of platemark
21.7 x 15.4 cm; size of
sheet 24.7 x 18 cm

Circ.273-1963.
Purchased 1963

There is a thread of family likeness in the images which I find, which speak to my own particular nervous system. That is to say, there are certain conjunctions of form which touch each person's inborn predilection.[33]

As a young artist, Graham Sutherland was attracted to the etchings of the nineteenth-century Romantic artist Samuel Palmer, admiring above all the way in which Palmer allowed his strong emotion to 'change and transform the appearance of things'.[34] Sutherland's own early etchings are idealized landscapes in the Romantic tradition, idyllic celebrations of rural life that led artists of the older generation, including Frederick Griggs, to hail him as the heir to Palmer's Romantic vision.

In 1929, however, Sutherland's art began to betray other feelings. The Sutherlands' three-month-old son died that year, a personal tragedy that coincided with the general hardship of the Depression. Etchings that Sutherland produced at this time show a landscape that is threatening and tragic: in his *Pastoral* (1930), for example, bare twisting trees, dark shadows and a rotting tree stump contribute to an atmosphere of profound disquiet. Sutherland had begun to communicate a new message through the traditional language of etching.

The Garden shows the artist's own garden at the White House, Farningham, Kent. A mature work, the etching anticipates his later abstract forms: descriptive elements mingle with abstract ones in a vision where forms take on value and size according to the significance Sutherland finds in them. He places the rose tree at the centre of the image and concentrates on the light that suffuses it, capturing the way in which some leaves appear distinct while others seem to dissolve in the brightness. He records the curling leaf forms and strong shoots of the plants at the foot of the rose tree and the close-cropped texture of the grass. Tipping up the circular flowerbed, he emphasizes its geometrical form and, as if echoing the decorative formality of the garden, arranges the composition so that the buildings and shrubbery frame the rose tree. Although not sinister like *Pastoral*, the imagery of *The Garden* conveys a sense of experience rather than idealized innocence. The halo of light and roses blossoming from the pruned rose tree could be read as a spiritual or religious symbol of hope following sacrifice or loss.

LO

Georges Braque (1882–1963)

Hera et Themis, 1932–9

Illustration to Hesiod's *Théogonie* (Theogony) from the suite of 16 commissioned in 1930 by Ambroise Vollard. Reserved by Vollard in 1932 for printing by Démétrius Galanis. Printed some time between 1932 and 1939

Signed in brown crayon *G Braque*. Numbered *45/50*

Etching on Hollande van Gelde paper by Galanis

Size of platemark 36.8 x 29.9 cm; size of sheet 53.3 x 37.8 cm

Circ.102-1949. Purchased, with two other plates from the set, 1949

DURING THE 1920s and 1930s classical art and literature played an important role in the work of artists and writers throughout Europe, not least for those in its cultural Mecca, Paris. Braque's own interest in these subjects developed into something of an obsession, and when in 1930 Vollard approached the artist for an illustrated book, Braque immediately proposed the *Theogony*. Despite the general interest in classical literature, this was not the most likely work to be chosen for such a project. It describes the creation of the world through endlessly repetitive pairings and battles of the gods (the illustration shows the mythological Hera, sister and wife of Zeus, and Themis, Greek goddess of justice and wisdom), and is rather less gripping than other epics such as Homer's *Iliad* or *Odyssey*. Yet Braque declared that he had read it with complete admiration, finding it more interesting than Aeschylus or Sophocles. Its theme of order out of chaos was an appropriate metaphor for Braque's post-Cubist 'genesis of linear form',[35] so perfectly expressed in this suite. The remarques (marginal drawings) of the first edition set enhance this sense of search for linear expression.

About the same time Braque was making low plaster reliefs in a drawing style found on very early Greek and Etruscan terracottas and bronzes. In this he may have been influenced by S.W. Hayter, the English artist working in Paris who was also interested in ancient Greek and Sumerian relief techniques and who from 1931 was making prints by pouring plaster onto incised or etched plates.

As with so many of Vollard's commissions Braque's *Theogony* was subject to various delays and diversions. Braque made numerous drawings as studies for the suite, and by 1932 the plates were ready. Vollard entrusted sixteen of these to Démétrius Galanis, but he was painstakingly slow in his printing. Nevertheless, individual plates were evidently released before Vollard's death, as testified by the exhibition of one at the Museum of Modern Art, New York, in 1936. *Hera et Themis* was one of the earlier group printed, but its exact date of production seems uncertain. The book itself, with plates trimmed of the remarques, was finally published by Maeght, Paris, in 1955.

RM

63

Lill Tschudi (born 1911)

Ice Hockey, 1933

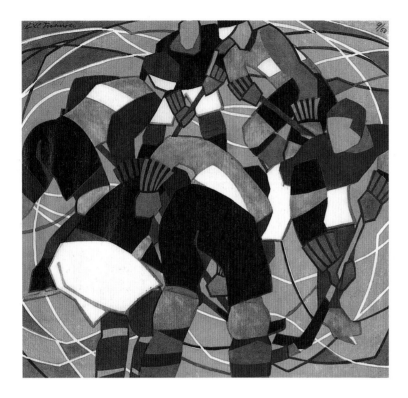

64

Signed in pencil *Lill Tschudi* and inscribed with title. Numbered *9/50*

Colour linocut

Size of printed surface 28.5 x 30.4 cm; size of sheet 28.5 x 32.3 cm

Circ.163-1933. Purchased 1933

THE RISE OF colour linocuts in the 1920s and 1930s stemmed from the work of Claude Flight (see p.10), a tutor at the Grosvenor School of Modern Art, London, and an energetic proselytiser for the medium through exhibitions and his own writings. One of his most promising pupils was Lill Tschudi, whose work he particularly promoted.

Although a few individual artists had used lino as a printing medium earlier in the century, it had not been widely adopted, largely because it was stigmatized as a children's art material. To Flight, writing in 1934, this meant that 'the linocut is different to the other printing mediums, it has no tradition of technique behind it, so that the student can go forward without thinking of what Bewick or Rembrandt did before ... he can do his share in building up a new and more vital art of tomorrow.'[36] His students readily embraced this challenge, not just through their technical use of the medium, such as superimposing colours and avoiding the key block of traditional colour print-

ing, but also through the subjects they depicted, which were chosen to emphasize the speed and vitality of the everyday world.

Lill Tschudi was Swiss and studied with Claude Flight only for a short period in 1929, though she kept in close touch through correspondence and annual reunions. Because of Flight's exhibitions of her work, however, she became better known in Britain than in her native Switzerland. *The Times* critic of the fourth exhibition of British Linocuts organized by Flight at the Ward Gallery, London, in 1933 wrote that 'one of the most successful exhibitors is named Miss Lill Tchudi [*sic*]. Her "Ice Hockey", in black, green, grey and white, strikes us as exactly what the lino-cut ought to be ...'[37]

Although the work of Flight and his pupils has certain similarities, Tschudi's output is distinct in various ways. Her subject matter often related to life in Switzerland and France – in this case, Swiss winter sports. She was also very interested in life drawing: in *Ice Hockey* the characteristic stances of the hockey players are skilfully captured, despite being broken down into simplified shapes that fill the picture space. Here speed is conveyed by the circular composition, which apparently focuses on the unseen chuck at its centre. Movement is conveyed by the rhythmic lines of the skates' incisions in the ice. This print was widely praised and was bought by the V&A and the British Museum within a few weeks of its exhibition at the Redfern Gallery, also in 1933. In fact, during this exhibition (which toured around the UK and Canada from 1933 to 1936) the artist was requested to send more impressions, which she then individually hand-printed.

After 1939 – by which time linocut exhibitions were no longer popular – Tschudi's work started to become more abstract: she wrote to Flight that as a result of the war she felt that she was no longer able to depict humanity with optimism and that pure abstraction was the only way left to her.

JB

Louis Marcoussis (1878–1941)

Rosemonde, 1934

Plate 21 illustrating
the line *Mes doigts
jetèrent des baisers*
(Kisses flew up from
my fingers) from the
suite of 34 plates, plus
title page, etc., illus-
trating *Alcools*, the
collection of poems by
Guillaume Apollinaire.
Printed by the artist
on the press of the
Académie Moderne,
Paris. Unpublished

Printed in letterpress
with the plate number
beneath the image

Etching

Size of platemark
15.5 x 9.7 cm; size of
sheet 19.2 x 12.8 cm

Circ.142-1968.
Purchased 1968

Marcoussis was an inventive exponent of Cubism and his illustrations to *Alcools* are delivered in a variety of styles with affinities to Surrealism and Symbolism as well. Such freedom of appropriation was particularly suited to the nature of this work. *Alcools* was a collection of verse by Guillaume Apollinaire, who was, as his translator Oliver Bernard points out, 'the first writer to understand what the Cubists were up to'.[38] Apollinaire's own writing relates to the principles of Cubism in its unconventional construction, and like the Cubists he 'collaged' together fragments of daily life – in his case scraps of conversation or visual and aural experience. He invented the term Surrealism and his style anticipates that of some of the Dadaist artists whose concerns lay with undermining cant and bourgeois values. He was to become one of the most creative writers in Europe before his tragically early death in the influenza epidemic of 1918.

Louis Marcoussis had come to Paris from Poland in 1903. Apollinaire, who also had a Polish

mother, had persuaded Ludwig Markus, as he then was, to change his name and adopt a more Latin identity, as he himself had done. They became life-long friends, and Marcoussis's illustrations to *Alcools* were a kind of posthumous tribute. Solange Milet, introducing the *catalogue raisonné* of Marcoussis's prints, notes how the friendship emerged through Marcoussis's response to the poems: 'In accordance with the modernity of the vocabulary and the suppression of punctuation in the poems, the plastic artist continued his research and conceived of forms which intensified the sense of the text. He adopted new ways of organizing the work on the page, resorting to superimposition and harmonic invention.' *Rosemonde* records Apollinaire's silent farewell to a beautiful woman whom he had followed for two hours, unseen by her, until she disappeared into a house. Smaller than life size, the raised palm of the illustration is both monument and floating spectre; with the pattern of lips drawn out in the hand's fragile lines of fortune, the vulnerability yet strength of desire is simply but powerfully expressed.

RM

Gertrude Hermes (1901–83)

Autumn Fruits, 1935

Signed and dated in pencil *Gertrude Hermes 1935* and inscribed with title. Numbered *3/30*

Wood engraving

Size of printed surface 34.7 x 34.7 cm; size of sheet 42 x 42 cm

E.258-1947. Purchased from the artist 1947

GERTRUDE HERMES WAS one of the most innovative wood engravers of the twentieth century. She broke the boundaries of the medium in her aesthetic interpretation of subjects, as well as in her handling of the technique. She was not inhibited by the tradition of the wood engraving and its close associations with book illustration, which had heavily influenced its size and format. Hermes used it to explore her personal artistic vision, and in particular the struggles of life. Indeed, as an old lady, she insisted that 'when she began she'd never heard of Bewick, never heard of anybody, wasn't influenced by anyone at all'.[39]

Autumn Fruits is one of her most groundbreaking works and is of special interest since it treats a type of subject matter traditionally associated with wood engraving: natural plant form. Hermes, however, handles her subject with a thrilling virtuoso technique, using an enormous range of tools in the process. The intricate patterns in the background, and within the still-life subjects themselves, create an extraordinary sense of light and movement, a truly celebratory vision of the fruits of autumn. This vitality is further enhanced by the large format and circular shape of the print: Hermes later exploited this format in a number of her most exciting prints, and indeed two of these (*One person*, 1937, and *Welcome to the Avocets*, 1948) used the same block, resurfaced.

Gertrude Hermes studied from 1921 to 1925 at Leon Underwood's pioneering Brook Green School in London, which focused on painting, sculpture and printmaking, with all revolving around life drawing. The wood engravers who came out of Underwood's school were in fact initially inspired by a fellow student, Marion Mitchell, to take up wood engraving, and were therefore largely self-taught. Several of these students (including Hermes), as well as Underwood himself, were interested in both sculpture and wood engraving, and together they formed the nucleus of a breakaway group – the English Wood-Engraving Society. In the early part of her career Hermes worked closely with another dynamic wood engraver, Blair Hughes-Stanton, whom she was to marry in 1926. Their work was stylistically very similar, but with the breakdown of their relationship in 1931, Hermes developed her own unique vision. She worked concurrently in printmaking and sculpture, the two media inspiring each other. According to her daughter, 'she regarded the engraved block as the creation very much as she would a carving, and, as she was a direct carver, perhaps the print was of secondary importance rather than the end in itself'.[40]

Hermes's work was widely respected by fellow wood engravers, such as Clare Leighton (see p.7), who published her praise in *Wood Engravings of the 1930s* (1936) and hung this print over her own work space. Another, Simon Brett, paid tribute to the unique quality of her work: 'In Hermes' prints, imagery remains simple imagery, pattern remains pattern; but a thunderous visual music is built up in the relationship between the two.'[41]

JB

(Imre) Anthony Sandor Gross (1905–84)

La Maison du Poète (The Poet's House), 1936

Signed and dated in the plate *Ay. Gross 1936*. Signed in pencil *Anty Gross*. Inscribed in pencil *Poet's House* and numbered *47/50*

Etching

Size of platemark 16.5 x 24.5 cm; size of sheet 29.2 x 39 cm

E.4902-1960. Purchased 1960

A VISIT TO France in 1936 gave Anthony Gross the inspiration for one of his finest prints, *La Maison du Poète*, which gained him an award at the third exhibition of Black and White in Lugano in 1954. Today it is regarded very much as a 'signature print' among his work, epitomizing many of the qualities for which he is most admired, including decorative texture and line, achieved through the use of varied and innovative tools.

Anthony Gross showed an early flair for printmaking, encouraged by both his Hungarian-born father, who was a map publisher in London, and his headmaster at Repton School, who became one of his first patrons. In 1923 Gross began studying painting at the Slade and joined evening classes in engraving at the Central School of Arts and Crafts in London; within eighteen months he had transferred to highly esteemed courses in Paris and Madrid, producing a substantial body of etchings in the process. Impressed with his work, Deighton's Gallery in the Strand, London, offered him a contract that secured his independence; this allowed him to roam Mediterranean Europe and North Africa, recording the places and people he met *en route* with evident spirit and enjoyment.

Whether working in oil, watercolour, on copperplate or on film, Gross's work is imbued with both a strong sense of place and an interest in the intricacies of daily life. *La Maison du Poète*, with its crumbling masonry and lopsided gateposts, is at once a highly romantic image of solitude and decay and a commonplace sight in rural France. The scene has an air of dereliction, with the garden's tangled undergrowth and the house's broken shutter, yet closer examination reveals signs of habitation and activity: a thriving vegetable patch on the right-hand side of the garden and a contemplative figure framed in one of the top windows. According to Gross, he was never sure of the real identity of the owner of this majestic property, but on enquiring of a boy who passed by as he sketched, he was enlightened with the casual reply, 'C'est la maison du poète'. The name has stuck ever since.

AH

Edouard Vuillard (1868–1940)

Le Square Vintimille, third state, 1937

Published in Jean
Gabriel Daragnès (ed.),
Paris 1937, Paris 1937.
Collection of 31 essays
on Paris by French
writers, each with
two illustrations by
different French artists

Signed *E.Vuillard*

Etching and drypoint

Size of platemark
33.9 x 25.8 cm; size of
sheet 50 x 32.2cm

Circ.195-1961.
Purchased 1961

VUILLARD WAS A perfect choice of artist to pro-
duce an intimate view of Paris. Quoted by
Claude Roger-Marx as saying that 'the painter's
instrument is his armchair',[42] he had spent very lit-
tle time away from the city, living a very quiet,
modest life with his mother while she was alive. His
last twelve years were spent in the apartment over-
looking Square Vintimille.

Although early on Vuillard was grouped with
the Nabis, who practised a kind of symbolist paint-
ing, from about 1900 he was associated more
closely with Bonnard as a so-called 'Intimiste'. This
name appropriately conjures up the charming
domestic interiors and Parisian street scenes for
which he became so fêted as a painter and, under
the imprint of the magnificent Ambroise Vollard, as
a lithographer. Despite Vollard's legendary determi-
nation and vision, many of his publications did not
receive a very enthusiastic reception, and according

to Claude Roger-Marx, his friend and biographer,
Vuillard's almost total withdrawal from lithography
between 1903 and 1935 was probably due to this
public coolness. Even so, he seems to have been far
more relaxed about using lithography than etching,
for he worked on only seven etching plates during
his entire life. His first was a portrait of the painter
Theo van Rysselburghe made in about 1898, but
then there was a gap until a single print of about
1924 and another of 1930. The last – three studies
and the finished plate for *Le Square Vintimille* –
were made in 1937, when he was almost seventy.

It is not surprising to learn, therefore, that *Le
Square Vintimille* was a commissioned work, and
as the etched studies and several pencil sketches
on paper suggest, Vuillard did not take this on
lightly. Nevertheless, Roger-Marx notes that

> a few [etched] sketches were sufficient for him
> to divine the particular resources of a form of
> etching that could be called bitten drypoint.
> The burrs, retaining the ink, mix the fineness of
> the light furrows intertwined with more reso-
> nant affirmations together with areas that are
> grainy, like a stippling of divided touches.[43]

In conclusion he suggests the piece 'could be
held to be one of the very rare Impressionist
engraved masterpieces. Monet (even though he
never made an etching) or Sisley could have signed
this piece, whose silvery vibration makes one think
equally of Corot.' He goes on to describe it as
'so tenderly precise that it could be called an
engraved portrait'.[44]

RM

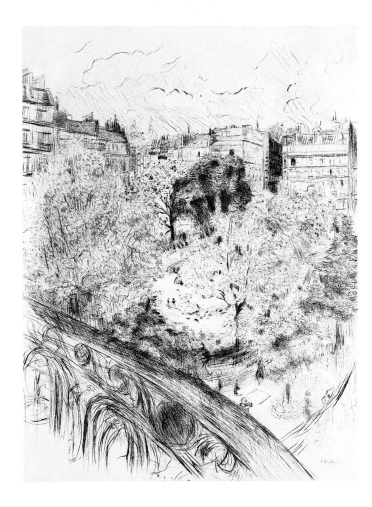

Edward Jeffrey Irving Ardizzone (1900–1979)

The Bus Stop, 1938

Signed in pencil
Edward Ardizzone.
Lettered *Published by*
Contemporary
Lithographs Ltd.,
London

Colour lithograph

Size of printed surface
46.5 x 61.5 cm; size of
sheet 50.9 x 67.1 cm

Circ.201-1938.
Purchased 1938

THIS LITHOGRAPH WAS produced as part of a series of prints for Contemporary Lithographs Ltd, a pioneering company founded in 1936, whose output was intended to compete with the many colour reproductions of oil paintings available on the market at this time. Its stated aim, as expressed in a prospectus of 1938, *Original Prints by Living Artists*, was to 'introduce the work of living artists to the general public in the original'.[45] This was based on the premise that 'the lithographic print is an original, faithful to the artist's conception and printed in his colours'.[46] Two series of prints were issued by the company, the first in 1937 aimed at schools, and the second in 1938 intended for the general public. Ardizzone's print was part of the second group of thirteen lithographs, which sold for £1. 5s. each.

Ardizzone's print appeared alongside those of contemporary British artists such as John Piper (co-founder of the company), Vanessa Bell, Ivon Hitchins and Edward Wadsworth. The lithographs depicted simple, familiar scenes which it was hoped would appeal to the British public. Ardizzone, perhaps best known as an illustrator, was a natural choice as a contributor to the series, and this print is typical of his work. He drew his inspiration from observing and sketching everyday life around him in London where he lived. His delight in the commonplace scene is expressed in simple spontaneous lines and economy of composition. He had a keen eye for human attitudes and behaviour, and the expressions and gestures of the characters in this scene convey the humour of the moment. The print captures a still familiar scene: the conductor appearing to relish his decision that no more may board the bus, outfacing a group of spurned passengers who stand in varying attitudes of defiance and resignation.

FR

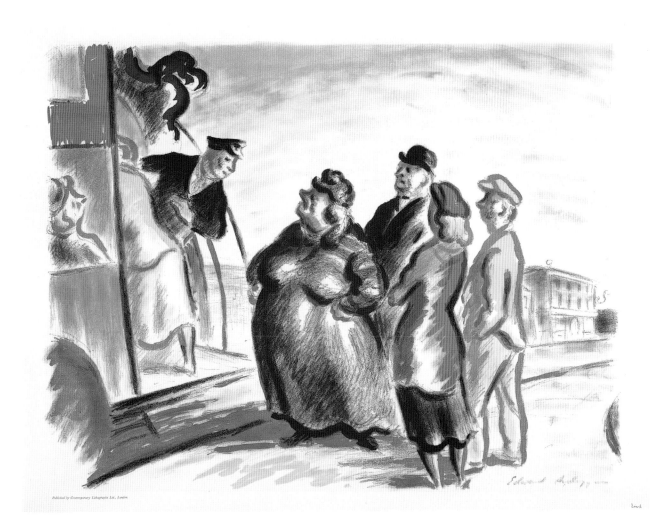

Published by Contemporary Lithographs Ltd., London

Martin Lewis (1881–1962)

Shadow Magic, 1939

Signed in the plate
with the artist's mono-
gram *ML* and again
below the platemark in
pencil *Martin Lewis*

Drypoint

Size of platemark
34.2 x 24 cm; size of
sheet 39.2 x 29.2 cm

E.573-1980.
Purchased 1980

BORN IN AUSTRALIA, Lewis arrived in America in 1900 and, though he had little formal training, he worked there as a painter. However, his greatest successes came as a printmaker, and he was a regular prize-winner in this capacity throughout the 1920s and 1930s. Having taken up etching in 1915, he developed a remarkable technical ability allied to an original vision and a feeling for atmosphere. His finest prints are all of New York scenes and explore the graphic potential of sun, snow, rain and artificial light in the urban landscape. He was influenced by Edward Hopper (see p.46) but his subjects were very different. This abstract drama of light and shade is one of Lewis's most powerful and success-

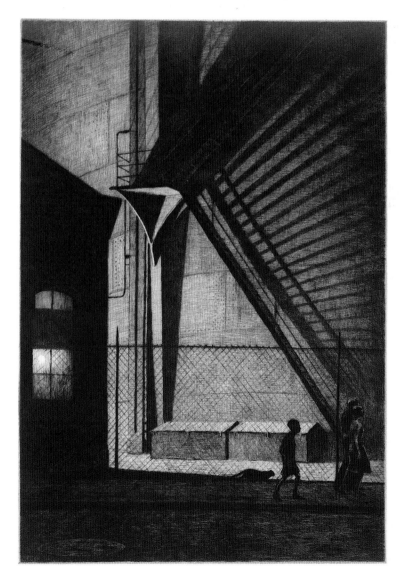

ful prints. It won the John Taylor Arms Prize at the twenty-fourth National Arts Club Exhibition in New York in December 1939.

The three figures, and the slinking cat, are almost incidental, little more than measures of scale; the real subject is the dramatic interplay between the floodlit bulk of the gas tank, with the fan of shadow lines from the iron staircase rising diagonally up its side, and the dark shape of the building to the left, flattened in silhouette-like stage scenery. Lewis contrasts two very different light sources here: the floodlight blast that animates the centre of the composition, and the bare light bulb in the window on the left (created by leaving a tiny circle on the printing plate unworked), which shines with a pure clear light like a small displaced moon. The insistent verticals and diagonals of architecture and shadow are set off by the filigree of the chain-link fence that marks the boundary between the street and the gasworks. Lewis makes effective use here of drypoint, the medium of all his best prints. Drypoint is a method of engraving by drawing directly onto the plate with a sharp tool, leaving a burr of displaced metal along the edges of the incised lines. Ink is held in the burr as well as the furrows, giving a soft blurred character to the printed lies, a quality that Lewis has exploited to produce subtle variations in density and texture.

Several preparatory drawings have survived; one is inscribed with a line from a poem by one of his circle of literary friends, Edna St Vincent Millay: 'Euclid alone has looked on beauty bare.'[47] Clearly Lewis saw in this a neat analogy for his own aesthetic of urban geometry.

GS

John Piper (1903–92)

Byland Abbey, 1940

Trial proof,
unpublished

Inscribed in ink in
another hand on the
back *Byland Abbey.
1940. Aquatint. John
Piper*

Etching and aquatint
on grey paper

Size of platemark
17.8 x 27.6 cm; size of
sheet 27.8 x 33.1 cm

Circ.277-1948.
Purchased 1948

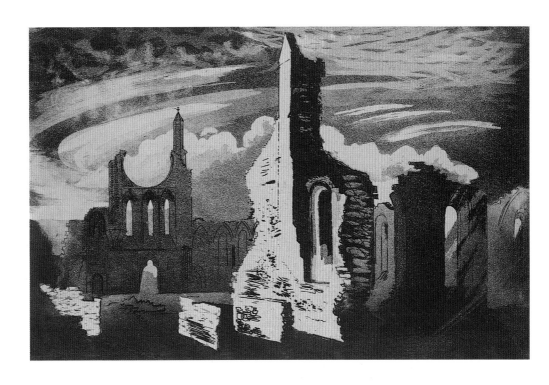

73

IN 1939 PIPER was received into the Church of England, a decision that has been interpreted as a gesture of cultural conservatism. Certainly it reflected a significant shift in his interests and allegiances; his work moved away from the earlier formal experiments with modernism and abstraction, in favour of a very English obsession with architecture and antiquarianism. This new interest was fostered by his association with John Betjeman and their work on the *Shell Guide to Oxfordshire*, published in 1938. Buildings – especially churches and ruins – were to become his characteristic subject matter, and he later wrote a virtual manifesto for this Neo-Romantic sensibility in an essay entitled 'Pleasing Decay' (which appeared in *Architectural Review*, September 1947). He began to regard himself more as a craftsman than an artist; in keeping with this view he devoted much of his subsequent career to print-making, and also to the design of ecclesiastical art, notably stained glass.

The subject here – a ruined church dramatically silhouetted against a stormy night sky – prefigures the characteristic Piper mannerisms: a dramatic, almost theatrical setting, flattened forms like stage scenery, and the 'Gothick' air of picturesque decay.

The ruined church was the archetypal Romantic motif, and Piper's work is a conscious continuation of the Romantic landscape tradition exemplified by Thomas Girtin and J.M.W. Turner. He was also drawing on his knowledge of eighteenth- and nineteenth-century aquatints by artists such as John Sell Cotman, who specialized in architectural subjects. Piper's earliest experiments with the medium resulted in his innovative series *Brighton Aquatints*, published in 1939. In the *Byland Abbey* print he has made effective use of the painterly character of aquatint and its capacity to represent a range of tones. An aquatint is typically made by applying a ground of resin particles to the plate. When exposed to acid, the plate is eaten away between these particles, giving a grainy texture when printed. The deeper tones are achieved by leaving the plate in the acid for longer, having 'stopped out' (protected) the areas that are to remain lighter. For Piper's purposes aquatint offered a visual equivalent for the texture of stonework, and it could reproduce atmospheric effects such as clouds and mist.

GS

Giorgio de Chirico (1888–1978)

... e le stelle del cielo caddero sulla terra (... and the stars of heaven fell unto the earth), 1941

Plate 8 from the suite of 20 illustrations to *L'Apocalisse* (The Apocalypse). Printed at the studio of Piero Fornasetti, published by Edizioni della Chimera, Milan, 1941

Signed in pencil *G de Chirico*. Inscribed within the plate with title

Lithograph coloured by hand with pastel under the direction of the artist

Size of printed surface (irregular) 30.1 x 21.9 cm; size of sheet 34.5 x 27 cm

Circ.903-1967. Purchased 1967

D E CHIRICO'S PROFOUND influence on Surrealism and the subsequent course of twentieth-century art is largely due to his canvases from the period 1911 to 1917. Characterized by classical sculpture or lay figures, and isolated within theatrically deep perspectives of colonnaded buildings, they project an atmosphere of nihilism, menace and pathos. Early influences on de Chirico himself were as much philosophical as visual; Schopenhauer and especially Nietzsche played formative roles. It seems odd therefore that an artist who had admired Nietzsche, the opponent of conventional Christian morality and religious thought, should want to illustrate scenes from the Apocalypse – after all, a kind of ultimate assertion of such thinking. However, it was almost certainly the climate of impending doom arising from the Second World War that drew de Chirico to the Apocalypse. He must have felt particularly threatened, since his beloved wife Isabella, for whom he had the deepest respect, was Jewish. Doubtless he was also attracted by the fantastical aspect of the Revelations of St John the Divine (this image is from Revelations 6: 13). In his text 'Why I illustrated the Apocalypse' de Chirico wrote of the artist being 'between and beyond the known and unknown', in a world of fantasy; and he used the metaphor of theatre to describe the way his audience might need to look upon the work.[48]

With his interest in the old masters, de Chirico would have known many historical versions of Apocalypse illustrations, most significantly, for the conception of his own, the woodcut illustrations by Albrecht Dürer. De Chirico had spent several years of his youth in Germany, developing a taste for German art as well as philosophy. But despite undoubted parallels between some of his imagery and that of Dürer, this particular plate has an uncharacteristic nursery-book feel. It is curiously reminiscent of Antoine de Saint-Exupéry's delightful illustrations to his fable *Le Petit Prince*, published in 1943 and itself a wildly fantastical and metaphysical work, if in a generally more endearing and less troubling way. This plate, with its unexpected and probably unintended humour, and its great charm, contributes to the image of de Chirico as an enigma – a word he himself so frequently applied to his paintings.

RM

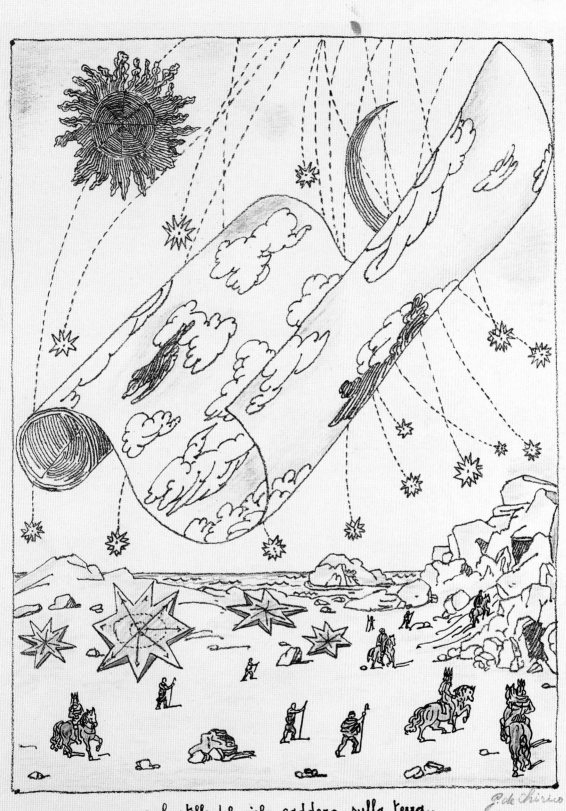

.......e le stelle del cielo caddero sulla terra.

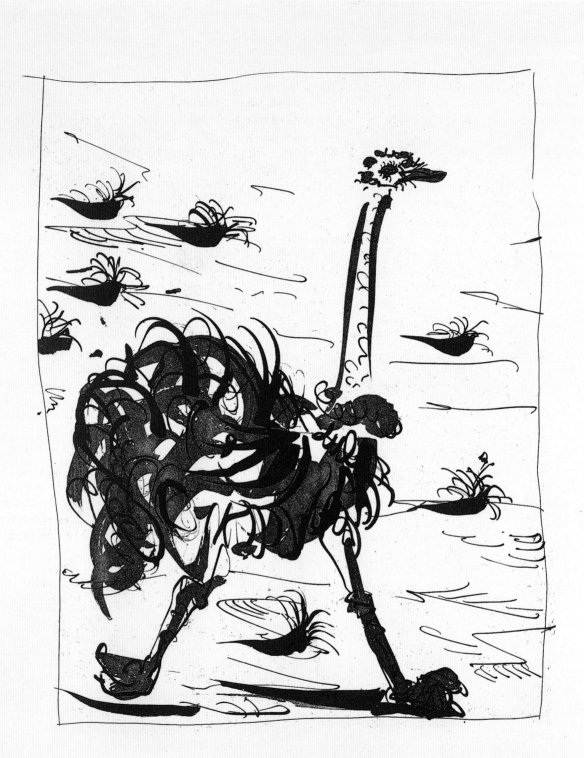

LA ⵣTRUCHE

Pablo Ruiz Picasso (1881–1973)

La Øtruche [sic] (L'Autruche/The Ostrich), 1942

Drawn on the plate by Picasso, etched in the sugar aquatint method by Roger Lacourière and published by Fabiani, Paris, 1942

Lettered in drypoint with the title

Sugar aquatint on Vergé de Montval paper

Size of drawn frame (irregular) 27 x 21.2 cm; size of sheet 36.5 x 27.8 cm

E.222-1947. Transferred from the Library, Victoria and Albert Museum

PICASSO PRODUCED THIS humorous rendition of an ostrich as one of thirty-two illustrations to an edition of the eighteenth-century reference book, *Histoire Naturelle*, by the French naturalist Georges Louis Leclerc, Comte de Buffon. The project was conceived by the art dealer and publisher Ambroise Vollard in the 1930s, by which time Picasso was well established as printmaker and book artist. Although quite obsolete scientifically, Buffon's account of the animal kingdom is still regarded as a classic among French literature and forms part of a long tradition of books that attempt to codify the natural world, often by allegory. In the same spirit Picasso brought to life an eclectic group of animals ranging from the goat to the grasshopper, capturing both their physical features and their behavioural traits. While these illustrations display a rare degree of naturalism in Picasso's *oeuvre*, many are also shrewdly anthropomorphic. According to Buffon, the ostrich was commonly thought to be deprived of hearing as well as flight, but his own view was that its behaviour was more likely to result from stupidity. Appropriately, Picasso has depicted the ostrich striding along with a somewhat vacant look in its eye.

Using the sugar aquatint method, which enables dark areas to be drawn directly onto the copper plate with pen or brush, Picasso has achieved an effect resembling an ink and wash drawing. In the first state of the print he established the bird's feathers and legs with bold calligraphic strokes, indicating the contours of its head and neck with finer marks. In this, the second state, he has etched the shadows more deeply and incised additional details, such as the sand dunes and the tufts of grass, to indicate a desert. Why Picasso gave the illustration the title *La Øtruche* rather than the conventional spelling *L'Autruche* is unclear, but the wayward charm of the drypoint lettering certainly adds to the effect of the ostrich's ungainly movement. It would appear that he exercised similar artistic licence elsewhere in the book, transforming Buffon's *Taureau* into *Le Toro Espagnole* and *Le Lion* into *La Lione*.

Picasso began working on the prints for Buffon's *Histoire Naturelle* in 1936 at the studio of Roger Lacourière, initially at the prolific rate of one a day. However, both he and Vollard were engaged in other projects at the time, which contributed to a long delay between the production and publication of the eagerly awaited volume. For a joke Picasso omitted an illustration of the cat, until Vollard, a cat lover, forced him to produce it. Yet Vollard, who died after a road accident in 1939, never saw the project to its completion, and all the rights to it were inherited by his partner, Martin Fabiani. With the outbreak of the Second World War and discrepancies that arose between Buffon's text and the existing prints, the finished book did not appear in print until 1942.

AH

(George Claude) Leon Underwood (1890–1977)

Harvest Corn, 1943

Signed and dated in
pencil *Leon U./43*.
Inscribed in pencil
with title and
numbered *3/25*

Colour linocut

Size of printed surface
(irregular) 45.7 x 61.3
cm; size of sheet
55 x 73.7 cm

E.120-1943. Purchased
1943 under the terms
of the A.M. Shrimpton
and William Giles
Bequest

L EON UNDERWOOD WAS an influential artist in inter-war Britain. He worked in a wide range of media, covering various types of painting, sculpture and printmaking. His etchings, wood engravings, linocuts and lithographs were produced both as fine art prints and as illustrations. He also liked to experiment, often inventing techniques in areas where he had no formal training. This brought a particular vitality and vigour to his printmaking. One consistent interest throughout his career was life drawing, which he both practised and taught.

The human figure features in the majority of Underwood's works, and his two-dimensional work reflects his concern as a sculptor for volume and rhythm. His portrayal of the human form also shows his admiration for the simplified, monumental forms of primitive art. He began collecting African sculpture as early as 1919 and was particularly interested in Palaeolithic art. From 1920 he travelled widely, visiting Iceland, the cave paintings at Altamira in France, and Aztec and Mayan remains in Mexico.

Leon Underwood was also an influential teacher and philosopher. He taught life drawing at the Royal College of Art and then at his own private drawing school in Brook Green, London, attended by – among others – Blair Hughes Stanton, Gertrude Hermes (see p.66), Henry Moore and Eileen Agar. His influence extended beyond stylistic to more fundamental concerns. By the late 1920s Underwood felt increasingly isolated from many contemporary artists, with their belief in abstraction for its own sake; he wished to empha-

size the importance of subject matter. His treatise *Art for Heaven's Sake: Notes on the Philosophy of Art To-Day* (published London 1934) was a response to a situation where he perceived that art and life had drifted apart, a state further aggravated by art's increasing elitism. In Underwood's view many abstract artists looked at primitive art for inspiration, but missed the essential point that primitive art communicated to the masses, and contributed to a general spiritual life through its understandable subject matter.

Harvest Corn was created during the Second World War, during the time that Underwood was travelling round the country, engaged on camouflage work. The print depicts the goddess of the harvest. In many ways it is reminiscent of Underwood's Mexican reclining figures, inspired by the sculpture of the god Chacmool from Chichen Itzá, as well as by the beauty and colourfulness of the Mexican women. The white outline, used in many of his prints, is here also evocative of the primitive chalk figures found on British downlands. The print represents both the spirit of harvest and the power of nature, and also the fruit of the artist's labours. As Underwood said: 'The artist is the sower who casts about him original thought, woven out of his intuition and imagination, and when the conditions are right, germination takes place. The artist is the sower who at the harvest time is over the horizon – on his way to sow new ground.'[49]

JB

79

Josef Albers (1888–1976)

Tlaloc, 1944

Signed and dated in pencil *Albers 44*. Inscribed with title and numbered *5/35*

Woodcut on Japanese paper

Size of printed surface 30.4 x 31.6 cm; size of sheet 37.8 x 36.2 cm

E.34-1994. Given by the Josef Albers Foundation

ALBERS STUDIED AT various institutions, but most famously at the Bauhaus, where he subsequently also taught. He worked mostly with glass, typography and furniture, and had made very few prints before he emigrated to the USA in 1933. However, he then began to work quite intensively with graphic forms and media, through which he addressed the ambiguities of perception. By the early 1940s he was experimenting in drypoint with what appeared to be 'automatic writing' but was in fact composition through the methodical and balanced distribution of lines in space. His series of lithographs *Graphic Tectonic*, 1942, create ambiguous illusions of space and vol-

ume through close, repeated, parallel lines in geometric patterns. Together with his colour experiments from 1949, these are seen as one of the most significant contributions to the analysis of visual perception in the twentieth century.

In 1944 Albers returned to relief-printing, working with wood, linoleum and cork. As with his earlier lithographic prints, these images are spatially equivocal. Geometric figures, subtly evolved from his experiments with *Graphic Tectonic* and not fitting any conventional canon of perspectival drawing, float above the picture plane with a kind of surreal beauty. *Tlaloc*, aptly named after the Mexican water god, relies on a contrast between the moiré pattern of wood grain and the spidery geometry of the figure hovering above it to give an aqueous depth to the picture plane. With this group of prints, however, Albers seems to have concluded that any kind of curved line was no longer relevant to his highly methodical investigations.

In the mid-1960s, when interest in optical and minimal art was at its height, the V&A's Department of Circulation acquired a number of prints by Albers for a travelling exhibition, primarily intended for colleges of art and education. Some works were gifts from the artist, others generously offered on indefinite loan. Albers was a great teacher, and for his work to be made accessible in this way doubtless gave him much pleasure. In 1994 the Albers Foundation in Connecticut translated most of the loans into gifts, and even added other pristine impressions as well as prints that the Museum did not already have. Through this happy sequence of events, the Museum now has a splendid representation of Albers' work.

RM

Jean Dubuffet (1901–85)

Paysage (Landscape), 1944–5

Plate xvii from the suite of 34 to accompany the text by Francis Ponge, *Matière et mémoire ou les lithographies à l'école* (Matter and memory or lithographs at school). Printed by Mourlot frères, Paris, 1944, and published by Fernand Mourlot, 1945

Signed in pencil *j Dubuffet* and numbered *9/10*. Inscribed faintly *D.16 X*

Lithograph on Auvergne paper

Size of printed surface 27.7 x 22.2 cm; size of sheet 33.2 x 25.4 cm

Circ.116-1961. Purchased 1961

IN 1923, WHEN still a young man, Dubuffet was given a copy of *Bildnerei des Geisteskranken* (Artistry of the Mentally Ill) published the previous year by Dr Hans Prinzhorn, a researcher in the archives of Heidelberg Psychiatric Clinic. Prinzhorn's theory that creativity exists potentially in everyone fascinated Dubuffet and intensified his own interest in less conventional aspects of creativity. In fact, recognizing the disparity between his own beliefs and those accepted by the contemporary Paris art world, he virtually abandoned his own art for the next eighteen years. However, in 1942 he took up painting again, more or less as an amateur (believing himself to be too old to make a career of it), although determined to work strictly to his own principles. Within a year he was being fêted by a group of the more literary avant-garde, including Francis Ponge, whose celebration of the commonplace was in sympathy with Dubuffet's own ideas.

It is extraordinary that this suite of prints (which accompanied Ponge's treatise on lithography) was made – even though under the professional eye of the printer Mourlot – less than five months after Dubuffet's very first attempt at printmaking in his own home on a borrowed press. The illustrations in *Matière et mémoire* have enormous vivacity and spontaneity born of a true understanding of the lithographic process and its potential. Dubuffet found the matrix of stone, grease and water particularly in tune with his interest in earthy materials. Much later he was to create impressions directly from natural materials themselves – orange peel, rocks, straw, human flesh – using a process of transfer lithography. But even here, at this very early stage, we see how he could render urban graffiti and 'frottage', as well as 'primitive' mark-making on cave and rock, by a process of rubbing, scratching and scraping. The obsessive repetition of the same mark, the rearrangement of 'real' perspective to accommodate the most significant pictorial elements, and the simplification of form characterize the productions of the mentally disturbed, the child or even the untrained 'common man'. Dubuffet employed such elements to articulate his beliefs about the process of creativity. 'The true value of painting', he wrote – though his remark is equally applicable to his printmaking and to this *Paysage* – 'lies in its luring the beholder into a world of miracles. All the depicted or suggested objects appear unfamiliar, yet plausible and irrefutable ...'[50]

RM

81

Giorgio Morandi (1890–1964)

Large Circular Still Life with a Bottle and Three Objects, 1946

Signed and dated
***Morandi 1946*. Signed**
in pencil *Morandi* and
numbered *4/65*

Etching

Size of platemark
25.7 x 32.4 cm; size of
sheet 34.9 x 50 cm

Circ.360-1960.
Purchased 1960

THE BOLOGNESE ARTIST Giorgio Morandi made 135 prints in all. Like his paintings, they are mostly still lifes, landscapes and flower pieces. When he was at the peak of his activity as a printmaker between 1927 and 1931, Morandi produced between thirteen and sixteen etchings a year. This is the only print he made in 1946, by which time he was fifty-six years old.

The print depicts a near view of four objects standing on a shallow shelf seen slightly from the left. Light falling from the right casts shadows on the left. The image is entirely made up of intersecting etched lines. These lines vary in density from a single row of parallel lines, for the highlight in the interior of the bowl, to nets of lines that overlap to such an extent that almost none of the paper underneath is visible, as in the aura surrounding the bottle. These networks of lines are only evident when the print is viewed close up. Seen at a normal distance they resolve themselves into a harmonious and poetic expression of forms and shadows – the product of a lifetime of study and thought by the artist.

A rectangular plate was used to print this image but the artist etched only a central circular area. This circular 'tondo' format is also seen in a few of Morandi's paintings of the 1940s. It brings to mind religious paintings and sculpture by Italian High Renaissance artists such as Michelangelo and Raphael. The circular format of the whole image contains within it other circles, depicted or suggested. There are other echoes between the forms within the image, such as the gadrooning on both the bottle and the sphere, and the spaces between objects are shapes as much as the objects themselves. These relationships were carefully calculated by the artist who would sometimes take days to decide which studio objects to combine, and in what position, before he began. In the placing of the objects, this print is very nearly a reversed version of a rectangular Morandi oil painting of 1946, now in a private collection in Bologna.

Morandi takes inanimate objects and imbues them with a sense of monumentality and mystery that lifts them out of the realm of everyday existence and instils in them a universal and timeless quality. Like Chardin and Cézanne, both artists he greatly admired, Morandi is someone who raised the art of still life to new heights.

EM

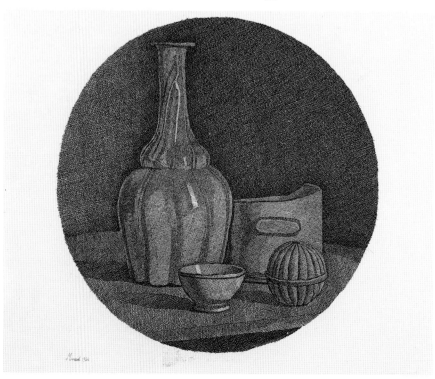

Barnett Freedman (1901–58)

People, 1947

Signed *Barnett Freedman*. Lettered with title and *designed and lithographed by Barnett Freedman*. Published by J. Lyons & Co. Ltd. Printed by Chromoworks Ltd. London

Colour lithograph

Size of printed surface 72.4 x 97.5 cm; size of sheet 76.2 x 101.6 cm

Circ.235-1948. Given by Messrs J. Lyons & Co. Ltd

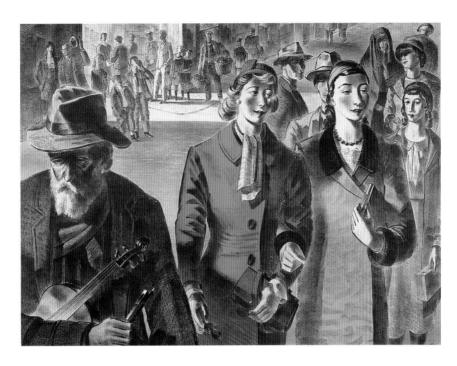

Bᴀʀɴᴇᴛᴛ Fʀᴇᴇᴅᴍᴀɴ'ѕ *PEOPLE* was one of a series of sixteen original lithographs published in 1947 as part of a scheme sponsored by J. Lyons & Co. Ltd. Initially, the prints were designed to decorate the walls of Lyons' tea-shops and Corner Houses, but in answer to public demand they were subsequently offered for sale. Prints in this first series were sold at 15s 9d. each. As the writer James Laver expressed it in *Art for Everyman*, his foreword to a pamphlet cataloguing prints published by Lyons in a later series,

> The scheme, sponsored by Messrs. Lyons, offers an opportunity of acquiring, at a reasonable price, the works of some of the most distinguished contemporary artists working in the field. Both in subject and in treatment there is a wide range of choice. The lithographs are printed on stout paper in fast colours and are suitable for the decoration of rest rooms, canteens, as well as for the home.[51]

People is a monumental composition. Its subject matter may be a post-war British street-scene, but its solemn figures process across the picture plane with the sculptural rhythm of a fifteenth-century fresco by Mantegna. Freedman's powerful humanism infuses the subject, each figure revealed with piercing realism yet profound sympathy. Using

chiaroscuro effects, the artist poignantly contrasts the shadowed face of the old violinist with the youthful radiance of the two young women in the foreground. His strong stylistic line captures every character in telling pose and expression within the tableau vivant.

Freedman's own background was that of a Russian Jewish family living in Stepney. Largely self-taught (ill health dogged his childhood), he discovered a talent for drawing, which he was determined to realize. He fought hard to get to art college, and then to take up a career as a painter and printmaker. He made his name as the illustrator of Siegfried Sassoon's *Memoirs of an Infantry Officer* (Faber & Faber, London 1931) and became a pioneer of the revival of colour lithography, commissioned by famous patrons such as Shell-Mex and BP Ltd, the General Post Office and the BBC. He loved the immediacy of lithography and the sweeping expressive effects that could be accomplished through the medium. His work achieves both the clarity of precise delineation (he used pen and ink as well as chalk to draw upon the stone) and an atmospheric sensibility realized through the application of delicate tones and colours.

MT

83

Man Ray (1890–1976)

Roman noir (Dark fiction), 1948

Initialled *MR* and signed and dated *Man Ray 1948*. Inscribed, signed and dated in pencil *Epreuve d'Artiste Man Ray 1948*

Colour lithograph

Size of printed surface 25.6 x 33.1 cm; size of sheet 31.4 x 43.6 cm

Circ.719-1964. Purchased from the artist 1964

A V&A CURATOR VISITED Man Ray at his famous Paris studio at 2 *bis* Rue Ferou, and acquired this print (for £5) with two sets of a portfolio of twelve Rayographs, plus an etching and a zincograph. The Rayographs (or photograms – photographs made, without a camera, by exposing objects on photographic paper to the light and then developing them) had been published in a limited edition of twenty copies in 1963. The acquisition rightly suggests Man Ray's pre-eminence as a photographer as well as emphasizing his interest in exploring many other media. His range as a print-maker included aquatints, too, but his oeuvre, as an artist, was even more various. He made inspired use of painting, construction, ready-mades and book illustration, as well as being an inventive and resourceful experimenter with photography and film. He spoke and wrote pithily on aesthetics. In a volume devoted to his graphic art, published in 1973, Man Ray addressed the question of 'ORIGINALS GRAPHICS MULTIPLES':

An original is a creation motivated by desire. Any reproduction of an original is motivated by necessity. The original is the result of an automatic mental process, the reproduction of a mechanical process. In other words: Inspiration then information; each validates the other. All other considerations are beyond the scope of these statements. It is marvellous that we are the only species that creates gratuitous forms. To create is divine, to reproduce human.[52]

His prints range over many styles, mainly within the Ecole de Paris (experimental Parisian painting based on post-Cubist styles), although this print was made during Man Ray's years in Hollywood, 1940–51. *Roman noir* reflects the Surrealists' interest in automatic drawing and may reflect the works in this genre by André Masson (whom Man Ray photographed in the 1920s). The dark tale drawn here is replete with random lines and fleeting forms that resolve briefly into the limbs of trees and women. Erotic metamorphoses are played out under a symbolic sun. Man Ray used a technique called 'rainbow printing': the colour modulates from top to base, from black through violet, deep brown, terracotta to deep brown again. The technique became characteristic of American West Coast psychedelia twenty years later.

MH-B

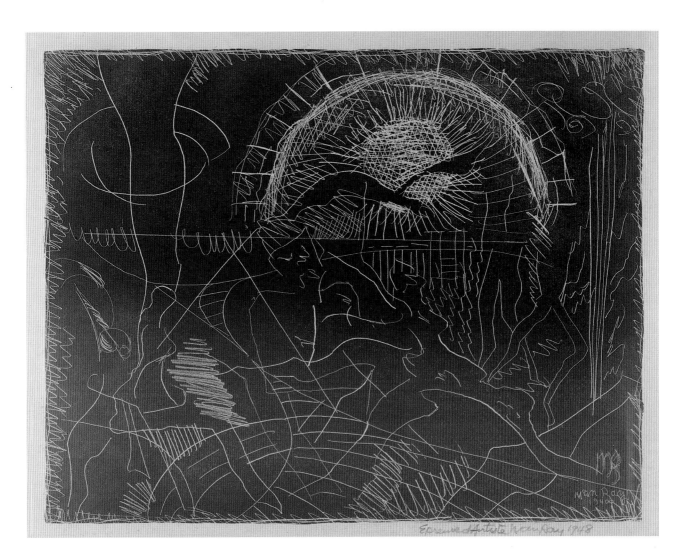

Keith Vaughan (1912–77)

Landscape, 1949

Signed and dated
in pencil *Keith
Vaughan / 49*

Colour lithograph

Size of sheet
46.2 x 55.7 cm

Circ.116-1950.
Purchased 1950

KEITH VAUGHAN HAD no formal art training and worked in advertising until 1939 when he became a full-time painter. In 1940 he joined the army but was able to make drawings and gouache paintings throughout the war, in particular taking advantage of his travels around the UK to study landscape. Finally, in 1945, at the age of thirty-three, he was able to commit himself fully to his art.

Keith Vaughan's work became identified with the Neo-Romantic school, which included Graham Sutherland, John Minton, Robert McBryde and Robert Colquhoun, all of whom he admired and knew. Like these artists, Vaughan focused on landscape or the relationship of figures in a landscape. However, by 1949, the year this print was made, Vaughan was focusing principally on more abstract elements of landscape, possibly because he had taught composition at Camberwell School of Art between 1946 and 1948, and additionally had been strongly influenced by the Picasso and Matisse exhibitions at the V&A in 1946. From 1946 he had also begun to paint with oils and became increasingly interested in using solid blocks of colour in a limited palette, trying to preclude distracting detail. He did not, however, believe in total abstraction. In 1949 he wrote to a fellow artist Norman Towne:

'I don't think great painting ever has or ever will dispense with the subject. The starting point, in the natural world, must be recognisable in order to gauge the extent of the artist's creative flight. Like a key in music …'[53] Nevertheless, from this period on details were increasingly excluded: faces became featureless, and trees were represented by single elemental arms.

It was at this point in Vaughan's career that this print was made. It was one of the first of at least nine colour lithographs published by the Redfern Gallery in London between 1949 and 1956. In 1948 the Society of London Painter-Printers had been set up, in collaboration with the Redfern Gallery, in order to establish a tradition parallel to that in France, in which leading artists – particularly painters – were encouraged to create original colour prints. To assist the artists who might otherwise be daunted by working directly in a workshop, transfer paper was provided so that images could be created in the artists' own studios, then later transferred to the lithographic stone by the printer. In France the majority of the images were printed by Louis Ravel, and in England by the Chiswick Press. The Redfern Gallery then exhibited the works, as well as holding portfolios on permanent display. Vaughan's paintings and prints were regularly exhibited, and by the late 1940s and early 1950s he had established an international reputation.

JB

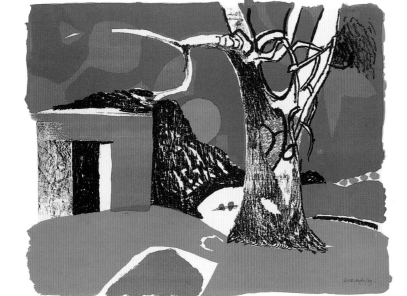

Michael Rothenstein (1908–93)

The Cockerel, 1950

Signed *Michael Rothenstein*. Signed again in pencil below *Michael Rothenstein* and numbered *8*

Colour lithograph with stencil and applied texture on thick cartridge paper

Size of printed surface 46.5 x 73.5; size of sheet 52 x 76.8 cm

Circ.180-1951. Purchased 1951

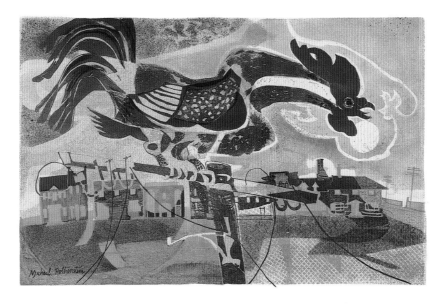

Perched high on a telegraph pole, the cockerel greets the new day. Rothenstein's colours are bold; shapes and textures are wittily chosen. The low horizon line and exuberant interplay of scale give a sense of giddiness: the cockerel fills the picture while the buildings below appear tiny. The swirl of cloud around the sun picks up the shape of the cockerel's plume and beak, visually uniting the sun and its herald, and drawing attention to the noisy cockerel's throat, which leads the eye in a sweep back across the image to the tail feathers. Different textures play across the picture, from the waxiness of crayon to a more fluid inky quality. Ink has been splattered onto the printing surface in places, while in the bottom right it has been pushed through a stencil onto the printing surface to create a mesh pattern (perhaps deliberately like chicken wire). The looping, flying lines of the telegraph wire add to the liberating sense of uncontained freedom.

As the younger son of the painter Sir William Rothenstein and brother of John (who was to become director of the Tate Gallery from 1938 to 1964), Michael Rothenstein was brought up in an intensely cultured world of art and literature. Having established his reputation as a painter, he took up printmaking in 1948 and went on to become an enthusiastic champion of the medium. First of all, he promoted printmaking through his own work, in which he experimented in woodcut, linocut and many other forms. In 1954 he set up his own graphic workshop with a second-hand printing press at his home in Essex, and subsequent visits to the famous atelier of S.W. Hayter in Paris widened the scope and inventiveness of his technique. He also acted as an ambassador for printmaking through his teaching, writing and constant encouragement of others. He became Chairman and later President of the Printmakers Council, and was for many years on the Committee of the Bradford Print Biennale.

The Cockerel is one of his earliest prints, made even before he had his own printmaking studio. It was commissioned by the Artists' International Association for a portfolio of twenty lithographs to celebrate the Festival of Britain, and was printed with the assistance of George Devenish at the Royal College of Art. The subject matter has several associations. Chickens were a common feature of life in post-war Britain – many people kept a hencoop in the back yard for a supply of fresh eggs – and the cockerel appears many times in Rothenstein's work. Often it is a symbol of the countryside, reinforcing a common theme in Rothenstein's work – the conflict between the living landscape and the encroaching machine. In this image there are as yet no lights on in the houses; for now, the cockerel rules the roost.

LO

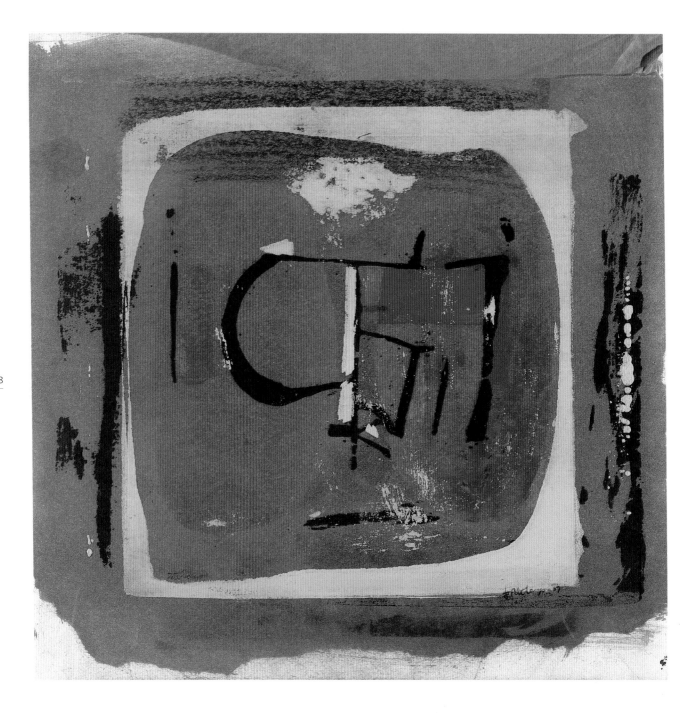

Peter Lanyon (1918–64)

Underground, 1951

Signed and dated in ball-point pen *Peter Lanyon 51* and in pencil on the reverse *Peter Lanyon 1951*. Inscribed in pencil on the reverse with title and *Silk screen*

Size of printed surface and sheet 27.6 x 27.9 cm

Colour screenprint

Circ.387-1960. Purchased 1960

PETER LANYON IS probably best known for his wildly expressive landscape paintings and constructions, inspired by a deep affinity with his native Cornwall. These portray the wild, rugged forms of the Cornish landscape, using colours that give an insight into its changing moods and qualities of light. However, in the early 1950s Lanyon had received instruction from Bouverie Houghton, Principal of the Art School in Penzance, which provided tuition in a variety of media for students, artists and lecturers alike. Lanyon, like the artists John Tunnard and Terry Frost, experimented with etching, engraving and other printmaking techniques. He explored drypoint and was further influenced by Naum Gabo, who used sgraffito techniques of incised lines on a wax/gouache surface.

Underground was created in a studio above the Leach Pottery in St Ives, under the instruction of the visiting American student potter Warren Mackenzie (born 1924). It is an interesting example of an early screenprint, showing the innovative and poetic possibilities of this particular process. According to a letter from Mackenzie,[54] Lanyon may have been partly attracted to screenprinting because it required less elaborate equipment than many of the other processes. Mackenzie explained that Lanyon washed the initial stencilled colours off with turpentine, leaving a transparent stain that formed the background for the print. It is almost impossible to trace exactly how the next stencil sequences were set down. However, his use of a blue screen together with a red/orange screen produces the resulting 'spark' of vibrant complementary colours against other darker backgrounds.

Only a few impressions were made of *Underground* but, having 'discovered' the staining that resulted from the initial use of a turpentine wash, Lanyon went on to produce a second print which he called *In the Trees*. These two prints were included in an exhibition at St Ives along with others by Warren Mackenzie and his wife Alix.

Why *Underground*? Lanyon often contrasts the free and open skyscape with glimpses of a more sombre landscape below: the deep underground pits that open onto the Cornish moors – dark openings to burial grounds, mines, shafts and subterranean caves. John Berger wrote of his work in 1952:

> *The West Cornish landscape is like a piece of ore … Its secret is in its centre … [Lanyon gathers] into one painting the sensation and vision of many separate viewpoints. He tilts the landscape up and looks at it from the air, he extends it sideways … He sounds its depths within its mine-shafts.*[55]

LN

Marc Chagall (1887–1985)

Le Loup et la Cigogne (The Wolf and the Stork), 1952

From the suite of 100 illustrations to *Les Fables de La Fontaine*. Commissioned by Ambroise Vollard in 1927, drawn 1927–30 and proofed by Maurice Potin. Printed at the Imprimerie Nationale de France under Raymond Blanchot and published by Tériade, Paris, 1952

Signed (very faintly) *Chagall*

Etching with drypoint

Size of platemark 29.3 x 23.8 cm; size of sheet 38.7 x 29.8 cm

Circ.79-1960. Purchased 1960

CHAGALL'S BEAUTIFUL ILLUSTRATIONS to *Les Fables de La Fontaine*, as well as those for the Bible and Gogol's *Dead Souls*, are all represented in the V&A's collection. To those interested in the history of print production they provide an extreme example of the frequent disparity between the date of proofing and that of publication. Work commissioned by the legendary Ambroise Vollard in the first four decades of the century was particularly vulnerable to delay. In his desire for perfection, as Una Johnson put it, Vollard 'thought nothing of holding in his shop plates that the artist had completed fifteen or twenty years earlier. Great patience, fatalism, and even self-abnegation were required of the artist who carried out this publisher's ambitious schemes.'[56] Thus it was for poor Chagall, who had waited so eagerly for the opportunity to work with Vollard and had lavished enormous creative energy on his projects. Both the *Fables* and *Dead Souls* were still unpublished stock several years after Chagall had completed them. After Vollard's death in 1939 the folios languished throughout and after the war, until finally being rescued by Tériade. Tériade, like Vollard before him, was one of the great art publishers of the twentieth century.[57] Besides publishing the leading journals *Minotaure* and *Verve*, he collaborated with some of the finest artists of the time to produce stunningly illustrated books from the inter-war years up to the 1970s.

Rounded on by the French academic establishment for choosing a foreign artist to interpret this national treasure of a writer, Vollard defended his choice by pointing out that La Fontaine was not himself the originator of the fables: he had actually recreated stories by Aesop and others from around the world. Vollard inferred, and rightly so, that Chagall's proven interest in myth and folklore would bring him closer than many native French artists 'to the spirit of La Fontaine in density, subtlety, realism and fantasy'.[58]

Originally Vollard had hoped to have the etchings completed in colour. With this in mind, Chagall produced one hundred gouaches of the same subjects as the illustrations. When they were shown at Bernheim Jeune in 1930, they drew a mixed response, ranging from great indignation (for the reason given above) to admiration. Notwithstanding these reactions, when it came to the printmaking process, transferring colour to the plates proved so difficult that it was abandoned. When the prints were finally published, Chagall, as a gesture of friendship to Tériade, coloured impressions of eighty-five of the illustrations by hand – this amounted to thousands of images. But the black and white etchings stand perfectly as they are, a tribute to Chagall's wonderful narrative and technical skill, and Vollard's original determination and insight.

RM

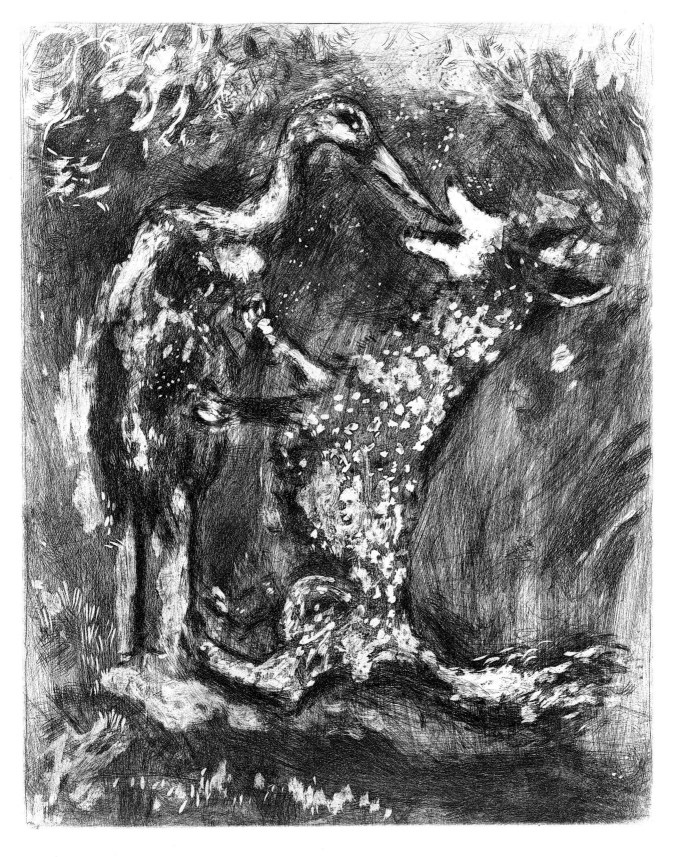

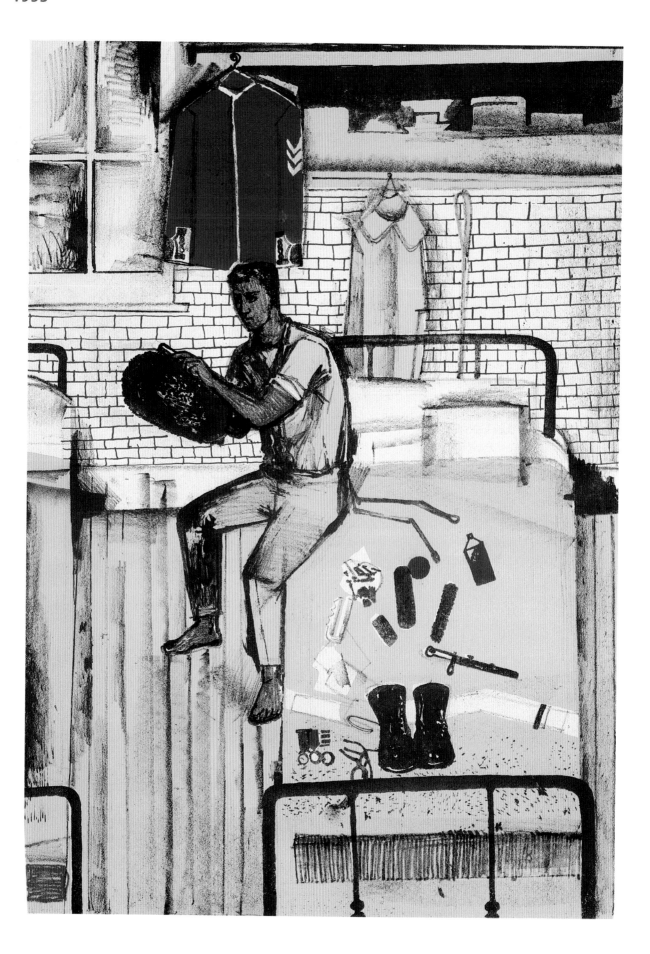

John Minton (1917–57)

Dressing Rooms at Whitehall, 1953

Signed in pencil *John Minton*

Colour lithograph

Size of printed surface 42.4 x 30.4 cm; size of sheet 56.1 x 38.3 cm

Circ.329-1953. Given by the Royal College of Art

DRESSING ROOMS AT WHITEHALL is John Minton's contribution to a series of twelve lithographs printed and published by the Royal College of Art to mark the coronation of Queen Elizabeth II in 1953. Other artists included in the suite are Robert Austin, Edward Bawden, Robert Buhler, Ronald Glendenning, Alistair Grant, Edwin La Dell, John Piper, Ceri Richards, Leonard Rosoman, Kenneth Rowntree and Julian Trevelyan. Around 1948 (the year he joined the teaching staff of the School of Painting at the Royal College of Art) Minton produced another lithograph of the same title for the Redfern Gallery, London.

While Minton's most ambitious work was his painting, he also produced a large volume of work intended as illustration for books and magazines. Much of his work therefore had the clarity of line and form that allowed it to be reproduced in a variety of sizes, while retaining the essence of the image. Minton first began practising lithography in 1948 and, although he did not produce very many lithographs, he was attracted to the medium because he believed it to be closer to painting than any other graphic art; he also enjoyed 'the business

of building shapes that interlock, overlap and interplay'.[59] In *Dressing Rooms at Whitehall* the regimented aspect of military life is contrasted with the intimacy of the moment: the guardsman is captured sitting on his bed, out of formal uniform, absorbed in brushing his bearskin. Minton distorts the perspective of the bed, making it a flat vertical plane in order that the viewer can see the guardsman's possessions and equipment laid out on the bed, as if for inspection.

Minton's (homo)sexuality was, by his own admission, an important influence on his work: 'There is no more revealing human personality than a visual artist,' he claimed in a radio programme on William Blake, 'for a man will paint only of himself and of the things he knows, loves, hates, desires.'[60] Guardsmen were popular figures of attraction to many upper- or middle-class gay men in the 1950s and gained a reputation for their availability for sexual liaisons. This image of a guardsman, like many of Minton's portraits, draws on the artist's fascination for and attraction to a 'manly ideal'.

SC

Ben Shahn (1898–1969)

*Alphabet, c.*1954

Signed *Ben Shahn*

Serigraph

Size of sheet
102 x 69.3 cm

E.5-1959. Given by
Mr S.S. Spivack

SHAHN'S FAMILY – JEWISH Lithuanian craftsmen – emigrated to New York in 1906. Shahn had already shown a precocious talent for drawing, and at the age of fourteen he was apprenticed in a lithographer's shop. In *Love and Joy about Letters* (published 1963) he recalled the rigorous training in which he was forced to draw the letters of the alphabet hundreds of times before they were considered to be good enough. The discipline and the craft skills he learned there are evident in all his later graphic work. Though his career encompassed painting and also photography, writing and teaching, he worked extensively as a book designer and illustrator.

The design of this print is based on the letters of the Hebrew alphabet. Shahn used a similar design for the front cover of his book *The Alphabet of Creation* (New York, 1954). *Alphabet of Creation* is one of the legends from *Sefer Ha-Zohar*, or *Book of Splendour*, an ancient Gnostic text written in Aramaic by the thirteenth-century Spanish scholar Moses de Leon. It celebrates the great mystic Rabbi Abulafia who believed that letters had a divine origin, that they held the deepest mysteries and that through the contemplation of their shapes the devout might ascend to the ultimate abstraction of union with God. This legend had considerable appeal for Shahn, who had been fascinated by the flowing Hebrew script from childhood; he described his pleasure in copying letters from the prayer book 'because in each letter there was some subtle part of the others'.[61] His design, with its angular calligraphy and abstracted letter forms, is an apt and elegant expression of this characteristic of the alphabet. And the balance between figure and ground, black and white, is evidence of the teaching of the foreman in the lithography shop who had stressed the importance of spaces around the letters as well the shapes of the letters themselves. The design further reflects his experience as a lithographic engraver, where, as he said 'each line of letters had to be a unit, to form a single and not a scattered silhouette.'[62]

This print is a serigraph, which means that instead of using a stencil, the artist painted or crayoned the design directly onto the silkscreen. Serigraphy is generally more expressive and often has a greater autographic immediacy than the commercial screenprint process. This would have appealed to Shahn, because, for him, lettering was above all an expressionistic art.

GS

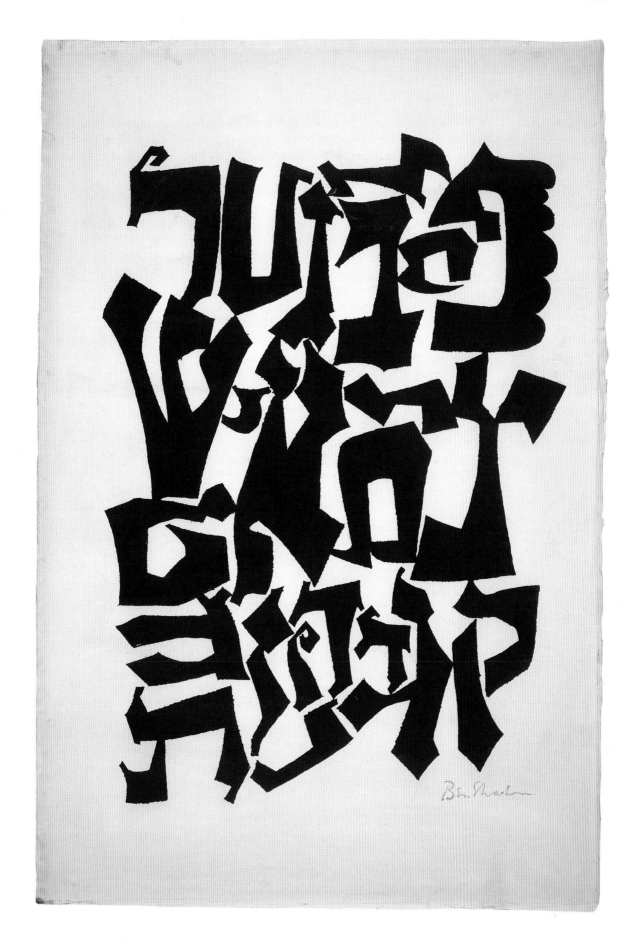

Naum Gabo (1890–1977)

Opus 6, 1955–6

Signed in pencil *Gabo* and inscribed with title *Op.6*

Wood engraving and monotype printed in blue on Japanese paper

Size of printed surface 38.5 x 33.3 cm; size of sheet 48 x 39.5 cm

E.3126-1990. Purchased 1990

GABO, RUSSIAN BY birth, studied in Munich and lived for some years in England before settling in the USA in 1946. He is best known as a sculptor allied to Contructivism. His sculptures are often a kind of drawing in three dimensions, constructed from transparent materials – glass and plastic – and linear elements – metal strips and nylon thread. He took up printmaking at the suggestion of American print historian William Ivins. Gabo was impressed by Ivins' view of prints as a powerful historical and cultural force, rather than as a secondary form of artistic expression. Ivins provided the practical impetus for Gabo's printmaking, too, supplying him with tools, paper and basic instruction in woodcutting.

The method of printmaking that Gabo adopted – a combination of traditional craft skill with autograph marks and a responsiveness to variation and accident – is at odds with his aims in sculpture, where he wished to make works using contemporary materials and characterized by an impersonal geometric precision. There is nevertheless an affinity between the prints and the sculptures: both employ curvilinear forms that appear to float in space. Indeed, the abstract motifs in the prints are equivalents for his ethereal sculptures that explore the relation between line, form and space. Though there is never a direct correlation between sculpture and print, this particular example, based on a drawing from around 1950, does closely prefigure a bas-relief he made for the US Rubber Company Building, New York, in 1956. It seems that he may have used small pieces of plastic, cut for a model for the sculpture, as templates for the print. For Gabo wood engraving was a kind of sculpture and he said that 'making a woodcut is like cutting a bas-relief'.[63]

Gabo's prints are unusual in that they use the print medium to explore and experiment with form rather than to repeat or reproduce it. His method of making prints was unconventional too. He would engrave part of the image on the end grain of a woodblock but would then introduce variations in each impression through the inking and printing of the block. He did not use a printing press; he preferred to use hand-pressure because of the opportunities for varying the results and allowing accidental effects. None of Gabo's prints was produced in an edition. There are thirty-one known impressions from the block used for *Opus 6* (now in the Tate Gallery archive, 798.6), exhibiting a considerable range of effects. There is a second significantly different impression in the V&A collection (E.3127-1990).

GS

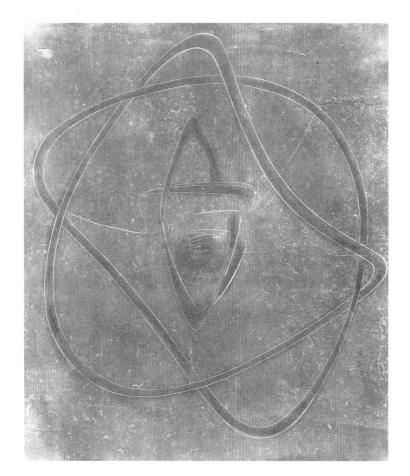

Edward Bawden (1903–89)

Town Hall Yard, 1956

Colour linocut

Size of printed surface
41 x 61 cm; size of
sheet 54.8 x 73.7 cm

Circ.865-1956.
Purchased as a result
of the 1956 Giles
Bequest Competition

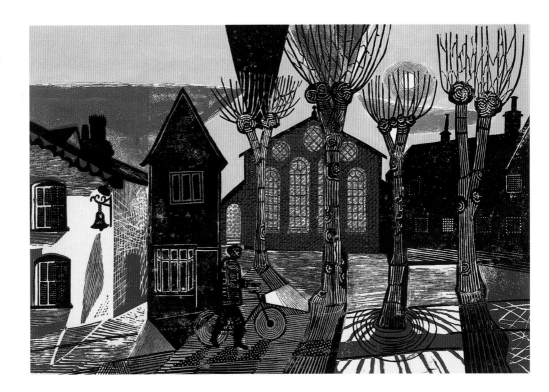

'LINO-CUT — THAT cinderella among printing methods, the favourite weapon of teachers who wish to show school-children emergent from kindergartens how easily they can get nice arty effects – has now taken on a new look for which Edward Bawden and Michael Rothenstein are largely responsible ...' wrote the reviewer of a 1956 exhibition featuring this print. The exhibition was *New Editions* at the Zwemmer Gallery in London (the venue for Bawden's very successful, first one-man show of watercolours in 1933). The reviewer went on to characterize Bawden's new-look linocut as 'deliberately using its natural boldness to do apparently impossible things'.[64]

Bawden had been making linocuts since his student days at the Royal College of Art, not just for fine art prints but also for wallpapers, and for designs for book jackets and posters. He described linocut as creating images out of shapes, flat forms and silhouettes, and noted how its limitations in suggesting recession and perspective needed to be compensated for by certain exaggerations of scale, in order to elucidate significant details. He called it 'very much a designer's medium'.[65] It is also a very demanding craft. Bawden compared the hazards of cutting a lino block to somewhat like walking a tightrope: one slip is irretrievable, and a wrongly cut line cannot be tinkered with.

In this print Bawden reveals his interest in the ornamental patterns created by architecture: the rhythms set up by the door and the row of round-headed windows, by the various styles of glazing and by the wavy line of a barge-board. The pollarded trees with their gnarled trunks and delicate branches stretching upward also have a decorative quality.

The artist makes skilful use of his five colours, printed from separate blocks. The scarlet of the grid printed across the facade of the building on the far side of the yard also picks out the back wheel of the bicycle. The improbably mustard-coloured sky, interrupted by strange angular grey and black shapes, still looks right in a print that is otherwise rooted in the artist's observation of his surroundings.

EM

Eduardo Paolozzi
1957

Eduardo Paolozzi 1954

CIRC. 230-1959

Eduardo Paolozzi (born 1924)

Automobile Head, 1954–7

Signed and dated
Eduardo Paolozzi 1954.
Also signed in black
ink *Eduardo Paolozzi
1957*

Screenprint, from a
collage with pen and
ink drawing, with pink
wash added by hand.

Size of drawn and
printed surface,
including wash
49.6 x 31.5 cm; size of
sheet 55.7 x 38.1 cm

Circ.230-1959.
Purchased from the
artist

Paolozzi is widely regarded as the creator of the first masterpiece in screenprint: *As is When*, made with the printer Chris Prater in 1965. He made many more brilliant images in the 1960s, a decade when printmaking became a primary artists' medium, thanks largely to the encouraging lead given by those artists who were making screenprints with Prater. The latter's blend of skill and imagination seems to have had a magical effect on all those who worked with him. *Automobile Head*, conceived in the 1950s (the V&A's print is dated 1957 and screenprinted by the artist himself), has a certain historic significance in that in 1962 it was the first image Paolozzi handed to Prater to work on; the printer then made a new screen based on the original collage. This marked the beginning of a long and very fruitful relationship.

Screenprinting's commercial roots lent it a kind of aesthetic integrity when it came to engaging with industrial production and mass media, both of which fascinated Paolozzi. From 1949 to 1955 Paolozzi was teaching in the Textiles Department of the Central School of Art and Design, London, where he was shown the screenprint technique by an Austrian émigré technician. Francis Carr, credited with making the first artist's screenprint in Britain in 1949, also taught Paolozzi for a short while. Paolozzi's friendship with Nigel Henderson would have given him a special insight into photography, an art integral to modern screen processes. From at least 1951 Paolozzi was in the habit of making screenprints, cutting them up and re-cycling them as collage. At the same time he was making collages and drawings, often mixing the two and using them as the basic material for his prints.

Automobile Head, created from a collage of machine parts taken from a motor catalogue, was acquired by the V&A along with another impression dated 1958. The later one is printed through a screen soaked in turpentine, which caused the ink to 'flood' and so make a darker, blurred image. As part of the same purchase, the V&A also acquired three other prints of a standing figure, similarly processed, with two different variations on the treated screen. This little group, typical of Paolozzi's graphic production of the mid-1950s and closely allied to his sculptural projects, represents his fascination with variations on a single image, something that became an enduring theme in his work.

RM

99

Joan Miró (1893–1983)

Les Forestiers, 1958

**Signed in pencil *Miró*.
Numbered *47/75***

Colour aquatint

**Size of platemark
49.4 x 32.2 cm; size of
sheet 66 x 50.2 cm**

**E.5336-1960.
Purchased 1960**

JOAN MIRÓ, ONE of the most prominent members of the Surrealist movement, is best known as a painter. He was also a great ceramicist and a prolific printmaker, although he did not make his first lithograph until 1930 and his first etching until some two years later. *Les Forestiers* is one of three prints with the same title but printed in different inks. The images are very close to each other but there are small changes, which appear to take advantage of the 'chance happenings and even mistakes' that occurred during the printmaking process.[66] This was something that Miró found particularly interesting.

Miró was a tremendously enthusiastic printmaker and it is worth quoting Roland Penrose on the subject. He recalled that

> the team of craftsmen who had helped in the printing of these graphics have told me of the excitement they felt in working with Miró. After long periods of contemplation he would plunge into new experiments, inventing unheard-of techniques with complete and unhesitating conviction ... The atmosphere was one of continuous exhilaration and youthful enthusiasm.[67]

In the light of this commentary, it is worth noting that Miró was well into his sixties when working on Les Forestiers, and such 'youthful enthusiasm' often accompanied delightfully child-like imagery. Children's and so-called primitive art

was admired by a number of the most significant artists of the twentieth century, including Klee and Dubuffet, as well as Miró himself.

Crommelynck and Dutrou, who printed this series, formed one of the most notable twentieth-century printing studios in Paris. They worked with some of the finest artists of the period. Collaborating with such experienced printers, Miró was able to carry out his artistic projects with the help of a team of highly skilled craftsmen. He found the co-operative aspect of printmaking immensely rewarding.

The freshness of colour and texture and the freedom of line so characteristic of Miró's printmaking in general may have owed a great deal to what he learned with the English printmaker, Stanley William Hayter. Hayter had originally set up his atelier in Paris in the 1920s, and in 1947 (some years before making *Les Forestiers*) Miró had been invited to work in the studio when it was temporarily evacuated to New York. Hayter was an important influence on the development of colour intaglio printing and 'experiments in gestural mark making',[68] something to which Miró was already temperamentally inclined. *Les Forestiers* appears spontaneous and simple in design, but this has only been achieved through Miró's remarkable grasp of the inherent possibilities of the medium.

RM and FR

André Masson (1896–1987)

Couple aux fleurettes (Couple with flowerets), 1959

Signed in pencil *André Masson*. Numbered *5/50*

Lithograph printed on laid handmade paper in which are embedded flower heads and fern leaves

Size of sheet 65.2 x 51 cm

E.99-1961. Purchased 1961

BY VIRTUE OF his extraordinary versatility, the French artist André Masson is difficult to categorize in terms of any one artistic movement or technique, although his name is most often linked to Surrealism. Equally comfortable with painting, drawing and printmaking, he also experimented with sculpture and attracted commissions ranging from book illustration to stage design.

Masson's talent was recognized at an early age; he was admitted to the Académie Royale des Beaux-Arts in Brussels at the age of eleven and later continued his training in Paris. His first solo exhibition in 1923 brought him in contact with the writer André Breton, who invited him to join the Surrealist group and introduced him to the concept of automatic drawing. Miró, Ernst and Masson were the first artists to experiment with this technique in which imagery was allowed to flow from deep within the unconscious. As Masson observed: 'Physically, you must make a void within yourself ... the first graphic apparitions on the paper are pure gesture, rhythm, incantation, and as a result pure scrawl. That is the first phase. In the second phase, that image (which was latent) reclaims its right.'[69]

It is interesting that Masson's earliest prints are all etchings, drypoints and lithographs, for these printmaking techniques are perhaps the closest to freehand drawing, allowing for considerable spontaneity and freedom of movement. In the 1950s Masson began to take the philosophy of automatic drawing in another direction, inspired by oriental art and Zen Buddhism. He was fascinated by the ancient art of calligraphy, which required great discipline and control, yet had all the appearance of natural fluidity.

In this lithograph of 1959 these influences are played out quite clearly in both composition and technique. The silhouettes of two lovers, entwined, are picked out in black and white. The woman is outlined with bold, swift strokes drawn directly onto the lithographic stone, while the man appears as a textured, shadowy figure on her right. Inventively, Masson exploits the potential of the lithographic process to great effect. First, he has scratched out linear highlights in some of the most densely shaded areas, such as the male figure, giving it a shimmering effect so that it almost seems to vibrate. Secondly, he appears to have used a transfer process to introduce 'borrowed' textures, such as canvas or other woven materials, to the background and darker areas of the image.

Masson's choice of paper, with its floral inclusions, is quite unusual, although the tradition of printing on handmade papers derives from China and Japan, tying in with his oriental interest of the time. This example may originate from the Auvergne, since he used other handmade papers from the Moulin Richard de Bas in Puy-de-Dôme between 1954 and 1956; a very similar type containing pressed wild flowers and ferns is still made there today. In this print it gives a wonderful impression of leaves tumbling about the oblivious couple.

AH

103

Sam Francis (1923–98)

The White Line, 1960

Printed by Emil
Matthieu at Emil
Matthieu Atelier,
Zurich, and published
by Kornfeld and
Klipstein, Bern

Signed in pencil *Sam
Francis*. Numbered
35/75

Lithograph on Rives
BFK paper

Size of sheet
91 x 63.5 cm

E.31-1961.
Purchased 1961

FRANCIS LEFT HIS native California to study in Paris in 1950. There he developed a fluid spontaneity in his application of paint to canvas, initiating a method that was to become known internationally as *tachisme*, an art of spots and stains. His methods and his distinctive abstract forms were readily translated into a variety of graphic media, but his favourite print medium was undoubtedly lithography, probably because he could work with liquid tusche (a greasy lithographic ink) applied with a brush in much the same way as he would paint on canvas. He made 335 lithographs, compared to 115 intaglios and 21 screenprints. His characteristic immediacy was well suited to lithography, and he found he was able to make prints with the same intuitive directness that characterized his painting. As he described it, 'What has happened is that I have found a way to get into that machine [the printing press]. When I am working with these prints, I *am* the paper, I *am* the paint, I *am* the machine. I am not trying to "make something."'[70] He loved the sensitivity of the stone's surface and the mysterious alchemy of a process based on the antipathy of oil and water. Francis's approach to printmaking was unusual: each print was developed as a response to his work as a whole, and many proofs were taken to incorporate changes and study their effect. Like the other artists of his generation who were part of the renaissance of printmaking in the US around 1960, Francis always worked closely with professional printers. His interest in this collaborative process led him to set up his own print workshop in 1970.

Based in Paris from 1950 to 1959, Francis also travelled widely in Europe and beyond. A visit to Japan, where he had been asked to paint a mural, enhanced his interest in Eastern religion, philosophy and art. In French painting he found inspiration in the rendering of light, colour and space. These ideas and influences are evident in *The White Line*, which has a vibrant energy, with coloured shapes and splatters that seem to explode, creating the dynamic void at the centre. This, and similar paintings, have been read as Francis's radical re-interpretation of the window compositions by Pierre Bonnard and Henri Matisse, with the abstract colour blocks evidence of his fascination with Matisse's cut-outs. Certainly, Francis's art – including his printmaking – represents a vibrant synthesis of French styles with American gestural abstraction.

GS

Yozo Hamaguchi (born 1909)

Black Cherry, c.1960–61

Signed in pencil
hamaguchi. Numbered
in pencil *7/50*

Colour mezzotint

Size of platemark
19.5 x 26.6 cm; size of
sheet 32.9 x 50.2 cm

Circ.143-1961.
Purchased 1961

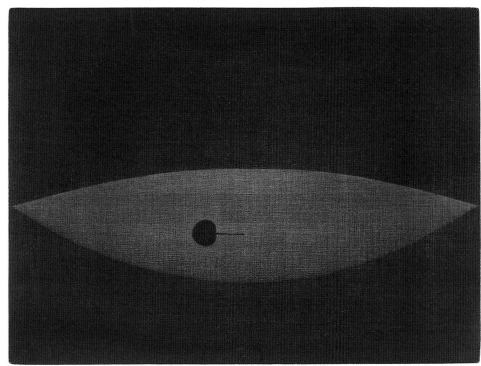

7/50 hamaguchi

ACQUIRED BY THE Victoria & Albert Museum in 1961 for inclusion in an exhibition of modern Japanese prints, this mezzotint is entirely characteristic of Yozo Hamaguchi's work. The artist was born in Japan in 1909 and studied at the School of Fine Arts in Tokyo, an institution modelled on European lines and one where traditional Japanese crafts went untaught. He later moved to Paris, living there for many years before relocating again to the United States. Perhaps it is this international background that leads Hamaguchi to draw on nature, a subject of universal reach, in this and so many subsequent prints.

The simplicity of this image only increases its ambiguity. The longer one looks, the greater the number of possibilities that emerge: a cat's eye, a fish in water, the moon in the night sky, a hammock strung between two trees, a canoe gliding across a lake, an island seen from afar or a leaf floating in a pool. And it works equally well as an abstract composition. So mesmerizing are the moody hues and weightless forms that one soon leaves questions of imagery behind. Ultimately, however, Hamaguchi intends no confusion: it is of course a single black cherry lying on a boat-shaped dish.

The colour mezzotint, the type of print Hamaguchi specializes in, demands both hard labour and exacting skill. Before any image-making can begin, the artist must treat the copper plate with a 'rocker', a fine-toothed tool which dents the surface and throws up minute metallic burrs. These burrs are then selectively rubbed away: the areas of the plate where they remain most dense will carry the most ink and the print will be at its darkest. To complicate matters, different types of rockers will create different surface qualities (note the distinctive cloth-like effect here). With separate plates required for each colour, the artist's skill is further tested by the need to align each second, third and fourth impression exactly with the first. That this effortless image belies the difficulty in its making shows why Hamaguchi is commonly considered the master of the twentieth-century mezzotint.

MG

David Hockney (born 1937)

The Diploma, 1962

Signed and dated in
pencil *David Hockney
'62* and numbered
11/50

Etching and aquatint
in two colours

Size of platemark
40.6 x 28 cm; size of
sheet 57.1 x 39.8 cm

E.1084-1963. Purchased
from the artist 1963

DAVID HOCKNEY IS among the most popular and versatile British artist of recent years. As a student at the Royal College of Art in 1959–62, he was one of several young painters subsequently celebrated as the founders of Pop Art in Britain. Like his friend R.B. Kitaj, Hockney sought to re-integrate narrative with a modernist style. His early works combine a fascination with the art of Ancient Egypt and the Renaissance with a child-like figuration reminiscent of Picasso and Jean Dubuffet, and include subjects ranging from fairy stories to the artist's own experiences.

Hockney later recalled that 'I started etching [at the Royal College] because I hadn't any money. You know I hadn't any paint. Someone told me that everything was free in that department so I thought I would try my hand at it.'[71] In 1961 he made his first visit to the United States, where he sold etchings to the Museum of Modern Art, New York, earning 'two hundred dollars, which was a lot of money for me, and I bought a suit, an American suit, and bleached my hair'.[72] On his return he began his first major suite of etchings, *A Rake's Progress*, inspired by the engravings of William Hogarth.

When Hockney graduated in 1962, the Royal College initially withheld his diploma as he had not satisfied the requirements of the General Studies Department. Undaunted, he etched his own diploma, parodying the official certificate. Set within an elegant, neoclassical frame, this includes a mirror image of the royal arms, in red, accompanied by the words 'ROYAL COLLEGE OF ART' and the graffiti-like inscriptions 'rules', 'regulations' and 'DIPLOMA'. The central figure is a caricature of Sir Robin Darwin, the principal of the college, depicted with two heads, inscribed '1st FACE' and '2nd FACE', and wearing an academic gown. He is supported by the raised arm of a goose-stepping, moustached and bespectacled figure wearing an old school tie, jackboots and medals inscribed 'ABC', 'DE', 'FG' and 'HIJ', apparently a caricature of Michael Kullman, the tutor in charge of General Studies. Hard on his heels follows a striped crescent-shaped creature, like an open mouth with pointed teeth, also wearing a medal and a tie, representing John Moon, the college registrar. At the bottom left a frieze of tiny dejected figures holding artists' equipment, bent double as though supporting the weight of the framed edifice, probably depicts the students of the college. Although Hockney subsequently received both his diploma and the gold medal for painting, he never forgot the slight and recently remarked that an artist – unlike a dentist – had no need for a certificate.

ME

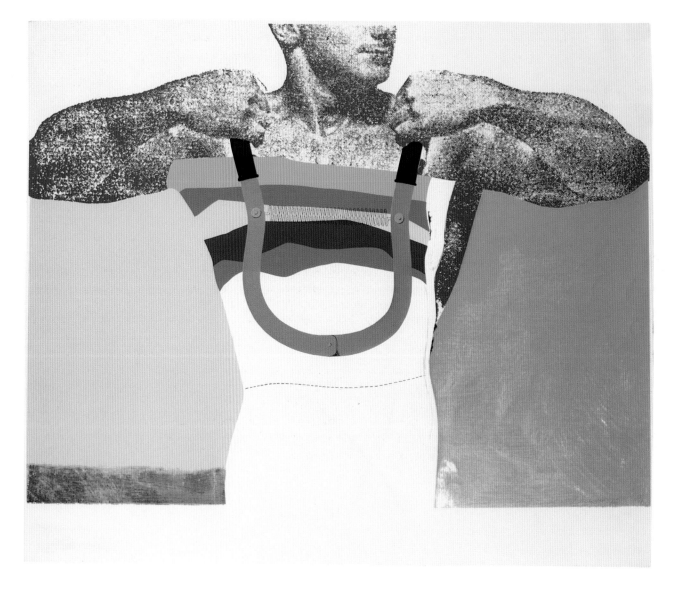

Richard Hamilton (born 1922)

Adonis in Y Fronts, 1962–3

Printed by Chris Prater,
Kelpra Studio, London,
in an edition of 40

Signed and dated in
pencil *R Hamilton 63*
and numbered *13/40*

Colour screenprint
from 12 screens

Size of printed surface
60.9 x 81.6 cm; size of
sheet 68.9 x 82.3 cm

Circ.59-1964.
Purchased 1964

IN THE LATE 1950s and early 1960s Gordon House, a young artist and designer, was working with Chris Prater, a then unknown but extraordinarily capable commercial screenprinter. Infected with Prater's enthusiasm for the screenprint medium, House began to experiment in a somewhat unusual way with posters he was making for the Arts Council. This attracted the attention of the photographer Nigel Henderson, and then that of Eduardo Paolozzi and Richard Hamilton. Following House's lead, Hamilton himself began to make screenprints with Prater: *Adonis* was the very first of these. Subsequently, Hamilton persuaded the ICA (Institute of Contemporary Arts) to commission twenty-four young artists to make screenprints with Prater; the results were exhibited in 1964 and demonstrated the medium's exciting potential for a new generation of artist-printmakers.

Adonis, first conceived by Hamilton in a series of paintings, was created from an amalgam of mass-media images: a photograph from *Life* magazine of the Hermes of Praxiteles, a *Playboy* illustration of a male model and references to brand names and pop music (the title of the work plays on that of the pop song *Venus in Blue Jeans*). The conspicuously 'photographic' surface of the male torso, with its well-endowed physique, draws attention to mass-produced popular imagery. The 'painterly' attributes of other parts of the image, however, also suggest that the 'popular' is as valid a subject for aesthetic investigation as more established pictorial imagery. Already loaded with metaphor and irony relating to issues of mass production, cultural expectations and originality, the image prompts further questions about how we view art, when the 'unique' painting is translated back into the 'mass-produced' print.

For most of the twentieth century screenprint had been used primarily as a commercial medium, even though artists began using it in the 1930s. In the UK Francis Carr was experimenting with it in the 1940s; in the 1950s Richard Gear and Peter Lanyon (see p.89) were notable early exponents, while John Coplans was persuading other artists to try it. Hamilton, Paolozzi and Kitaj, however, are the artists most associated with its rise to a position of unprecedented significance as an artist's medium. This development in the 1960s and 1970s was immeasurably furthered by Hamilton's formidable grasp of the implications of contemporary printing technology for a relevant contemporary aesthetic.

RM

Roy Lichtenstein (1923–97)

Crak! Now, Mes Petits ... Pour La France! 1964

Published by Leo
Castelli Gallery, New
York

Signed and dated in
pencil *rf Lichtenstein
'64*. Numbered *150/300*

Colour offset
lithograph

Size of printed surface
47.3 x 68.8 cm; size of
sheet 48.9 x 70.2 cm

Circ. 365-1964.
Purchased 1964

LICHTENSTEIN'S EARLY REPRESENTATIONAL work, which was influenced by Cubism, used themes from American folklore. There followed a period in the 1950s when his work was akin to Abstract Expressionism but he found the style unsatisfactory. He was one of Pop Art's most prominent exponents, continuing and expanding upon the tradition established by artists such as Robert Rauschenberg and Jasper Johns in America, and Richard Hamilton and Eduardo Paolozzi in Britain. From 1960 Lichtenstein began to experiment with incorporating commercial art and advertising graphics into his work. He also drew upon the varied imagery of cartoons and comics, and started putting hidden comic images such as Mickey Mouse, Donald Duck and Bugs Bunny into his paintings.

From 1962, the time of his first solo exhibition at the Leo Castelli Gallery in New York, until 1967 Lichtenstein designed several series of images to be used as posters and mail shots advertising his exhibitions. These were printed by offset lithography. According to Ivan Karp, the director of the gallery, the print overruns proved to be so popular as giveaways that the gallery began to order extra copies of around 300. A minimal fee of $5 or $10 was charged to cover production costs. Many were issued as signed prints in numbered editions and, Karp says, 'it became a regular tradition at the gallery to have signed posters available'.[73]

This print was conceived for his exhibition at the Castelli Gallery in 1963 and was subsequently published in an edition of 300 in 1964. The subject draws on both the imagery of womanhood found in the love stories from which Lichtenstein derived much of his source material, and on the imagery of aggression taken from his war references. The central figure is somewhat unusual: Lichtenstein's females were almost always willowy blondes, mostly in submissive situations, but this lady is a dark-haired fighter with patriotic fervour, guts and glamour. The finished piece draws parallels with political and propaganda posters. Also, as in his paintings of this time, Lichtenstein uses comic-book techniques to increase the impact of the print: enlargement of scale, Ben Day dots imitating coarse screenprinting, thick black fluid outlines, bright primary colours, and speech bubbles around the staccato vocabulary of the comic strip.

Lichtenstein is frequently mentioned in the same breath as Andy Warhol and Claes Oldenburg. Warhol met Lichtenstein in 1962 when he came to see his first solo exhibition at the Castelli Gallery. From that moment Warhol stopped painting cartoons and not long afterwards began painting Campbell's soup cans. The two are closely related in that Warhol desired to achieve mechanical perfection in his work as can be seen in the silkscreens he produced in the Factory, and Lichtenstein wished to show in his work the mechanical perfection of the mass media.

JS

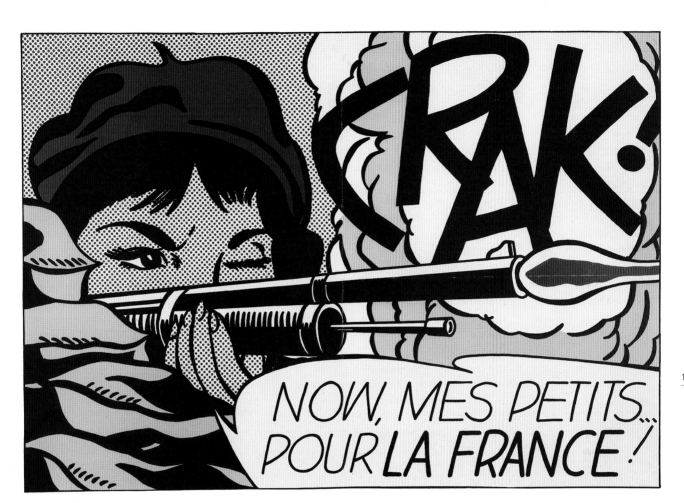

Jim Dine (born 1935)

Eleven Part Self Portrait (Red Pony), 1964–5

Printed and published
by Universal Limited
Art Editions, New York

Signed and dated in
pencil *Jim Dine 1965*
and inscribed with
title. Numbered *3/13*.
Blind stamped with
ULAE, upper left corner

Lithograph printed in
red and black on paper
watermarked *BFK
RIVES*

Size of sheet
105.5 x 75.1 cm

Circ.396-1965.
Purchased 1965

DINE IS GENERALLY categorized as a Pop artist but his work has always been warmer and more expressive than mainstream Pop (so-called because its subjects were drawn from everyday life and popular culture, and its presentation tended to reproduce the slick deadpan surfaces of commercial advertising). He was an originator of the chaotic Sixties' performances known as 'Happenings'. As a painter, he routinely incorporated junk and evocative objects from the real world in his 'combine' paintings and assemblages, both of which were kinds of three-dimensional collage. He has consistently made prints since the early 1960s, exploring and exploiting the inherent qualities of a range of different graphic media.

In 1962 Jasper Johns took Dine to Universal Limited Editions in New York, where he began to make lithographs of tools and bathroom paraphernalia. *Eleven Part Self Portrait* continued this theme of depicting everyday objects, but marked a shift to more personal imagery. Dine later explained that he wanted 'to upgrade the content of the subject matter and instead of dealing with the obscure metaphor for the human figure … [he wanted] to deal with the human'.[74] Like much Pop Art imagery,

his bathrobe motif was inspired by an advertisement, taken in this instance from the *New York Times*. It first appeared in his paintings in 1963, and though the robe was a found image not a personal possession, it nevertheless became his most enduring surrogate for self-portraiture, recurring in his paintings and prints for more than a decade. The earliest examples have the broad stocky outline that mirrored Dine's body shape at the time. Approximately life-size, the motif here has a flat diagrammatic character, emphasized by the addition of the numbers. In fact the numbers have no significance – they were randomly inscribed and meaningless. The cryptic subtitle 'Red Pony' was added as an afterthought because the red washes reminded Dine of the coat of a dappled pony. These washes clearly relate to Dine's work in watercolour, and the image as a whole brings to mind a paint-by-numbers kit. Such kits offer both constraints of medium and form, and also opportunities for invention and modification – a neat analogy for the way in which Pop artists, and Dine in particular, experienced printmaking.

GS

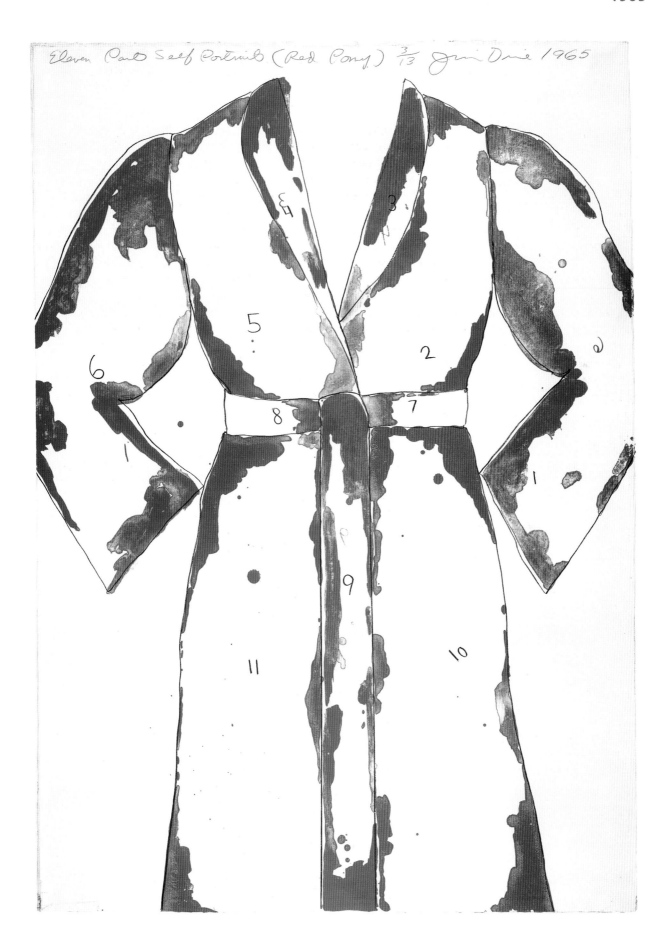

Eleven Part Self Portrait (Red Pony) 3/13 Jim Dine 1965

Victor Vasarely (1908–97)

Zett-R.G, 1966

**Published by
Overbeck-Gesellschaft,
Lübeck**

**Colour screenprint
on card**

**Size of printed surface
and sheet
70.2 x 70.6cm**

**Circ.1107-1967.
Purchased 1967**

VASARELY IS GENERALLY considered the founding father of Op Art, the artistic movement that flourished in the 1960s and explored the visual effects of optics and kinetics. He evolved his artistic theory slowly, reaching his mature style only in the early 1960s. Born in Hungary, where he trained as a painter and then as a graphic artist under the Bauhaus-taught Alexander Bortnyik, Vasarely came to Paris in 1930 as a commercial artist. He was fascinated by ideas of perception and, through observing nature, studying the work of Constructivists such as Malevich and reading a wide range of scientific texts (on theories such as relativity, wave mechanics, cybernetics and astrophysics), he arrived at his own colour-form unit theory. In this each unit was composed of two forms – the square that became the background, and another geometrical form contained within it – and two colours. The numbers of colours and forms were strictly limited to form an 'alphabet', but the number of combinations possible was almost infinite. According to Vasarely writing in 1962, this theory could be applied universally: 'A true planetary folklore is already taking shape before our eyes, modern in both theory and practice, unitary at its base but highly complex in its peaks ... The colour-form unit is the basis of a new plastic language, new in its adaptability to industrial techniques ...'[75]

The reference to industrial techniques is relevant for Vasarely's working practice. He believed that art should be available to all and therefore produced 'multiples' in the forms of reliefs in various materials, sculptures and silkscreen prints. Multiples were possible, he commented, only because technical developments meant that quality as well as quantity could be guaranteed. Vasarely devised a work practice in which basic elements for his 'prototypes' were mass-produced. He had large sheets silkscreened in his specified colours, and then had the shapes punched out. Next he would arrange these shapes on scale paper. This prototype could then be photographed and a silkscreen created.

Vasarely was introduced to his printer, Wilfredo Arcay, in 1954 when André Bloc published a portfolio of silkscreen reproductions of paintings, *Jeunes Peintres d'Aujourd'hui.*[76] Arcay recalled how the contributing artists (who included Vasarely) were struck by the remarkable way silkscreen could reproduce their paintings in flat, brilliant colours. Vasarely quickly recognized silkscreen as a perfect medium for the solid opaque colours he required, as well as responding to Arcay's great technical skill and precision.

Despite Vasarely's complex theory and rigid working practice, the work he created was of extraordinary luminosity, and the thick layers of silkscreen ink, far from being mechanical and austere, are lush and tactile. Vasarely stated in 1963 that he saw 'physics as the new poetic source',[77] and his words of 1969 seem to sum up his vision: 'Two dimensionality is a magical infinite space in a tangible, minute volume. The supra-dimensions (colour-form plasticity, light, movement-time) originate in the two-dimensional plane only to spill over, along a scattered front, onto sheets of paper, walls, and screens. Let's offer something to be seen, that man might truly live.'[78]

JB

Andy Warhol (1928–87)

Marilyn, 1967

From a portfolio of
10 screenprints in
different colourways

Printed by Aetna
Silkscreen Products,
Inc./Du-Art Displays,
New York. Published
by Factory Additions,
New York

Size of printed
surface and sheet
91.4 x 91.6 cm

Circ.121-1968.
Purchased 1968

Marilyn Monroe is one of the iconic faces of the twentieth century. Countless images of her are in circulation, but perhaps the most familiar representation of her features is Warhol's. By 1967 he had already produced screenprint portraits of Elizabeth Taylor and Jackie Kennedy, but Marilyn perhaps best expresses the essence of celebrity that so fascinated him. Every print and painting he made of Marilyn used the same publicity photograph, taken by Gene Kornman for the 1953 film *Niagara*.

This half-length portrait was close-cropped by Warhol to show only the head, with part of the collar of the halter-neck dress she is wearing. In Warhol's prints the vivacious original is reduced to an identikit, a caricature, with all the details obliterated by the simplified cut-out forms that are overprinted on a black photographic 'key', but deliberately out of register with it. There are four colour screens – for face, hair, lips and dress, and background with eye-shadow and beauty spot. In the version reproduced here the colours are approximately naturalistic, but other versions in the series are printed in luridly arbitrary colour combinations. The simplified motifs of mouth, hair and eye-shadow advance the idea that the public face of the celebrity, and especially of the film star, is a cosmetic mask, constructed for an audience. Warhol accepts, at face value, the image already established in the collaboration between Marilyn, the studio stylist and the photographer, but emphasizes its artifice.

Pop Art is characterized by its symbiotic relationship with popular culture – with comics, advertising, cinema, celebrity and all the aspects of the consumer culture ushered in by a buoyant US economy in the 1960s. Printmaking, which had been of little interest to the previous generation of artists, experienced a major revival. Those characteristics of prints that had led them to be seen as a second-class medium, inferior to painting and sculpture, were celebrated as virtues by Pop artists. For Warhol, in particular, mass production, mechanical processes and the distancing of the artist from the artwork were desirable qualities which had their parallels in the mass media that supplied his subjects. He even silkscreened his paintings, and produced paintings as well as prints in series of near-identical images. Indeed, his method of making art imitated the worlds of industry and commerce: in a studio named the Factory he employed a number of assistants working to his instructions on a production line of paintings.

In contrast to the way he worked on his silkscreened paintings, which were made in the studio by him or under his direct supervision, in his collaborations with printers on editions of silkscreened prints he withdrew (at least in the 1960s) from the whole process. For the *Marilyn* portfolio he left most of the decisions to project director David Whitney, including the initial choice of colours, and he was not even present when the prints were proofed. His printmaking was largely motivated by commercial considerations, and has also been interpreted as a conceptual gesture against the status accorded to the unique and hand-made work of art.

GS

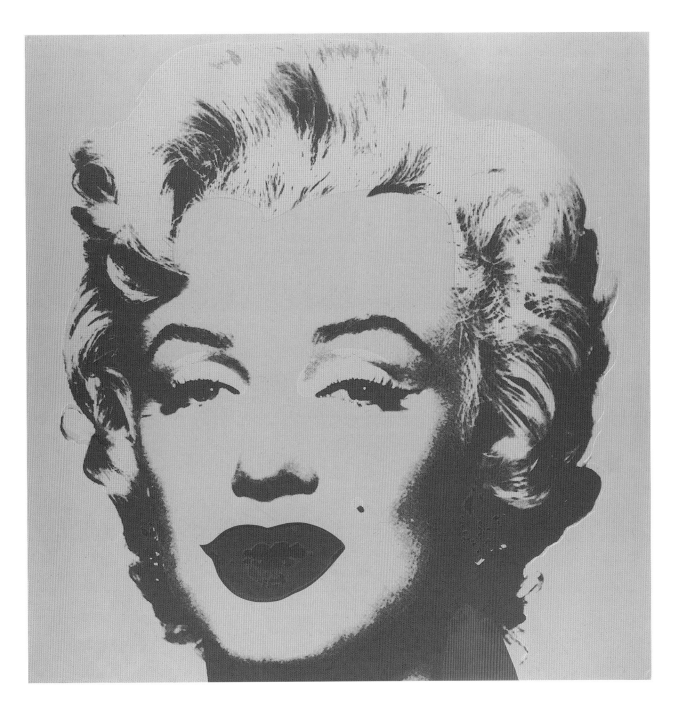

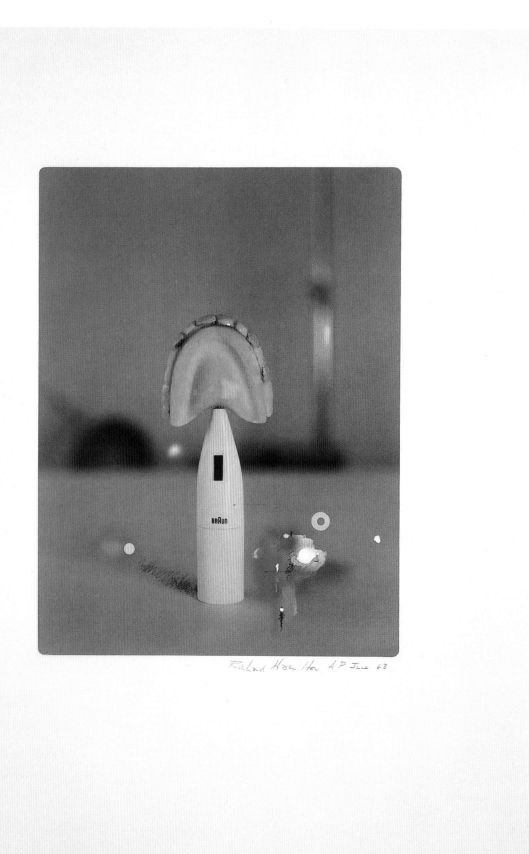

Richard Hamilton (born 1922)

The critic laughs, 1968

Published by the
Documenta IV
Foundation, Kassel

Signed, dated and
inscribed in pencil
*Richard Hamilton AP
June 68*

Laminated colour
photo-offset
lithograph with
screenprint, enamel
paint and collage

Size of printed surface
34.2 x 26.2 cm; size of
sheet 59.6 x 46.5 cm

E.1075-1980.
Purchased from the
artist 1980

PRINTMAKING IS AN essential part of Richard Hamilton's artistic oeuvre, often part of a whole range of interlinked works in various mixed media. In this case the subject was the result of a chance gift of some edible sugar teeth, which the artist attached to his electric toothbrush. Recalling Jasper Johns' satirical sculpture *The Critic Smiles* (1959) – a toothbrush with its bristles replaced by molars – Hamilton decided to call his image of vibrating teeth *The critic laughs*. It was created in 1968 as a print to raise money for the Documenta Foundation's exhibitions in Kassel. Three years later Hamilton made a three-dimensional multiple, reproducing the original object and adding packaging and an instruction leaflet. Then in 1980, for the BBC's *Shock of the New* television series, he made a 'television commercial' promoting *The critic laughs* as a consumer product: 'For connoisseurs who have everything ... at last, a work of art to match the style of modern living ... "The critic laughs" ... by Hamilton.'[79]

This print reflects two of the artist's dominant interests – the aesthetic philosophy behind Duchamp's 'ready-mades', and consumer culture. The object was photographed with a soft-focus background, then touches of paint were added; next, an offset lithograph was made and laminated. The print was then given a white silkscreened border at the now famous Kelpra Studio to give the illusion of a photograph mounted on card; further touches of paint and collage were added. The lamination recreates the glossy allure of advertising brochures, while the use of a variety of printing techniques and autograph marks emphasizes the separate elements that form the print. This laborious and painstaking approach was typical of Hamilton's methodology.

The artist was particularly interested in exploring photographic and printing processes in order to understand how the images of mass media were created and how a manipulation of these techniques could add further dimensions to a work of art. In 1969 he described his interest in the parallel paradoxes of the painter interpreting the three-dimensional world in two dimensions and the photographer's ambiguous relationship to 'truth to nature'. He wrote: 'The directness of photographic techniques, through half-tone silkscreen, for example, has made a new contribution to the media of painting. In my own case there was a time when I felt that I would like to see how close to photography I could stay yet still be a painter in intent.'[80] In the final count the success of this print lies not only in its subject matter but also in the sensuous appeal it makes through textures and colours.

JB

119

Patrick Caulfield (born 1936)

Two Jugs, 1969

Printed at Kelpra
Studio, London.
Published by Leslie
Waddington Prints,
London

Signed in pencil on the
reverse *Patrick
Caulfield*. Numbered
31/75. Lettered on the
reverse with
title and ICP (Institute
of Contemporary
Prints) number.
Stamped with the
printer's mark and seri-
al number

Colour screenprint

Size of printed
surface and sheet
35.5 x 30.5 cm

E.849-1976. Given by
the Institute of
Contemporary Prints

Two Jugs EPITOMIZES the style and subject matter of Patrick Caulfield's work in the 1960s: familiar still-life subjects, such as bottles, glasses, food and drink, portrayed within an illusory space. Characteristically he rendered these subjects with flat areas of pure colour, uniform densities of hue and tone, and heavy black outlines. The silkscreen process lent itself ideally to this discipline.

Caulfield studied at the Royal College of Art, London, between 1960 and 1963, and during this time he visited Crete on two occasions. There he became intrigued by Minoan frescoes, and in particular by postcard reproductions of the ancient drawings, in which black outlines had been used to strengthen the contours of their forms. This technique made a lasting impression on the artist.

This print engages the viewer by its simplicity and by the subtle way in which the green of the jugs relates to the green of the background. Caulfield is able to suggest space just by the punctuation of the greens with the black outlines. The influence of the French painter Fernand Léger, who used a similar device of outlining objects to emphasize particular parts of his paintings, is clear. Caulfield has exploited this idea so the whole composition is dependent on a harmonizing balance between an unvarying line and the three colours.

Although Caulfield was associated with a group of artists who produced what became known as Pop Art, he never felt comfortable with this title. The idea of using direct, sometimes shocking, references to contemporary mass culture was somewhat contrary to Caulfield's less confrontational and more traditional approach. He was interested in personalizing his own visual language, including making references to artists such as the Spanish Cubist painter Juan Gris, who had re-established new ways of depicting traditional still-life subjects.

Throughout the 1970s and 1980s Caulfield's imagery became less focused on single objects and more concerned with placing them within an environment. He did this by creating greater spatial depth, and by more complex arrangements of the still life in his works. He also introduced different styles and techniques, such as the photo-collage effects seen in some of his prints. More recently, his images have become simplified again, and his preoccupation is with the light and shadow cast on a single object, which is as integral to the composition as the object itself.

DG

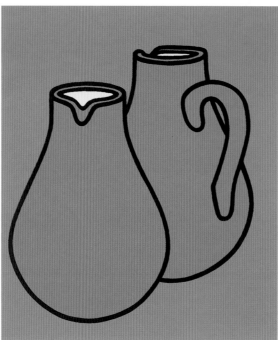

Ronald Brooks Kitaj (born 1932)

Transition, 1970

From the suite of 50 plates entitled *In Our Time: Covers for a Small Library. After the Life for the Most Part.* Printed by Kelpra Studio Ltd, London, 1969 and published by Marlborough A.G., Schellenberg F.L., Germany, 1970

Signed in pencil with the artist's initials *RK*, numbered *49/150* and stamped on the back with the printer's mark

Colour screenprint

Size of printed surface (irregular) 37.7 x 29.4 cm; size of sheet 78.4 x 55.7 cm

Circ.189-1975. Purchased 1975

DESPITE INITIAL RESERVATIONS – he has always thought of himself primarily as a painter – Kitaj's use of screenprinting has been highly individual and influential. His mix of interest in literature, history and politics is conveyed through both images and texts; physical appearance is as significant as intellectual substance. From his earliest works with the printer Chris Prater (see also pp. 99, 109), such as *Good God Where is the King*, almost entirely composed of text fragments, and *Acheson Go Home*, where a book jacket and fragment of newsprint contribute to narrative and composition, Kitaj has frequently relied on text to expand the meaning of the image. The suite *In Our Time*, however, goes much further than most in its

celebration of literature: it is not only a memorable key to the artist's concerns and interests but a succinct expression of a particular age and intellect.

In conceiving this work, Kitaj was particularly influenced by the great German Jewish critic and writer Walter Benjamin. In the essay 'Unpacking My Library: a talk about book collecting' Benjamin writes that the true collector has 'a very mysterious relationship to ownership, to objects, which does not emphasize their functional, utilitarian value ... but studies and loves them as the scene, the stage of their fate ... collectors are the physiognomists of the world of objects'.[81] Benjamin also talks of the tension between order and disorder in the life of the collector – and Kitaj's images may be juxtaposed at will, triggering a variety of associations.

Kitaj later came to view the suite as possibly too close to the 'ready-made', the concept of virtually unmediated appropriation of objects of daily life with which Marcel Duchamp had mocked the art establishment over half a century earlier. Yet unlike the latter, who used only objects to which he felt indifferent, Kitaj chose 'ready-mades' with which he had a close personal bond. As a collection, they present a very different value from the kind intended by Duchamp. Benjamin suggests that the art of collecting implies a rebirth for the object itself. A triumph of Prater's skill, the fifty book-covers, reproduced in fastidious yet sensual detail, were enlarged, isolated and endowed with a quality that belongs traditionally to the religious icon. Kitaj's representation gave re-birth not only to the books, but also to the meaning of icon, biography and the relationship between visual arts and literature.

RM

121

Joseph Beuys (1921–86)

Druck I (Print I), 1971

Published by Editions Staeck, Heidelberg

Inscribed in blue ink
Der Eurasier lässt schön grüssen Joseph **(The Eurasian sends warm greetings Joseph). Stamped in purple ink with the artist's medallion mark** *Hauptstrom* **(main current), etc.**

Letterpress

Size of sheet 79.9 x 57 cm

E.496-1981. Purchased 1981

Beuys' art stemmed partly from his desire to achieve political and social revolution through creative discourse. This led him to produce a body of work, including large print editions and three-dimensional objects, as part of this process. When asked in an interview with Jörg Schellmann and Bernd Klüser in 1970 why he produced multiples, Beuys spoke of the need to reach a larger number of people than he might by producing unique works or none at all. He also used them as a means of staying in touch and prompting further enquiry and debate. Beuys' multiples included many types of objects (prints on paper were just one form), and he incorporated materials as diverse as felt, fish bones and enamelled tin.

This print, one of a pair paying tribute to the people of Eurasia, recalls the profound significance for Beuys of a region where he perceived materialism as kept in check by more spiritual values, arising from a particular life style and a close relationship with nature. As with so much of his work, the image reproduces objects that both commemorated and grew out of his experiences in the Second World War. The cross brings to mind both survival kits and religious belief. The felt suit, which had itself been made up as a multiple by Beuys, symbolized the protective qualities of the original felt and fat in which he had been wrapped and

kept alive by the (Eurasian) Tartars of the Russian Steppes after his plane had crashed in their territory in 1941.

During his potentially controversial visit to the USA in the late 1970s Beuys scattered sulphur over his installation *Aus Berlin*. As Robert Morgan explained in *Who Was Joseph Beuys*, 'In alchemy, sulphur is considered to have remarkable transformative powers that could heal and reconstitute matter and give it new depth and substance. *Aus Berlin* was an installation, but it was also a process and a performance, a statement about potential unity and reconciliation.'[82] The second print, the image of which duplicates that of the first, is printed with glue and powdered sulphur to imply the same kind of 'transformation' from one state (signified here by conventional letterpress) to something more. From his considerable scientific knowledge Beuys would have been aware of sulphur's inflammable quality and its capacity to generate heat – the production and channelling of energy was for Beuys a lifelong concern. It is also intriguing to note the existence of large deposits of sulphur round Daghestan – close to the region where Beuys was cared for by the supposed enemy.

RM

子供たちに開放されていて、絵を描いたり、デザイナーの作ったブランコに乗ったりしている。芸術にたいする事大主義をとり払った、この美術館の演出が、そのまま、ボイスの、超芸術ともいうべき世界とつながっているのが面白い。夜、高松、リンドブロムと一緒に、評判のセックス・フィルムを見る。

三月一日。省略。

三月二日。朝から大雪。鴨のような水鳥の群が雪で固まった海辺の上を平気で歩いているので、よく寒くないものだと思う。ボイスと昼食の約束をしたので、近代美術館で落ち合う。すでに作品の梱包がはじまっており、樽をひとつ木箱につめているのが物珍しい。昨日までの緊迫感にみちた会場が、急に閑散として、その空々らしさがまた不思議である。

高松、フルテンと一緒に「オペラ」というバーでボイス一家と昼食になる。行く途中、ボイスはいつもかぶっている帽子を、食事のときは脱ぐだろうか、と高松と賭けたが、食卓でのボイス氏は無帽であった。きっと頭がないからいつも帽子をかぶっているのだ、といった冗談を交していたものだが、その頭は毛が薄く、少ない毛をなでつけて、ひたいにた

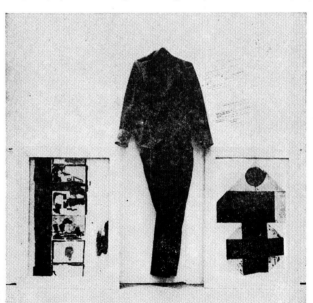

ボイス展風景

202

Coloured Greys 34/125 Bridget Riley '72

Bridget Riley (born 1931)

Coloured Greys III, 1972

Signed and dated in pencil *Bridget Riley '72*. Inscribed with title and numbered *28/125*

Ten-colour silkscreen

Size of printed surface 57.2 x 58.9 cm; size of sheet 69.9 x 73.3 cm

Circ.258-1976. Purchased 1976

ALTHOUGH RILEY'S WORK always generates striking visual sensations, her concern is not merely to dazzle the eye with optical effect. The basis of her art is the pleasure she derives from looking. Writing of the cliff walks of her childhood in Cornwall or of a visit to Egypt, she describes with delight how scenes can astonish the viewer with the vibrancy of their light and colour. As she notes, such pleasures are essentially enigmatic and elusive: 'One can stare at a landscape, for example, which a moment ago seemed vibrant and find it inert and dull.'[83] In her art Riley arrives at equivalents for these and other experiences; based on pure visual energy rather than description, the works possess the essential startling quality of immediate experience.

Riley works with colours that taken together generate a visual field through which the sensation is experienced. In *Coloured Greys III* colours are built up in different ways. First the greys are literally tinted with pigment. A constant mauve-grey is set against a shifting grey which is subtly modulated from the top to the bottom of the picture, at the top appearing green in colour, at the bottom taking on a blue hue that seems to expand and blend into the mauve. The changing juxtapositions induce colour tints by optical fusion and contrast as the colours bounce off each other. The curves provide long edges along which this optical activity can take place and thus enliven the print with movement: the green seems to shift down the image with the pulsing diagonal repetition of the curves.

Riley has written of her work:

The colours are organised on the canvas so that the eye can travel over the surface in a way parallel to the way it moves over nature. It should feel caressed and soothed, experience frictions and ruptures, glide and drift. Vision can be arrested, tripped up or pulled back in order to float free again. It encounters reflections, echoes and fugitive flickers which when traced evaporate.[84]

At first sight Riley's works, with their repeating patterns, appear to lend themselves easily to reproduction. Indeed, in the 1960s they were plagiarized for everything from dresses to sets for television programmes. However, Riley's prints are never just reproductions of her works on canvas. Scale is critical to her work, as it controls the tempo of the visual sensation. Each print is therefore an original creation. Moreover, capturing an image like this in a print demands considerable technical expertise. The colours have to be balanced with precision, and to achieve the direct juxtaposition of hues in the silkscreen process, the curving bands have to overlap slightly, the most transparent colours printed first. Riley employed her specialist printer, Graham Henderson, to execute this work. He recalls that for one of her sets of prints 500 impressions had to be printed to achieve a perfect edition of 75.

LO

Brice Marden (born 1938)

Untitled, 1973

Printed by Hiroshe
Kawanishi at Simca
Print Artists, New
York. Published by
Simca Print Artists
and the artist

Signed and dated in
pencil *B. Marden 73*.
Numbered in pencil
42/50

Colour screenprint on
Rives BFK paper

Size of printed
surface 45.7 x 39.3 cm;
size of sheet
105.9 x 75.8 cm

E.941-1978.
Purchased 1978

THOUGH MARDEN'S WORK of the 1970s is often identified with Minimalism, he actually has little in common with that austere 'industrial' aesthetic and the self-sufficient language of the grid. A sensual materiality characterizes even his most severe geometric abstractions. Throughout his career there has been a close correlation between his printmaking and his painting, with experiments in one medium feeding into the other. As a graduate student at Yale, Marden had followed a course entitled 'Painting, Printing and Drawing', which gave equal emphasis to each medium; in the 1960s he also worked as a printer at the Chiron Press, then run as a screenprinting shop by the artist Steve Poleskie. However, the specific impetus for Marden's own screenprints came from having seen Jasper Johns' *Flag I* and *Flag II*, both made with master screenprinter Hiroshe Kawanishi at Simca Print Artists in New York.

Marden was particularly impressed by the way in which Kawanishi had managed to create a very painterly surface, quite unlike the uninflected surface that characterized the commercial screenprint. To achieve this he encouraged artists to draw directly onto the screen with tusche. Marden adopted this method, painting onto the screens using long vertical strokes, in the same way as he was then applying paint to canvas. The effect is enhanced by the slightly uneven application of the tusche, which allowed the earlier layers of colour to show through on the surface in places. In this print the matt opacity of the pigment is the equivalent of the light-absorbing encaustic (oil and wax) that Marden was then using to create an opaque 'skin' on canvas.

The composition of this print mirrored, and perhaps inspired, a change in his painting at this time. Previously his canvases were divided vertically into two panels of equal size. Here the right-hand section is divided in half again, destabilising the composition and creating a different rhythm. This division was adopted in *Winter Painting*, 1973–5 (Stedelijk Museum, Amsterdam), and other works from this period. However, in the paintings the division is physical, with separate canvases that abut one another. In the print this division is achieved illusionistically by fine lines printed from hand-cut screens.

GS

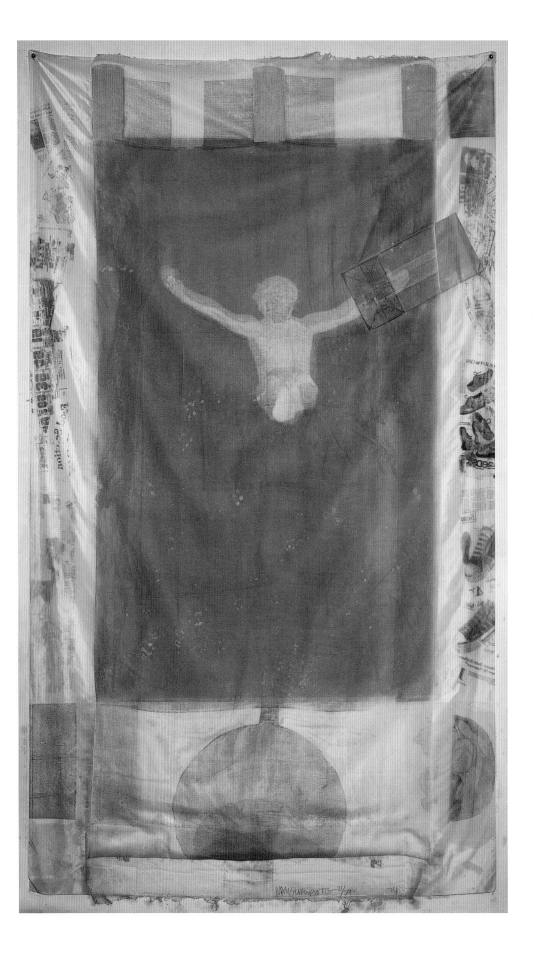

Robert Rauschenberg (born 1925)

Pull, 1974

From a series of nine prints entitled *Hoarfrost Editions*. Published by Gemini G.E.L., Los Angeles

Signed and dated in chalk *Rauschenberg 74*. Numbered *21/29*

Screenprint on cheese-cloth and silk taffeta with paper bag collage

Size of sheet approximately
226 x 122 cm

E.551-1975. Purchased 1975

RAUSCHENBERG DEFIES CATEGORIZATION and his artistic output always pushes outwards the limits of convention. As well as being a painter, sculptor, photographer, set designer and performance artist, he has conducted some remarkable experiments as a printmaker. Though considered by some as a Pop artist, his early abstract paintings of the 1950s in fact made him part of the movement called Abstract Expressionism, and some of the later works after 1970 are defined in the contemporary sense of installations. This print is a good example of how he subverted accepted ideas about the materials to be used and even the concept of printmaking itself.

If the most basic definition of a print is 'an exactly repeatable image', then his version of a famous photograph of an Olympic diver, screen-printed mistily on and through layers of fabric, collaged with paper bags sewn in between the muslin and taffeta, defies even this definition. The border areas of the print recall his earlier experiments in the 1950s with the technique he developed of 'solvent transfer'. Advertising images printed in magazines were transferred to another surface by soaking them in a liquid that partially softened and released the layers of printing ink from the original paper.

The ambiguity of the central image, a man diving gracefully like a bird, before plunging into the beautiful blue and uncertain depths of a pool, is reflected in the slightly out-of-register printing through the veils of fabric. This gives the effect of something clear-cut but glimpsed only at speed, a visual paradox, one of many that run throughout the artist's work. The image of the diving man has been used many times since, but it was Rauschenberg, as so often, who pioneered the way.

CN

Marcel Broodthaers (1924–76)

La Soupe de Daguerre, 1975

Published by Multiple Editions, Inc., New York

Inscribed in black ink on *trompe l'oeil* label with title. Signed and dated on a blue-bordered printed label on the reverse *M. Broodthaers 75*, inscribed *'La Soupe...'* and numbered *11/60*

Twelve C-type colour photographs and screenprinted label on card

Size of nine larger photographs 8.8 x 12.7 cm; size of three smaller photographs, cut to average 7.7 x 11.1 cm; size of card 52.7 x 51.5 cm

Ph.253-1980. Purchased 1980

Marcel Broodthaers was a poet who became a photographer, filmmaker and creator of miraculous sculptural objects. He enjoyed living in London and worked with great productiveness in many media until his untimely death. One of his last and most enchanting works is *La Soupe de Daguerre*. This was his contribution to *Artists & Photographs*, a collection of multiples. The other artists involved were John Baldessari, Bernd and Hilla Becher, Jan Dibbets, Ed Ruscha, Ger van Elk and William Wegman. Perhaps Broodthaers knew more about practising the medium than most of his colleagues, as he began photographing in 1957. However, Broodthaers used photography to play with ideas, including ideas about photography. Photography had become the major mass-information system of the twentieth century. With the advent of television, its hegemony was suddenly under challenge. Broodthaers was one of the leaders of a generation of artists who used the photographic medium in a new way: not to describe or interpret the world, to document facts or to explain them, but, instead, to reveal habitual patterns of thinking, to question systems and to undermine explanation. A paradigm shift had occurred, and artists were the first to notice it. Photographs were no longer simple facts, involuntarily captured by an optical-chemical technology. They had become mediated interpretations of phenomena, subjective and contingent impressions. They had become *prints*.

Such works as *La Soupe de Daguerre* epitomize this shift. It is an act of reclassification based on the complicated relationship between photography and printmaking. Broodthaers presents us with a pun – an amazing mixture of visual culinary ingredients that make up a conceptual soup. While the delectable ingredients are represented by photographs mounted like snapshots, the mock label at the base is a splendid piece of *trompe l'oeil* screenprinting. Broodthaers organizes his ingredients in three obvious ways. First, some of the items are repeated. We scan the six photographs of tomatoes to make some kind of sense of differences and similarities. Secondly, the photographs are displayed in a grid of three vertical and four horizontal rows. Generally, grids are used as a means of classification; individual items are arranged for easy inspection, family likenesses can be recognized and larger groupings established. Thirdly, on the 'label' at the base the name of the culinary soup (made up of the salad ingredients and freshwater fish) is attributed not to a famous chef or gourmet but to the inventor of an imaging system. (The first commercially available form of photography was announced by Louis-Jacques Mandé Daguerre in 1839.) Although the fish are represented by printed transfers, they are, like the images of vegetables, photographs – images authored, ultimately, by Daguerre. This is a fourth, not so obvious, way in which the ingredients are organized: by being photographically represented. If we are getting slightly lost at this point, it is just as Broodthaers intended. The same thing happened when Broodthaers questioned and challenged the various systems of museum classification in his 'Museum of Modern Art, Department of Eagles', which he set up in his Brussels apartment in 1968.

MH-B

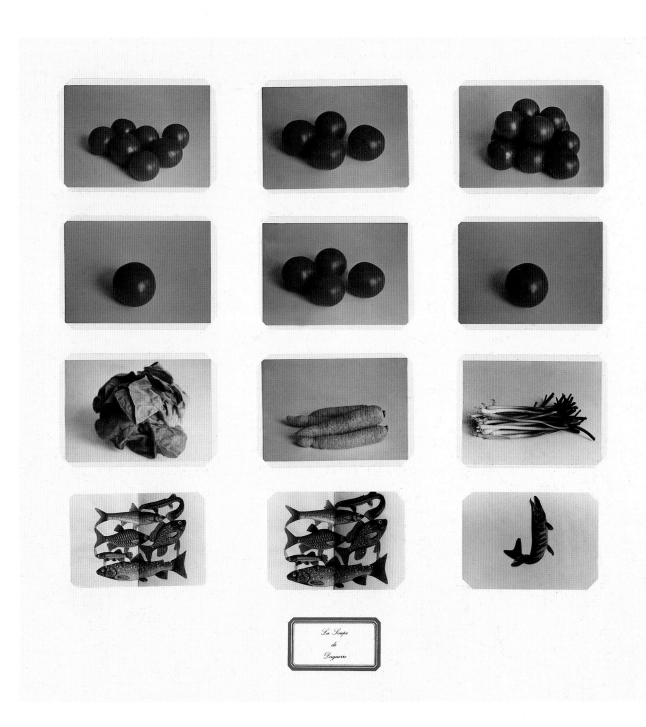

La Soupe
de
Daguerre

Claes Thure Oldenburg (born 1929)

Soft Screw in Waterfall, 1976

From a series of eight lithographs entitled *Soft Screw*. Published by Gemini G.E.L., Los Angeles

Signed in graphite *Oldenburg*, and numbered *18/35*

Blind stamped © *1976 CLAES OLDENBURG* and with the Gemini symbol of the publisher

Lithograph

Size of sheet 171.5 x 114.3 cm

E.758-1976. Purchased 1976

OLDENBURG IS BEST known for making soft sculptures. He has not always been keen on printmaking. In 1972 he described it as 'an excruciatingly unpleasant activity, like going to hospital for an operation'.[85] This may have been due to the technical discipline that certain printmaking processes impose, which the artist found inhibited his spontaneity.

Crayon lithography, however, is one of the printmaking techniques closest to drawing. In addition, a necessary precondition for successful printmaking in the second half of the twentieth century, by artists who are primarily either painters or sculptors, is technical support from highly skilled and sympathetic individuals who create the right working environment for the artist. This was provided here by Gemini G.E.L., the publishing workshop that in 1968 editioned an Oldenburg sculpture, *Profile Airflow*, and subsequently another sculpture, *Ice Bag*, produced in three different scales.

The set of eight lithographs, of which this print is one, was the first time Oldenburg had made either a drawing or a print on such a large scale. The artist approached the task in a very particular way:

I prepared an image very carefully, doing it many, many times, and rehearsed as though it were a performance. Then I had a good night's sleep, came in early the next morning where everything was set up with a high-quality transfer paper. I did one drawing a day ... I had to prepare, and the circumstances had to be just right.[86]

In the early 1960s Oldenburg's work was frequently exhibited alongside that of Andy Warhol, Roy Lichtenstein and Jim Dine, and their shared concerns for commonplace objects and mass popular culture led to Oldenburg being viewed as central to American Pop Art. Since then Oldenburg's art has demonstrated other personal, lifelong preoccupations, among them a fascination for specific geometrical forms, such as the screw. Another lithograph in the set prefigured the artist's creation of a large aluminium public sculpture entitled *Screwarch* in Holland in 1983.

EM

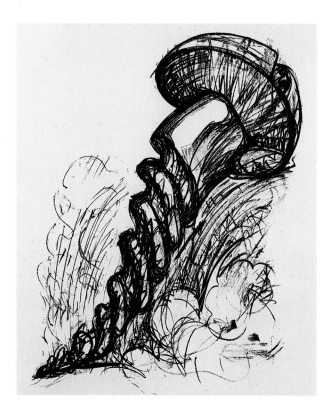

Gavin P. Jantjes (born 1948)

Freedom Hunters, 1977

Signed in pencil *Gavin P. Jantjes*. Numbered *8/35*

Screenprint with collage, in red and black

Size of printed surface 68.8 x 100.2 cm; size of sheet 70.8 x 100.2 cm

E.333-1982.
Purchased 1982

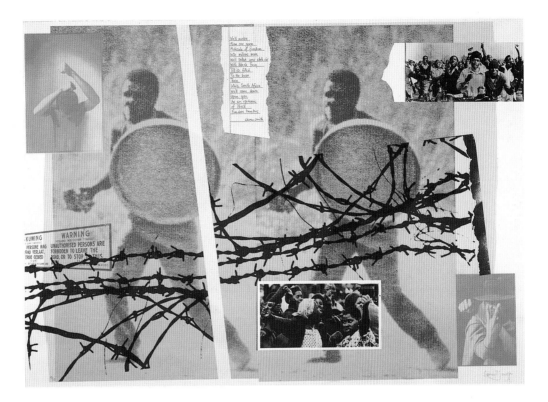

JANTJES FIRST CAME to Europe from South Africa on a German Academic Exchange Scholarship, studying in Hamburg from 1970 to 1972, then staying on as a political exile. In 1976, working at the Poster Collective in London, he made a set of anti-racist screenprints to be used in schools. He also exhibited at the ICA his suite of prints *South African Colouring Book* (1974–5), which used the metaphor of childhood pastime and educative toy to indicate the depth and cruelty of pro-apartheid indoctrination. *Freedom Hunters* more specifically commemorates the infamous massacre of students in Soweto on 16 June 1976; the image, lettered with a poem by Steven Smith ('We'll evolve ... As an epidemic of Black Freedom Hunters') echoes Nelson Mandela's own view on the new spirit of defiance developing at the time.

For his screenprints of the 1970s Jantjes used the photographic and collaging process developed by artists working with the printer Chris Prater (see pp.99, 109, 121); Jantjes had in fact studied with one of these artists, Joe Tilson, in Hamburg. Overtly political in tone, his commentary directly mirrors the imagery of television and press reportage through which Britain came to know of events in South Africa.

Deeply aware of his responsibilities, Jantjes placed his own very contemporary, media-orientated work firmly in a historical tradition; he wrote in 1978:

> If the axiom of art for art's sake still applies to Western European art, it is certainly not applicable to African art. I believe it never has been. For African artistic expression, whether rock painting or bronze sculpture, worksongs or war dances, never transcends either the physical or cosmic reality of the African people; African works of art appear meaningless unless seen in relation to Africa's cultural and historic reality. It has always been art for life's sake. The environment of today's Africa demands liberation from inhumanity. Can the art of Africa ignore this demand? Can it be anything else than art for liberation's sake?[87]

RM

Conrad Atkinson (born 1940)

Anniversary Print: From the People Who Brought You Thalidomide ..., 1978

Signed and dated in
pencil *Conrad
Atkinson April '78*.
Numbered *46/50*

Colour offset
lithograph with
additional colouring
by hand

Size of printed
surface 53.5 x 43.5 cm;
size of sheet
65.1 x 49.5 cm

E.1223-1979. Purchased
from the artist 1979

Hot off the press, *Anniversary Print* instantly became a *cause célèbre*, banned from exhibition at the Serpentine Gallery, London, and both warmly defended and acidly prosecuted in the pages of the national press. The year 1978 was the 150th anniversary of the founding of University College, London, and the Slade School of Art (part of the college) commissioned a portfolio of prints from various artists to be presented to the Queen Mother, then Chancellor of the University. Atkinson took this as an opportunity to challenge the Royal family's continued patronage of the Distillers Company, the multi-national that marketed the drug Thalidomide, a cause of irreversible deformity of limbs and organs in babies conceived between 1959 and 1961. Almost twenty years later some victims were still fighting for compensation from the company, whose profits were soaring. The facts were public and well known, and there had been appeals to the Royal family to withdraw their warrant.

Atkinson's deeply egalitarian concerns prompted him to channel his art-school training into making installations addressing the manipulation and abuse of ordinary working people; in these he used real documents like pay slips, tele-printed stockmarket reports, photos and Super-8 film footage. As with many of his peers in the 1970s and 1980s, Atkinson saw prints as a vehicle for raising debate. He did not see his work as propaganda, inasmuch as the word has come to be associated with distortion or deception in the furtherance of a cause, but he was a master of irony and skilful in deploying other visual formats to this end. *Anniversary Print* suggests a poster in its line-up of seductive liquor bottles and, snuggled down among them, some framed promotional copy proclaiming Distaval (the brand name of Thalidomide) as a 'safe' drug. Set on a kind of penthouse window seat against the background of an idyllic rural scene (the Distillers factory base?) together with the London skyline, they appear both to rise from and dominate the capital. The bottles unwisely flaunt their Royal crests, which are circled by Atkinson's shrewd pencil. The text below, giving the story of Thalidomide, is quite legible but somehow suggests the 'small print', a legal requirement usually designed to be ignored, though here rather more gripping than the picture and impelling us to read what we would perhaps rather not know.

RM

ANNIVERSARY PRINT

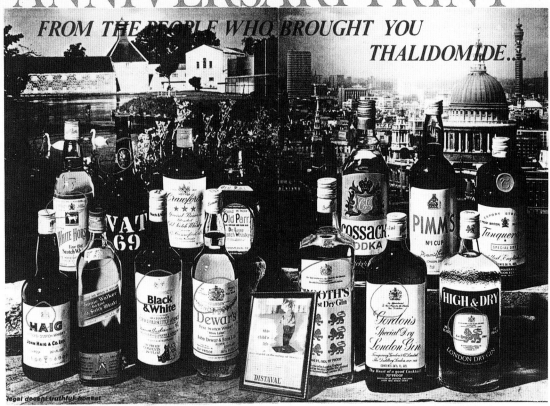

FROM THE PEOPLE WHO BROUGHT YOU

THALIDOMIDE...

legal decent truthful honest

a childrens story:

April	1958	Thalidomide was introduced into Great Britain by Distillers (Biochemicals), a subsidiary of Distillers Co. It was sold over the counter for two years under the names of Distaval, Distaval Forte, Asmaval, Valgis, Valgraine, Tensival.
	1960	After two years it was sold on prescription.
November	1961	It was finally withdrawn five months after Distillers were warned.
	1962	Distillers Biochemical was sold to an American Company. Distillers Co subsequently claim they therefore have no records of Distillers (Biochemical) regarding sales, profits etc.
	1961	First proceedings on a test case were started.
	1965	Fifty nine parents met Distillers and on lawyers advice, accepted an out of court offer averaging between £12,800 and £14,779 per child which has been estimated as about one fifth of the child's probable needs, or forty per cent of a successful court case.
	1968	Distillers profits – £41,000,000
	1970	Three hundred and forty cases still outstanding.
November	1971	The first offer to this group was made: this was that a charitable trust be set up which would receive £3,250,000 over eleven years. Half of this would be covered by tax relief to Distillers, thus the actual cost to Distillers would be £1,6000,000 or equal to £7,725 per child. The terms of that agreement were that every family would know in advance what they would get, if anything. A type of means test would be used to ascertain what each family would get. This split the families in their action.
	1972	A counter claim failed.
Summer	1972	A new offer was made in which families were given two options either a £3,350,000 trust over eleven years stripped of the collective unanimity clause or £2,900,000 cash sum to be divided up on average £8,400 per child. This also failed. In December another charitable trust was proposed over ten years of £11,850,000 which meant £1,185,000 per year. This contained three elements firstly a straight cash contribution from Distillers Co; secondly tax relief on that cash for Distillers Co; thirdly the interest gained on that part of the £5,000,000 retained by Distillers should be paid to Distillers. Thus the tax relief plus the interest gained equals £11,850,000 over ten years. The £5,000,000 equalled one months trading profit for Distillers Co.
	1972	Profits for Distillers – £86,000,000 A Royal Commission on Civil Liabilities was set up as a result of the Thalidomide case.

February	1973	A new offer of a charitable trust of £20,000,000 was made under the same conditions. This was dependent upon the creation of a new law releasing Distillers from some of their normal taxes. The parents were led to believe would be untaxed.
July	1973	The parents accepted this offer.
	1974	A Treasury ruling was issued that the Thalidomide children should be taxed at 48 pence in every £1. The Treasury argued that this was unavoidable without changing the law. The problem was resolved by the government paying the tax, which amounted to £5,000,000 out of public funds in effect subsidising the Distillers settlement.
November	1975	After some disagreement with their insurers (Lloyds) Distillers received £3,000,000 in insurance for the cases.
	1976	Profits for Distillers – £127,000,000.
December	1977	Eighty five children still not in receipt of any compensation. These children were placed arbitrarily into a Y list as doubtful by Kimber Bull (solicitors) for administrative reasons, some having absolute proof of having had the drug. Distillers issued a statement to say that they would consider new information (which the Daily Mirror alleges they already had). The diagnosis procedure for the Y list is questionable as the Medical panel initially set up was replaced by a specialist, Professor Richard Smithells. In one case a diagnosis made by Dr Michael Hamer in 1964 and subsequently confirmed by him in 1974 was contradicted by Professor Smithells without examining the child. A subsequent report to the Minister for the Disabled from Distillers said they had not received copies of all the childrens cases.
	1977	Profits for Distillers in the first six months – £74,000,000.
January	1978	MPs demanded that all subsidies, grants and tax reliefs to Distillers should be cut.
February	1978	Alf Morris, Minister for the Disabled announced an inquiry into the Y list. The parents of the Y list children had also signed the 1973 agreement therefore signing away all legal rights to take action against Distillers for negligence. Most Y list parents are low income families whose resources have been utterly exhausted and who are unfamiliar with litigation and the complexities of the legal procedures initiated and backed by the massive resources of a giant company. The cost to Distillers to clear the remaining eighty five cases is less than £3,000,000 that is less than the insurance they received from Lloyds. Distillers have always denied legal responsibility for the effects of Thalidomide.
April	1978	Twenty years later eighty five children have still not had one penny from Distillers. Pleas to Buckingham Palace to withdraw the Royal Warrant from Distillers products fell on deaf ears. Shareholders include: Eagle Star, Commercial Union, Legal and General, Phoenix Insurance, Pearl Insurance, Norwich Union, Prudential, Royal Bank of Scotland, Lloyds Bank, The Boroughs of Lambeth, Hammersmith, Hillingdon and Lewisham.

Conrad Atkinson April '78

46/50

135

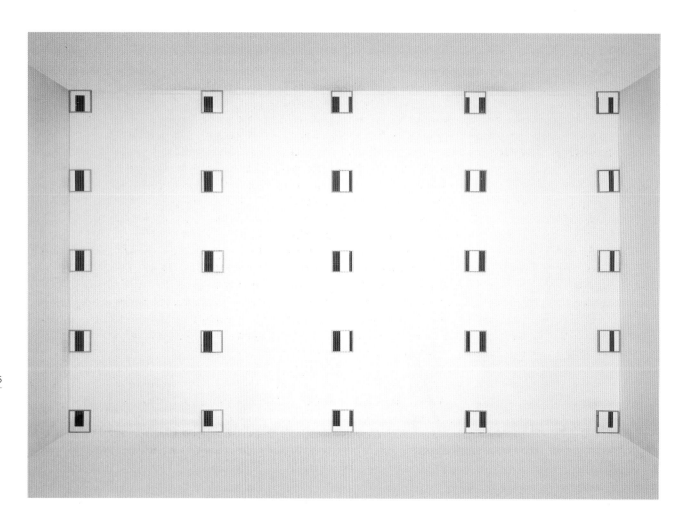

Another impression of *Framed/Exploded/Defaced*
installed in accordance with the artist's instructions.
Published by Crown Point Press.

Daniel Buren (born 1938)

Framed/Exploded/Defaced, 1979

Printed in an edition
of 46, each set in a dif-
ferent colourway, by
Lilah Toland and Nancy
Anello at Crown Point
Press and published by
Crown Point Press,
Oakland, California

Lettered on the back
of each fragment with
the edition number *19*,
and on the back of
each frame with the
same information and
artist's name, details
of publication, etc.

Colour aquatint in 25
individually framed
fragments

Each fragment, includ-
ing frame,
20.4 x 20.4 cm; original
size of printed surface,
before fragmentation,
91.5 x 91.5 cm; overall
size of installation
varies according to the
exhibition space

E.147A-Y-1981.
Purchased 1981

SINCE 1966 BUREN'S sole motif has been the stripe – a single colour on a white ground. His constant use of the stripe originated in an agreement with fellow French artists Niele Toroni and Olivier Mosset that each (using his own chosen motif) would repeat the same painting over and over again in every situation. For Buren this adherence to a single anonymous device made sense since his primary interest has been in the presentation and context of art. His career to date has constituted an exploration into the significance of the site. His works, which vary in scale or support, may be sited in museums, in commercial galleries, in the street or in a domestic space; he is interested in how the site itself influences the viewer's experience and understanding of the work. For Buren the use of a standardized motif in many different situations was to be understood as a single work in progress, a conceptual work that could never be seen in its entirety, a work that is both site-specific but generic, anonymous but instantly recognizable as 'a Buren'.

Just as his 'paintings' have evaded the conventional categories, so in this print Buren has resisted traditional definitions of an edition. This is an installation print comprising twenty-five sections, all originally part of a single print from a single plate bitten all at once in a tray of acid. Buren insisted that the stripe widths must vary by no more than a millimetre. This would have been impossible to achieve by painting them. Instead the printers bit the entire plate as evenly as possible and then cut a stencil to mask out the white stripes. This not only gave absolutely straight edges it also kept the stripes pure white: normally with an intaglio print the grain of the metal plate will hold some ink even where an unbitten area has been wiped clean. Buren then took this large print and cut it into twenty-five equal-sized squares to be framed individually. Having decided the size of the frame moulding, he cut down each square so that, when framed and re-grouped edge to edge, the fragments together were the same size as the original sheet. Buren also provided precise instructions for the installation of the work: the fragments can be hung on a wall of any size but must be arranged in an even grid extending to all four corners, and always in the same position relative to the others. When any obstructions on the wall – windows, doors, sockets, switches – occur where a fragment should be hung then that fragment must be omitted. These instructions are the only element of the work to be signed by the artist, and if 'the work is not installed as described … the artist considers the work neither completed nor authentic.'[88]

GS

Fragment R. Detail of *Framed/Exploded/Defaced* 1979 (edition number 19/46) E.147r–1981.

Frank Auerbach (born 1931)

R.B. Kitaj, 1980

Printed by Terry Wilson at Palm Tree Editions. Published by Bernard Jacobson Ltd

Signed and dated in pencil *Auerbach 80*. Inscribed with the name of the sitter and numbered *42/50*. Blind stamped with the printer's mark

Etching in black and grey from two plates

Size of platemark 15 x 13.5 cm; size of sheet 40.4 x 34.4 cm

E.587-1980. Purchased 1980

BEST KNOWN AS a painter and draughtsman, Auerbach has so far turned to printmaking only seven times in the course of his career. Yet the essentially linear quality of etching seems to create, in his hand, an electrically charged geometry that is absolutely in keeping with the rigorous energy of his other work.

As well as being dedicated to making transcriptive copies from the Old Masters (the National Gallery is a favourite haunt of his), Auerbach prefers to depict friends, or landscapes with which he is intimately familiar. Within this range subjects are frequently examined through a multitude of variations. For his painted portraits his sitters often return again and again for months, posing for a single image which nevertheless metamorphoses countless times in the making. Friendship allows persistence and a degree of re-working which a stranger might find too strenuous. Auerbach believes that, if you know a subject outside and beyond the moment at which you are describing it, you have a huge advantage. With people, you know the way they move, hold themselves, their interests and concerns; all these factors inform the way you construct their image.

Auerbach and Kitaj had known each other for many years, and theirs was a relationship of mutual admiration and respect. Here, Auerbach describes the craggy geology of Kitaj's head through two independent portraits, drawn from different angles but designed to be put together, subtly conveying latent movement. The two metal plates on which they were drawn were independently bitten (etched) with different acids. The effect echoes, but does not entirely duplicate, that found in two of Auerbach's landscapes of the mid-1970s, where a rather delicate etched line lies beneath a much stronger, brush-like, screenprinted one.

Although Auerbach is known to have used some rather unconventional tools and materials in his intaglio prints – for example, a nail sealed into a penholder for a group of drypoints made in about 1954, and a Japanese screwdriver from Woolworths for incising a group of portraits of 1989 to 1990 – the etchings made between 1980 and 1981 rely on more normal tools. The first of these, a portrait of the artist Joe Tilson, was made when Tilson invited several friends to stay at his house in Wiltshire, intent on getting them all to make etchings. Tilson provided all the equipment and etched the plates, while his son Jake proofed impressions. Despite the fact that print was not his favoured medium, Auerbach seems to have found the experience rather inspirational, and went on to make a further five portrait heads within the next year. Although he then temporarily abandoned the medium, he took it up again in 1989.

RM

Georg Baselitz (Georg Kern) (born 1938)

The Eagle, 1981

Signed with the artist's initial and dated *B 81*. Signed and dated in pencil *Baselitz 20 XI 81*

Woodcut

Size of printed surface and sheet 64.7 x 49.8 cm

E.945-1983. Purchased 1983

Born Georg Kern in Deutschbaselitz in Saxony, Baselitz was expelled for 'socio-political immaturity' after only a term at the School of Fine Arts in East Berlin, and moved in 1956 to West Berlin, where he adopted the name of his birthplace. Like his close associate A.R. Penck, he rebelled against the dominance of abstract art during the 1960s, developing an expressive and personal figurative style with roots in earlier German art and history. From 1969 Baselitz took to depicting subjects upside down, seeking by this means to stress the form and surface of motifs, rather than their subject matter. He has argued that 'art contains no information, at least no more than it has always contained; it cannot be used for anything else than looking at',[89] and 'the reality is the picture; it is most certainly not in the picture'.[90]

Baselitz has long been fascinated by birds and animals, and in 1966 moved to live in the countryside. In 1971–2 he painted a large painting of a majestic eagle in flight, returning to the subject a decade later with a series of twenty-five separate engravings, aquatints, linocuts and woodcuts of eagles. This subject is highly potent in German mythology and political culture: the traditional symbol of imperial Germany, as well as the emblem of the present-day Federal Republic. The deliberately rough handling of the woodblock – seemingly hacked with a cleaver, rather than expertly carved with a block-cutter's knife – recalls the art of earlier German Expressionist artists, such as Emile Nolde and Ludwig Kirchner. And yet Baselitz affirms: 'When I make my paintings, I begin to do things as if I were the first, the only one, as if none of these examples existed.'[91] This woodcut was printed by the artist's wife Elke as part of a portfolio of twelve prints in various media by the leading German painters Antonius Höckelmann, Jörg Immendorff, Per Kirkeby, Markus Lüpertz and A.R. Penck, as well as Baselitz. It was published in Munich in 1982.

ME

139

Howard Hodgkin (born 1932)

Bleeding, 1982

Published by Bernard Jacobson

Signed with the artist's initials and dated in pencil *H.H. 82* and numbered *25/100*

Colour lithograph printed by Judith Solodkin and Cinda Sparling at the Solo Press, New York, with hand-colouring applied by Cinda Sparling

Size of printed surface and sheet 92 x 152.5 cm

E.99-1986. Purchased 1986

... les vieux jardins reflétés par les yeux ...
(old gardens reflected in the eyes)
Stéphane Mallarmé, *Brise Marine* (Sea Breeze)[92]

Howard Hodgkin's paintings and prints evoke private moments memorable for crisis or pleasure. Perhaps both are present here. The *mise-en-scène* is a Manhattan apartment hung with four very large Indian painted-cotton panels. We can make out, as if in a reverie, the repeated motif of a flowering tree. This symbol dominated chintz designs made on the Coromandel Coast for the European market in the eighteenth century. Hangings of this kind are among the prime exhibits in the V&A's Nehru Gallery. They are exuberantly painted and dyed, with fantastic fruits and flowers and countless infill design inventions. Hodgkin has had a long-standing love affair with the paintings and applied arts of the Indian subcontinent (of the kind just described), which have many parallels with his own work – exuberant, fantastic and with countless inventions.

Working closely with skilful studios, Hodgkin has found ways to give printmaking much of the charge, energy, complexity and life of his paintings. The lithographic process required Hodgkin to draw on a separate acetate sheet for each colour – a much more programmatic method than his procedures as a painter. The prints are enhanced by hand-colouring applied in accordance with the artist's indications. He demonstrated to Cinda Sparling of Solo Press the kind of marks required – but she then applied the paint in her own way, repeating the gestures for all the prints in the edition. The print surface becomes a vibrant physical arena, alive with marks that are variously brushed, drawn, dripped, scuffed and swirled. There are stately oblongs of colour that could have floated out of late Matisse; there is a subtlety of execution reminiscent of the monotypes of Degas; there is a trust in the sensations of private life that relates Hodgkin not only to the passionate Intimistes, Bonnard and Vuillard, but also – behind them – to the poems of Mallarmé with their subjective interiors and startling imagery.

Here the bruised colour of ox-blood veils a magical garden of Indian reds and pinks, counterpointed by the freshest garden greens. Fiery colours glint beneath darker overlays, like a psychological encounter we can sense and share but never fully grasp nor explain. Like Mallarmé, Hodgkin set himself an almost impossible and exhilarating task: 'Peindre, non la chose, mais l'effet qu'elle produit' (Paint not the thing, but the effect that it produces).[93]

MH-B

141

Hamish Fulton (born 1946)

Humming Heart, 1983

A work in three parts, each part on a separate sheet. Printed by Editions Media, Neuchâtel, Switzerland. Published by Waddington Graphics

Signed in pencil and numbered on E.1491b *Hamish Fulton 12/60*. Each sheet printed with caption (E.1491: *Humming Heart*; E.1491a: *Cloud Rock*; E.1491b: *Dust to Snow to Dust. A twenty day walking journey from Dumre to Leder in Manang and back to Pokhara by way of Khudi, Nepal 1983*) and blind stamped with the publisher's mark

Photogravures printed in brown, circular plates on rectangular sheets, the lettering screenprinted in red and black

Size of sheets each 61 x 47.4 cm

E.1491, 1491a, 1491b-1984. Purchased 1984

HAMISH FULTON, LIKE his contemporary Richard Long, has focused his creative and imaginative energies on walking. He has written: 'My artform is the short journey – made by walking in the landscape.'[94] Unlike Long, he makes no deliberate interventions in the landscape. He takes photographs in the course of a walk or produces a text describing the walk, and his accompanying observations and emotions. His art celebrates and continues the nomadic tradition, an intimate physical but non-possessive relationship with the land. The journey itself is a kind of meditation, a way of freeing himself from 'urban thinking' and making contact with other levels of perception through a direct experience of a landscape and the elements.

Every work is a response to a specific walk. *Humming Heart* is a three-part work about a walk in Nepal, and the three images are intended to commemorate the journey in all its dimensions. The circular images, which suggest the lens of a camera or telescope, present the distant view, the foreground and the detail; the last – a single footprint – is an apparent reference to Fulton's belief that 'the only things you should leave [in the landscape] are footprints' and that only photographs should be taken away.[95] As in Richard Long's print (see p.148), the footprint is a simple emblem for the making of the work as a whole. The texts that form part of the work, as both captions and content, are characterized by a poetic economy –

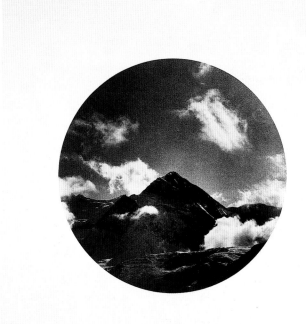

H U M M I N G
H E A R T

precise and simple, yet ambiguous and evocative. Though it draws on a specific personal experience, *Humming Heart* also acknowledges Nepal's wider reputation as a place of spiritual pilgrimage.

The sepia-toned photogravure prints are self-consciously anachronistic – photogravure is an ink-printing process popular in the late nineteenth century. Then its chief commercial use was for art publishing, but it was also favoured by the pictorial photographers of the period, such as P. H. Emerson, for its 'subtlety and delicacy'.[96] In the twentieth century photogravure has often been adopted by artists, like Fulton, who use photographic imagery but would not call themselves photographers. For Fulton the photograph is sim-

ply a record, not only of the place itself but also of his mood and the experience of the walk. He has said: ' I don't use a photograph unless when I took it I was feeling clear and good.'[97] In other words the moment of taking the photograph is more important than any technical proficiency or the quality of the negative produced. In this case the photogravure process enhances the prints, but also links Fulton to the nineteenth-century peripatetic photographers and the opening up of the Far East to Western travellers.

GS

CLOUD

A TWENTY-DAY WALKING JOURNEY FROM DUMRE TO LEDER IN MANANG AND BACK TO POKHARA BY WAY OF KHUDI NEPAL EARLY 1983

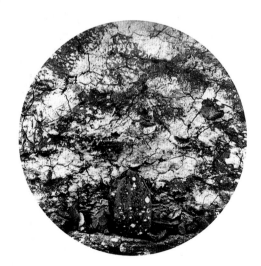

ROCK

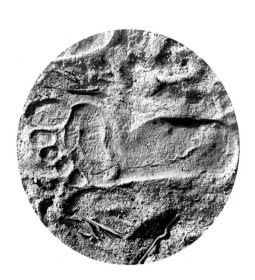

DUST TO SNOW TO DUST

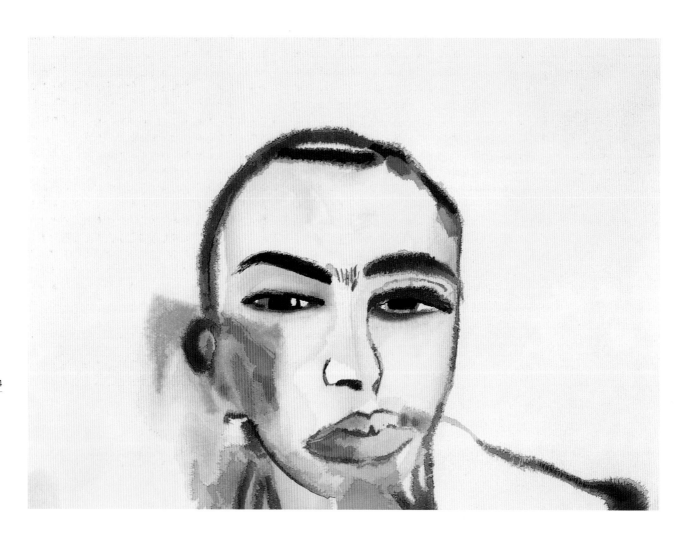

Francesco Clemente (born 1952)

Untitled (self-portrait), 1984

Printed by Tadashi
Toda, Shin-un-do Print
Shop, Kyoto. Published
by the Crown Point
Press, Oakland,
California

Signed in pencil
Francesco Clemente
and numbered
138/200. Blind stamped
with the publisher's
mark

Colour woodcut on
Tosa kozo paper

Size of printed surface
36 x 51.1 cm; size of
sheet 42.8 x 57.4 cm

E.427-1985.
Purchased 1985

CLEMENTE'S SELF-PORTRAIT offers us an exquisite deception, a virtuoso exercise in pushing the boundaries of a medium to the limit, confounding the viewer's expectations. The thin veils of colour, with the bleeding and puddling of watery washes, lead us to assume that we are looking at a watercolour painting. In fact it is a woodcut, a method of printing usually associated with a linear style and hard-edged blocks of colour (as used by Edvard Munch and the German Expressionists), rather than with the softness, transparency and fluidity we see here. To create this paradoxical print, Clemente worked with Kyoto's master block-cutter, the eighty-year-old Reizo Monjyu. The print was made in the traditional Japanese *ukiyo-e* manner: dozens of lime-wood blocks, with fourteen transparent pigments, were expertly superimposed and printed in forty-nine stages for each impression. By this painstaking method the fluent improvisatory style characteristic of Clemente's watercolours was captured and fixed.

Clemente is one of a group of Italian artists who emerged in the late 1970s as part of a European-wide revival of Neo-Expressionist figurative painting. The Italians also shared an interest in historical production processes – Clemente, for example, painted in fresco. This beautiful print was made while Clemente was artist in residence in Kyoto in July 1984. Not only does it use traditional printmaking techniques but it is also an exemplary demonstration of the collaborative nature of much fine-art printmaking, where the artist depends on the complementary technical skills of others such as the block-cutter and the printer to realize his ideas.

GS

Helen Chadwick (1953–96)

Vanitas, 1985

Installation comprising
photocopies on board
and engraved
Venetian glass

Size of board
240 x 290 cm; size of
glass 30 x 15 x 2 cm

Photographic credit:
Edward Woodman

Ph.783-1987.
Purchased 1987

Thy glass will show thee how thy beauties wear
(Shakespeare, sonnet 77)

HELEN CHADWICK WAS one of the most inventive installation artists from the late 1970s until her untimely death in 1996. *Vanitas* comprises two elements. The first is a large panel divided into a black half and a blue half. The black (left) half is hung with the photocopied and collaged image of curtains in tatters held back by a skeletal arm and hand. On the blue (right) half, fine curtains are held by a youthful, female arm. The arm is adorned with bracelets and the hand with finger-rings. In the centre, half black and half blue, is the replica of a hand-mirror, also made with a photocopying machine. The second element, hanging opposite the first at average eye-height, is the original hand-mirror. It is engraved with eyes weeping tears, based on a photograph of the artist's own eyes. (Chadwick had the mirror, with its frivolous kitsch frame, engraved in Venice especially for this work.) When a spectator gazes into the mirror, he or she is visually enveloped by the perfect and the ruined curtains – by present life and future decay.

Helen Chadwick used a Canon office photocopying machine in her studio in 1985–6 to make the works *One Flesh* (1985), *Vanitas* (1986) and *The Oval Court* (1986), all of which are in the V&A collection. She was attracted to photocopying because the technique made her independent – a prior collaboration with a photographer had ended badly. The machine she used had a toning device that enabled sheets to be coloured red, blue, green, purple, etc. Chadwick produced a pamphlet about *Vanitas* in which a text she wrote herself appears. It begins: 'Art like crying / an act of self repair / to shed the natural tears / that free us / make us strong ...'

Chadwick gained inspiration from many sources, for example the paintings of the Mexican artist Frida Kahlo, seventeeth-century Dutch *Vanitas* paintings, and the *gesamtkunstwerk* (or total work of art) she found in the Rococo pilgrimage churches of the South Tyrol. She greatly admired the rich collections of the V&A. She had visited the Print Room to examine designs for rococo silks by Anna Maria Garthwaite on the very day of her sudden death at the age of forty-two. It now seems uncanny that so many of her works address the theme of mutability.

MH-B

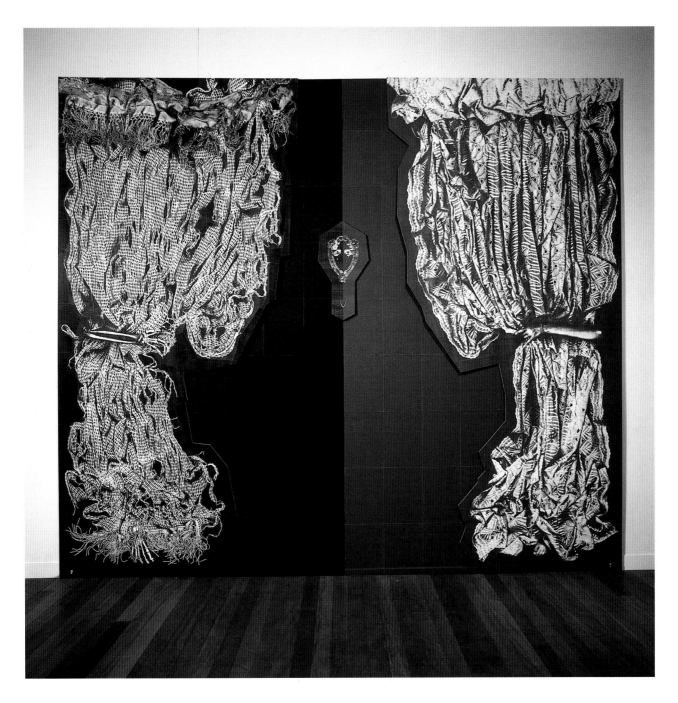

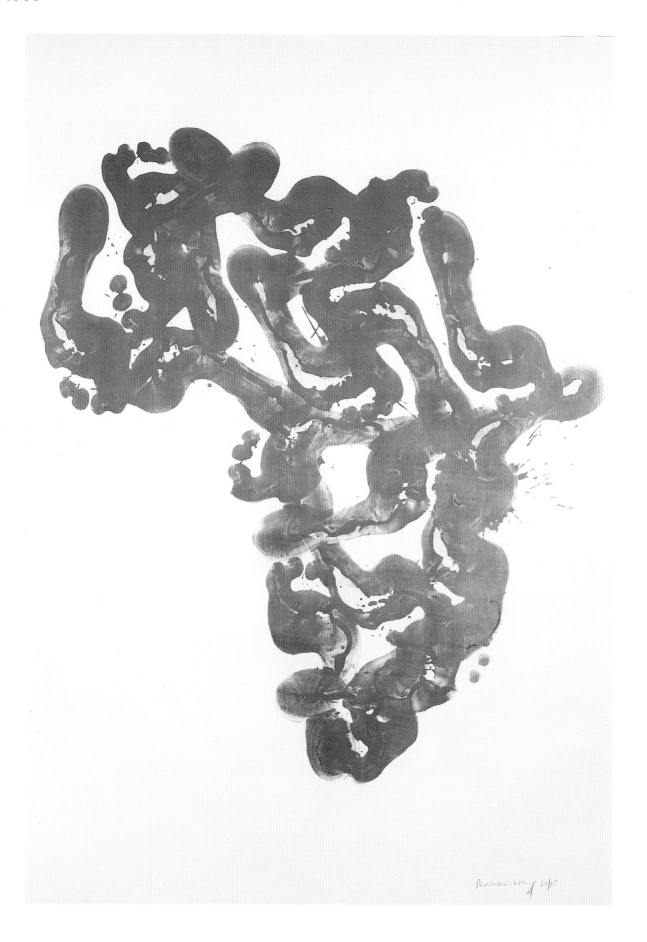

Richard Long (born 1945)

Africa Footprints, 1986

Printed by Cotswold
Collotype. Published
by Victoria Miro
Gallery

Signed in pencil
Richard Long and
numbered *68/75*

Collotype of mud
prints from the artist's
feet, printed in brown

Size of sheet
100.9 x 71.5 cm

E.340-1986. Purchased
1986

RICHARD LONG IS usually categorized as a sculptor, and he regularly exhibits works that use the forms and vocabulary of sculpture. However, the walk is his characteristic medium and his invariable starting point. He has made walking itself into a form of sculpture. One of his first works was *A Line Made by Walking England 1967*, a visible track in the grass made by walking back and forth across a field. Since then Long has walked in many countries, and represented the evidence and experience of walking in the form of photographs, annotated maps and lists of sights, sounds and sensations. He has explained: 'A walk is a line of footsteps, a sculpture is a line of stones. They're interchangeable and complementary. For me walking can liberate the imagination.'[98]

This print, in which the shape of the African continent is marked out by the artist's muddy footprints, was produced and published for a charity appeal to raise funds to alleviate famine in Africa. At the time he produced this image Long had already made two walks in Africa (Malawi 1978, Morocco 1979). It echoes not only Long's walking but also his gallery-based work. In 1985 he had made *Mud Foot Circle*, his own footprints in River Avon mud on a board. This strategy of making wall or floor drawings with prints of his hands and feet has continued to be a feature of his work. However, these pieces are usually site-specific and temporary; by using the photographic process of collotype here, he has fixed these inherently fugitive marks, while giving the illusion of a direct unmediated body print.

Walking, often barefoot, is the commonest means of travel in Africa. The path or track has a significance in all cultures because of its function as a channel of communication, of cultural exchange, of contact and connection between individuals and communities. We might also see this symbolic representation of walking as a reference to Africa as the cradle of human life: the famous hominid remains in Tanzania's Olduvai Gorge include a sequence of fossilized footprints. Thus Long's footprints are not simply the unique trace of an individual but a universal symbol of mankind.

GS

Peter Howson (born 1958)

The Heroic Dosser, 1987

Signed and dated in pencil *Howson '87*. **Inscribed in pencil with title and numbered** *23/30*

Woodcut on two sheets, joined

Size of printed surface 177.2 x 116.7 cm; size of sheets, joined 182.3 x 121.3 cm

E.970-1990. Puchased 1990

I N 1987 PETER Howson worked from a studio in the Gallowgate area of Glasgow close to a hostel for the homeless and to The Saracen's Head Inn – the oldest pub in the city, built in 1755 on the site of an old leper's hospital. This exposure to the street life of Glasgow, combined with time spent in the army and as a bouncer, provided him with a cast of characters – brooding men, boxers, dossers, derelicts, drinkers, squaddies – which he has incorporated time and again in his work. *The Heroic Dosser* is a subject that Peter Howson has produced in a variety of different media, first as an oil painting, then as a charcoal drawing, a screenprint and a woodcut. He utilizes the different media as a means of developing and discussing the themes that interest him.

This version is one of three large woodcuts (the others being *The Lonely Hero* and *The Noble Dosser*) made at and published by the Glasgow Print Studio. As well as a development of a favourite theme, these prints were an attempt to produce woodcuts on a scale not normally found in this medium. Here Howson uses the form to create a dark and brooding image of the dosser silhouetted against the night sky. The man rests on a rail, apparently supporting a building that rises above him – the symbolic representation of a heroic figure carrying the weight of the world on his shoulders, a tower of strength despite his downtrodden situation. The size of the woodcut allows Howson to use large, almost brutal incisions that add to the emotional atmosphere of his subject. Peter Howson's work of the late 1980s was representative of a trend towards figurative art with a social and political content. It led to his being commissioned to record the war in Bosnia in 1992.

SC

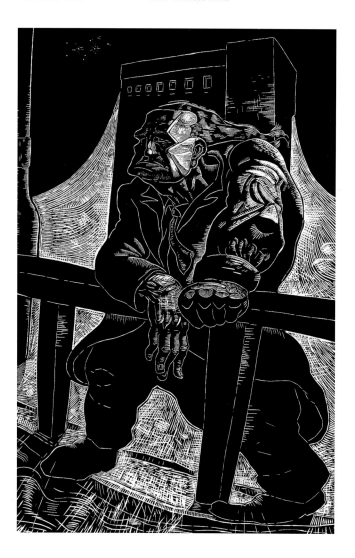

Anish Kapoor (born 1954)

Untitled, 1988

One of a pair printed
by Lawrence Hamlin
at, and published by,
Crown Point Press,
Oakland, California,
1988

Signed and dated in
pencil *Anish Kapoor
1988*. Numbered
6/20(II). Blind stamped
*Crown Point
Press/Lawrence J.
Hamlin* and with the
Crown Point Press logo

Aquatint printed in red
and black on Arches
Cover Paper

Size of platemark
113.2 x 89.6 cm; size of
sheet 134.8 x 106.9 cm

E.1884-1992.
Purchased 1992

MANY OF THE finest intaglio prints acquired by the Museum over the last two decades have been produced at Crown Point Press, since the 1960s one of the most stimulating workshops in the US. In an era when artists are increasingly turning their backs on traditional printmaking techniques to work with video, laser and computer-aided print, Crown Point proves that tradition still generates innovation. This image, one of a pair, clearly shows the medium of aquatint, offering translucence, variable depth and intensity, a perfect vehicle for Kapoor's concerns.

Speaking in 1991 of his experiences as an Indian working in Britain, Kapoor says that only after leaving college did he recognize that he was in any way different from his peers. A brief but crucial trip to India helped him to find the material with which to work. He explained in an interview with Marianne Brouwer:

I'm not talking about a physical material, but an emotional, mental material something to do with light and more than anything else with earth. In India there is an incredible romanticism about the earth as giver, nurturer, mother, like there is about the rain. The two go togeth- *er. Culture seems to spring directly from the earth instead of from the mind. When you talk about colour for instance, it's not an abstract phenomenon, it's a phenomenon of the earth, like a functionary of abundance. Inevitably light ties into that. Fundamentally everything seems to be about dichotomy, opposition, polarity ... [But] I am not setting out to make Indian art. I am setting out to make as deep and meaningful art as I can. Irrespective of whether I am Indian or not. At the same time, I will not refuse from myself that which is Indian. And if those who look at my work find that a stumbling block, they must educate themselves.*[99]

As this print exemplifies, Kapoor explores a whole range of dualities and contradictions: entry and exit; vagina and phallus; blood and fire; earth and water; fearful chasm or entry to sexual bliss. Such themes do reflect Kapoor's Indianness but also symbolize emerging ambivalences within the fusion of European, Asian and African identities in Britain in the 1980s.

RM

Paula Rego (born 1935)

Three Blind Mice, 1989

Printed at Culford
Press, London, and
published by
Marlborough Fine Art

Signed in pencil *Paula
Rego* and numbered in
pencil *30/50*. Blind
stamped *CP*

Etching and aquatint

Size of platemark
21.1 x 22.6 cm;
size of sheet
52.5 x 37.9 cm

E.285-1990.
Purchased 1990

Three blind mice, see how they run!
They all ran after the farmer's wife,
Who cut off their tails with a carving knife,
Did you ever see such a thing in your life,
As three blind mice?

IN 1965, JUST as she was beginning to earn recognition in the Portuguese and British art worlds, Paula Rego explained that she drew 'inspiration from ... caricature, items from newspapers, sights in the street, proverbs, nursery-rhymes, children's games and songs, nightmares, desires, terrors'[100] – an array of material that by its very nature would not be exhausted quickly. Indeed, it was nearly twenty-five years before Rego was to revisit the English nursery rhymes of her bi-lingual childhood with a series of etchings produced in honour of her infant grand-daughter; these were exhibited at the Marlborough Graphics Gallery in London in 1989. This print, *Three Blind Mice*, was the one chosen for acquisition by curators at the V&A.

In this illustration we find the farmer's wife standing over the three groping rodents, two already dealt with and one to go. In spite of the anguish on her face, she resolutely holds the severed tails in one hand and the knife in the other, suggesting that her purpose is stronger than her fear. But while these details are sufficient to illustrate the literal events described in the text, Rego clearly understood that, far from being nonsense verse composed for children, English nursery rhymes are often centuries-old lessons in human fallibility; moreover, as her accompanying illustrations reveal, they could have a dark and provocative sub-text. This understanding – coupled with the fact that she had already spent much of the 1980s exploring the male–female power struggle in paintings of anthropomorphic, pantomime-like animals – leaves little doubt that *her* three blind mice represent grown men. Indeed their crime may be a sexual one: possibly that of 'running after' a married woman. Looking closer still, we may even begin to see why some critics have argued that a gruesome castration is the punishment Rego really intends.

MG

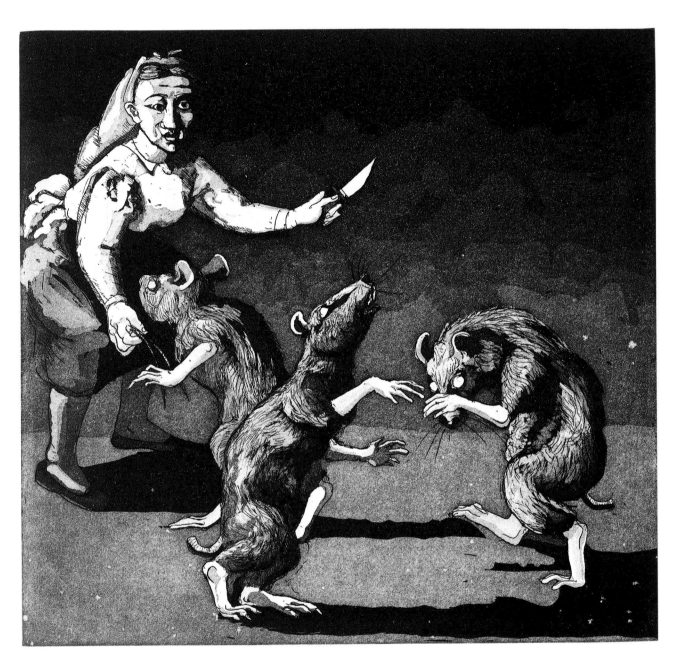

Antony Gormley (born 1950)

Untitled, 1990

From a portfolio entitled *Body and Soul.* Printed by Hope Sufferance Studios, London, and published by the Paragon Press, London, 1990

Signed and dated on the back in pencil *Antony Gormley '90* and numbered *30/30*

Soft-ground etching

Size of platemark 30 x 40.5 cm; size of sheet 50 x 58.2 cm

E.1591-1991. Purchased 1991

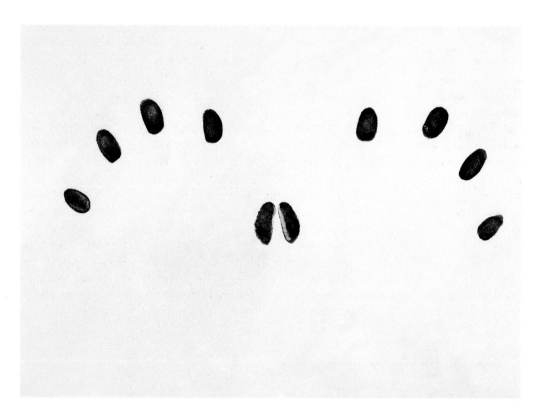

As a sculptor, Gormley's starting point is the human body, usually his own. Many of his characteristic lead and concrete figures are generated from casts of his own body. When he began working on a print project at the Hope Sufferance Studios in 1990, he experimented with different techniques and various methods of mark-making. His first efforts were drawn images, but, noticing his thumb prints at the edges of the soft-ground etching plates, he was inspired to make marks with parts of his body, dispensing with the etching tool altogether. The result of this new method was a series of enigmatic images from which he selected nine for the *Body and Soul* portfolio: five of the artist's orifices (mouth, nostrils, anus, penis and ears), plus his hands, knees, forehead and spine. The prints of the non-orifice body parts are printed in black on a white ground, but for the orifice prints the area surrounding the mark itself was aquatinted, so that the image appears predominantly white on a black ground. To the latter he also added a series of fine engraved lines radiating out from the centre. The black prints suggest the interior of the body, with the white area – the orifice – as an opening to the outer world. Gormley may have intended this to evoke his experience of being enclosed within a plaster or latex cast, with only tiny apertures left for air. He has described the dark plates as offering 'a vision of the inner realm of the body irradiated by what Blake called "the windows of the soul"'.[101]

For Gormley this set of prints is an important part of his oeuvre, the graphic equivalent of his practice as a sculptor. Rather than re-presenting our experience of the world through modelling or drawing, he connects directly with the physical by employing the body as both image and tool. In this way he induces in viewers a consciousness of their own corporeal reality. The impression of the mouth brings to mind suckling, kissing, sighing, speaking; the splayed fingertips suggest holding, caressing, moulding, making. For the artist, these prints – of the exterior and interior of the body – represent the unity of body and soul.

GS

Ruslan Kotev (born 1956)

The Tower of the Tempest, 1991

Artist's proof

Signed and dated in
pencil *Ruslan Kotev
'91*. Dated again
within the plate
6.9.1991. Inscribed in
pencil with title and
E A (Epreuve Artiste),
and numbered *9/10*.
Blind stamped in
Cyrillic with the artist's
initials

Etching

Size of platemark
28.9 x 21 cm; size of
sheet 38.8 x 32 cm

E.499-1996. Given by
Ekaterina Ovcharova,
in gratitude to Michael
Kauffmann

REJECTING WHAT HE felt to be the suffocating bureaucracy of the Fine Arts Academy of Bulgaria, Ruslan Kotev apprenticed himself for two years to the printmaker Dan Tenev and learnt his craft in isolation with his master in the manner of a medieval artisan. He explained: 'You cannot learn graphics from looking at prints; you can only learn from one-to-one contact, from watching somebody work. Dan Tenev gave me not only knowledge, but all the encouragement you need to understand your personal inner imagery trying to get out.'[102] Kotev's highly 'personal inner imagery' draws upon the visual language of the Italian architectural *capriccio*, or imaginary conceit, as well as on Bulgarian folklore and religious iconography. The composition of *The Tower of the Tempest* recalls the biographical icon, where a central devotional image is surrounded by a narrative border depicting scenes from a saint's *vita* (life) and miracles.

While Kotev avoids explicit allusions and resists literal readings of his work, the artistic imagination of Eastern Europe does seem haunted by the failed utopias of the twentieth century. If Vladimir Tatlin's *Monument to the Third International* of 1919–20 may be understood as the tower of revolution and Boris Iofan's 1936 proposal for the *Palace of the Soviets* as the tower of totalitarianism, Kotev's *Tower of the Tempest* is an apt symbol of the collapse of the Communist system in Europe. The year 1991 saw the formal dissolution of the neighbouring Soviet Union, the Warsaw Pact and its economic arm COMECON; in Bulgaria itself, after mounting political protest, free elections were eventually won by the UDF (Union of Democratic Forces), and the deposed Communist leader Todor Zhivkov was brought to trial on charges of corruption.

TT

155

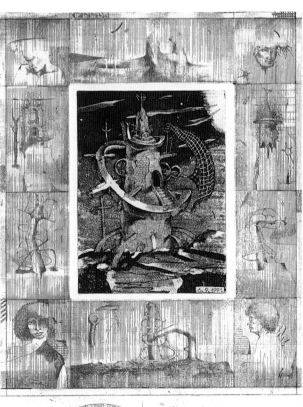

Chris Ofili (born 1968)

To T from B with L, 1992

Plates (4) from a suite of 10 etchings each signed Ofili and again in pencil with the artist's initials CO and numbered 1/10

E.681-1993 inscribed *View from Top Sagrada Familia* **and dated** *15/12/92*
E.682-1993 inscribed *Tibidabo* **and dated** *16/12/92*
E.684-1993 inscribed *Güell Park* **and dated** *18/12/92*
E.686-1993 inscribed *Barrio Chino* **and dated** *19–20/12/92*

BY COMPARISON WITH Ofili's large, colourful, often maverick paintings, these etchings appear modestly quiet. Yet, in a discreet way they, too, bring together elements of the pornographic, the religious and the popular. They are made up of tiny repeated marks, a technique of inventive appropriation, which also characterizes his paintings.

Born of Nigerian parents in Manchester, Ofili had his first direct experience of any African country when he travelled to Zimbabwe in the summer of 1992. He was intrigued by the cave paintings he saw there and, on his return to Europe, began to emulate the technique used to create them. The following winter, while still a student at the Royal College of Art, Ofili visited Barcelona. Every day, he armed himself with a prepared etching plate and found some conducive spot in the city. Familiarizing himself with the 'landscape', he then applied his total attention to his etching plate. With a mantra-like repetition of the fleck-like strokes, he worked without stopping to look up, rest, eat or drink until it was finished. His aim was to reach the same self-induced semi-hallucinated state perhaps experienced by the African cave painters.

The result was an extraordinary diary of his ten-day visit. Despite the fact that he barely looked at

Etchings

Size of platemarks
respectively 24.5 x 20,
25 x 19.8, 25 x 19.5,
24.5 x 19.9 cm; size of
sheets respectively
37.8 x 28.9, 37.8 x 28.9,
37.7 x 28.2, 38.3 x 29 cm

E.681, 682-1993; pur-
chased 1993. E.684,
686-1993; given by the
artist

the view that he was recording, there is an undeni-
able sense of place in each image. His *Barrio Chino*,
Barcelona's red light district, evokes the twisting
narrow streets and the figures hovering on many
corners, around a core suggesting the sexual act
itself. In *Tibidabo* the famous church is evoked in a
delineation of a *Pietà* – the dead Christ across the
Virgin's lap. *Sagrada Familia* presents a view from
the top of one of the cathedral's high towers, look-
ing down onto a map of treetops and streets. As a
suite, the prints suggest remembered images of
Western art, as well as being a personal emotional
response to each place.

The images can be construed as a complex mix
of cultural cross-currents – Renaissance sculpture,
Baroque architecture, Benin carving, Zimbabwean
cave painting, Cubism, Expressionism and Art Brut.
As Lisa Corrin remarks, Ofili 'lays no more claim to
an African inheritance than he does to the tradition
of American or European painting'.[103] His refresh-
ing portrayal of a European city through a
deliberately Afro-centric eye is an entertaining yet
powerful reminder of changing cultural perspec-
tives at the end of the twentieth century.

RM

Anonymous, after Barbara Kruger (born 1945)

Carrier Bag from the Barcelona Department Store, Vinçon, c.1993

Offset half-tone line block, printed in red, grey and black

48.3 x 44.6 x 16 cm (with handle, 58.6 cm)

E.2830-1995. Given by Merryl Huxtable

Barbara Kruger, who began her career as a graphic designer working on magazines, has developed a distinctive method that brings together the language and the strategies of advertising, propaganda and art to explore the nature of each and the extent to which they resemble and exploit each other. Kruger's work is informed by her earlier experience as a graphic designer; she works with images appropriated from films and advertisements which she then modifies and overlays with text to mimic the admonitory voice of authority or the seductive voice of advertising. Indeed, her work often takes the physical form of an advertisement and has appeared as posters on billboards and bus shelters, and in subway trains. The bald tabloid typeface and the dramatic black and white images framed in red became Kruger's trademark style – the aggressive methods of the market-place used both to promote and to subvert. Kruger's concerns and strategies are typically Post-modern, and Post-modernism has consistently stressed the commodity value of art, as opposed to the aesthetic value, an idea that is also explicit in the work of several other American artists, notably Andy Warhol and Jeff Koons.

This carrier bag was produced for a Spanish department store. Kruger has often marketed her ideas and her images in non-art contexts, and has produced or licensed products that are affordable, ephemeral and functional. Thus the image on the bag has also appeared as a postcard and on T-shirts. The image is a reproduction of Kruger's 1987 photo-collage *Untitled* (*I shop therefore I am*), a radical re-working of Descartes' famous proposition 'I think therefore I am'. This was one of a series of works in which she addressed the topic of money and the pervasive ideas generated by a consumer society. Kruger's observation that contemporary materialism has led us to be defined primarily by our habits of consumption is given a characteristically ironic slant by its appearance on a shopping bag. The image itself and its implicit message have thus become part of the circular exchange that now characterizes the relation between consumer culture, advertising and fine art.

GS

158

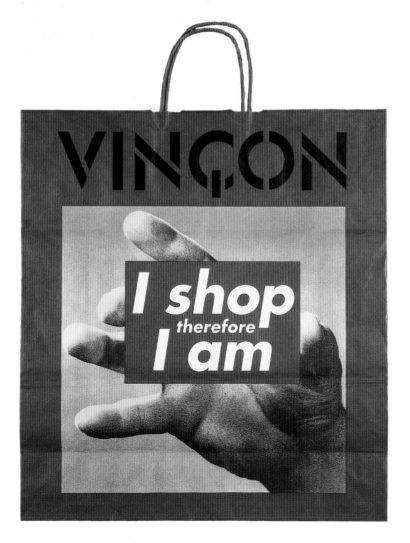

Renée Green (born 1959)

Untitled, 1994

Wall covering for the installation *Taste Venue*. Printed at the Philadelphia Fabric Workshop and first shown at the Pat Hearn Gallery, New York, 1994

Screenprint in red on cotton voile, on paper support

Width of roll 143 cm; length of drop approx. 457.5 cm

E.2320-1997. Purchased 1997

RENÉE GREEN'S FABRIC, conceived to cover a variety of surfaces, including the human body in the form of a costume, relies totally on the recognition of an authentic historical model for its effectiveness. Working with objects themselves, rather than images of objects, Green seeks to subvert the language they speak – domestic, economic, intellectual and so on – to induce a recognition of the power they wield: if there is only one 'language', whether verbal or visual, available to a particular society then all members of that society are bound to perpetuate it – unless they dare to create a new one. The perpetuation is manifest in many complex and subtle ways – for example the appropriation of particular types of architecture and buildings to house museums and colleges, or the appropriation of particular types of furniture and furnishing to suggest social or intellectual class. To present alternatives is to open up new possibilities of morality, authority and truth.

Green's concerns are often to do with the way racism has become an almost inextricable part of cultural history through language, nomenclature and classification. From a distance the design of this fabric is no different from the familiar eighteenth-century Rococo pattern of cartouches framing girls on swings and courting couples. Closer inspection, however, offers up different scenes, carefully researched by Green in other very much less familiar printed forms and transferred to replace the originals. The couple at the table are discussing an important legal document barring miscegenation, known as the *Code Noir*; the lynching scene derives from the San Domingo revolution of black slaves, famously led by the historic figure of Toussaint l'Ouverture; while the black nun is the heroine of a little known early nineteenth-century French novel, *Ourika*, about a Senegalese girl expelled from the domain of her patrons for falling in love with their heir.

The Philadelphia Fabric Workshop, where this wall covering was printed, began life as a charitable organization to offer learning and production opportunities to the local community. It developed a project with artists in the mid-1970s and since then has maintained an outstanding programme of commissioned work, encouraging artists to expand into new and possibly undreamt-of ways of working.

RM

Tayo Quaye (born 1954)

The Man, 1995

Signed, dated and
inscribed with place of
production *Tayo
Quaye Kaduna 1995*
and again in pencil
*Tayo T. Quaye,
Kaduna, Nigeria April,
1995.* Inscribed with
title, *Lino engraving*
and numbered *6/7*

Colour linocut on
Japanese paper

Size of printed surface
93 x 200 cm; size of
sheet 96.7 x 208.5 cm

E.455-1999.
Purchased 1999

TAYO QUAYE'S WORK comes out of a complex Nigerian tradition of Euro-centric art-school teaching (established in Nigeria since the 1940s) and a reassertion of indigenous approaches to visual imagery. The 'Natural Synthesis' theory (first propounded in the late 1950s by a group of artists at the Nigerian College of Arts, Science and Technology at Zaria) was, in the words of Nigerian art historian Chika Okeke, 'the merging of the best of the indigenous art traditions, forms and ideas with the useful Western ones.'[104]

Although the V&A has collected contemporary fine art prints from an international field since its foundation, the choice of sources has been influenced by changing political, economic and industrial developments, and by trade, migration and general cultural exchange. The Whitechapel Art Gallery exhibition *Seven Stories about Modern Art in Africa*, held in 1995, examined and exposed to a British audience artists from across the African continent in a way never previously dreamed of. Although representing only a fraction of what is happening in the visual arts in Africa today, it was important in introducing a British audience to the concept of modern African art. Catalogue texts sought to identify the how and why of national

character and African modernity and were helpfully informative on the links between African and European art history.

Quaye's work frequently addresses family relationships, and *The Man* is arguably his boldest, yet most finely drawn composition to date, elevating the concept of partnership between the sexes, with man being simultaneously part of, yet above, nature. It is a dynamic, powerful, yet delicate blend of African folkloric and mythical symbolism, with influences of a Western style evident in the drawing of the human figure. The print celebrates both humanity and nature on a highly ambitious scale (the image measures almost one metre in height by two metres in length).

Quaye's *The Man* makes a significant addition to the V&A's collection at a time of increasing multiculturalism in Britain, when there is growing interest by black and Asian as well as white communities in authentic work from African and Asian countries – particularly from those that have a strong connection with Britain.

RM

Tim Mara (1948–97)

Lightbulb and Book, 1995–6

Signed and dated in
pencil *Tim Mara
1995/6*. Inscribed with
title and numbered
7/25

Colour lithograph with
screenprint

Size of printed surface
and sheet
67.7 x 98.9 cm

E.670.4-1996. Given by
the artist

TIM MARA WAS Professor of Printmaking at the Royal College of Art, London, from 1990 until his death in 1997. His later work focused on everyday, seemingly banal objects presented on a large scale against a background of solid colour, and depicted with the startling clarity that his fabled technical virtuosity allowed. The effect was to lend them a special weight and presence: they were chosen for investigation not as designed products, or as vehicles of symbolic meanings and associations, but simply as objects 'that belong to all of us – not designer-objects where the designer should take the credit for it, but objects which have been refined by generations of use'.[105]

The hand and sketchbook represented in this image did indeed belong to the artist. Mara had a condition that caused the little finger gradually to tend toward the palm of the hand. On the right-hand open page of the sketchbook, the artist's record of the progress of his condition can be seen in the dated outline drawings of his finger. On the left-hand page there is a sketch of the chandelier that features in another work from this period. Some of the dabs of colour at the top of the page were applied to the print by brush. The self-referential nature of this work calls to mind Mara's expressed admiration for Velázquez's *Las Meninas*:

The painting has the painter in it, and the back of the canvas as well. So it is about its own construction. And it is saying 'this is only a picture', which helps the viewer to enter the pictorial language, to understand the conventions, and to be drawn into the artist's world. I always seem to be referring to Las Meninas *somewhere in my work.*[106]

TT

Virgil Marti (born 1962)

Bullies, 1992–7

Wallpaper produced at the Philadelphia Fabric Workshop

Fluorescent ink and rayon flock on Tyveck, with blacklights

Width of roll 138 cm; length 563 cm

E.277-1998. Given by the artist

IN THE LAST decade there have been many instances of artists designing wallpapers specifically for installations and exhibitions, rather than for the home. Wallpaper's role as a banal decorative backdrop to domestic life has made it the ideal medium for artists who wish to represent the home and everyday life within the neutral spaces of contemporary galleries, or as part of site-specific installations in non-art locations.

The *Bullies* wallpaper is a fluorescent flock, designed to be shown in a darkened room. The basis of the design is a floral pattern adapted from a French toile wallpaper. The faces of the teenage boys in *trompe l'oeil* frames were taken by Marti from the photographs in his junior high school yearbook. Seen in the dark, these faces lose their bright bland aspect and appear to loom menacingly from the walls. As an adolescent Marti was marked out as being different from his peers, most of them sports-playing 'jocks', and as a consequence he became a victim of bullying. By incorporating the faces of his tormentors – who may be real or imaginary – in the wallpaper design, he gives tangible form to the way in which darkness can magnify our fears or anxieties, exaggerating feelings which seem more manageable by day. The lurid fluorescent colours and blacklights give an intimidating emphasis to the imagined threat, and the space itself is transformed from the comforting familiar bedroom implied by the bright floral pattern to a claustrophobic arena for the imagination to run riot.

Flock wallpaper and floral patterns can be seen to represent conventional middle-class tastes and values. By integrating images of these aggressive adolescent males with wallpaper, Marti suggests that brutality and stereotypical male behaviour co-exist with – are perhaps even nurtured by – the ostensibly superior values of the middle-class home and a civilized society. In this context the masculine is seen to invade the home, traditionally identified with the feminine, and to overwhelm the delicate fabric of taste, order and civility.

Produced in an unlimited edition, as needed for exhibitions, artists' wallpapers blur the boundaries between fine art prints, commercial wallpapers and installation art. Drawing on the physical characteristics and potential meanings of each, they evade traditional categories to create a vigorous, richly inventive hybrid with the power to transform spaces and subvert the viewer's expectations.

GS

163

Sonia Boyce (born 1962)

Lover's Rock, 1998

Wallpapers (2) from a suite of 6 drops. Printed at Early Press, London, on paper supplied by Sanderson plc, 1998

Blind embossing

Width of rolls 56.2 cm; length of drops approx. 305 cm

E.466-1999 verse lettered *first you take my heart in the palm of your hand ...*

Size of printed surface 13.9 x 48.3 cm

E.465-1999 chorus lettered *oh don't you know that it hurts so good*

Size of printed surface 14.1 x 48 cm

E.466, 465-1999. Purchased from the artist

IN HER EARLY paintings Boyce ascribed a major role to wallpaper: it occupied large areas of her images, often signifying issues of cultural history and racial identity. As her concerns moved towards the relationship between public and private spaces she turned to using it in another way, not as a pictorial element in her paintings, but as itself. Her first wallpaper *Clapping* (1994) covered the walls of a space in which she and other artists exhibited objects loosely inspired by notions of absence. The repeat image of clapping hands had a paradoxical presence, at once offering applause, yet signifying that 'life is an on-going performance in which we are continually judged, even in our most private moments'.[107]

Lover's Rock, each sheet embossed with one verse or chorus from the song *Hurt So Good* (Susan Cadogan, 1975), and made while Boyce was artist in residence at Manchester University, also conveys notions of absence, yet presence. This time she daringly engages with a completely different creative dimension: that of music and dance – an intensely powerful expressive force, but also associated with very intimate and private moments. Entering the room in which the paper is displayed, the casual spectator will encounter only emptiness, blank white walls, but on closer inspection will read the words of the 'image', perhaps being shocked by the intensity and eroticism. To relate fully to the work we have literally to get up close. Boyce recalls that the 1975 song *Hurt So Good*

> was popular in a sub-cultural way, heard at West Indian house parties ... The dance is intense and intimate ... danced up against the wall ... The invisible and visible aspects are built into the song but also built into the piece as a wallpaper. After a party there would be marks around the room, where people rubbed against the wall, the after effects of people's presences.[108]

In the same interview Boyce spoke of the sensual quality of embossing, and the way it invites touch, as does dance, but also suggests pressure; this relates to the lyrics of the song, which invite damage in some way. Another writer, Mark Crinson, adds a further perspective: 'Frozen and silent, more tactile than visible, the lyrics now evoke but invert the solemn commemorative function of public inscriptions.'[109]

RM

first you take my heart in the palm of your hand and squeeze it tight
then you take my mind and play with it all night
you take my pride and you throw it up against the wall
then you take me in your arms and tease me till I roll up in a ball
I'm not complaining for what you're doing you see
cos this hurting feeling is oh so good to me

oh don't you know that it hurts so good
don't you know that it hurts so good
you know that it hurts so good
it hurts so good

Langlands & Bell (Ben Langlands born 1955, and Nikki Bell born 1959)

Frozen Sky (Night & Day), 1999

Diptych, printed in an edition of 45 with 10 artists' proofs

Proofed and editioned at Advanced Graphics, London. Published and distributed by Alan Cristea Gallery, London

Both signed and dated in pencil on the reverse *Langlands & Bell 1999*

Numbered in pencil respectively *6/10 AP* and *5/45*

Screenprints on 300 gsm Somerset Satin paper

Size of sheets, both 77 x 66 cm

E.254-2000 given by the artists; E.255-2000 purchased 2000

166

BEN LANGLANDS AND Nikki Bell studied at Middlesex Polytechnic, London, from 1977 to 1980, and have worked together since then. From 1978 they have made sculpture that draws upon architecture, often using the ground plans of buildings such as offices, public housing, prisons, places of worship, museums, airports, etc. Their treatment of these sources brings out the ambivalent nature of much public architecture: its utopian ideals and its direct expression of the way people behave and communicate with each other, and yet its authoritarian propensity to control our lives too. Through sculpture, free-standing objects, reliefs and more recently prints the artists continue to explore systems of communication that govern and codify our world. Structuring information about the interchange of people and places is crucial to their vision.

The minimalist perfection of *Frozen Sky (Night & Day)* is characteristic of Langlands & Bell's work. They have been using imagery derived from air route maps and destination codes since 1989, when they made a two-part work, silkscreened on glass, entitled *Air Routes of North West Europe (Night & Day)* for an exhibition at Le Magasin in Grenoble. This diptych follows on from their print *Sixty Cities*, 1997, an image in which far-flung cities, signified by the three letters of their airport

codes, are united in a circle around a globe. *Fifty Cities*, a sculpture that also functions as a seat and is based on the same concept as *Sixty Cities*, is now in the City Art Museum in Helsinki. Characteristically, the artists like the challenge of working in a variety of media. With printmaking, they are attracted by the medium's potential to be widely accessible to people; they also find it especially suitable for art that has a conceptual basis or aspect.

Frozen Sky is a constellation of the world's urban centres. The three-letter airport abbreviations (LHR = London, Heathrow, JFK = John F. Kennedy, New York, CDG = Charles De Gaulle,

Paris, etc.) cluster in a circle of sixty, like the penumbra of a sphere. It is a work of poetic imagination: 'a poetry of places in a global network where landing points offer departures into the imaginary'.[110] Through their concept we are also made to question the illusive reality of what is day or night, positive or negative, solid or void. The prints are imbued with added resonance from having been made in 1999, a year on the eve of a new millennium and with a total eclipse of the sun on 11 August.

MT

Lee Wagstaff (born 1969)

Shroud, 2000

Screenprint, using the artist's own blood, printed on Egyptian linen

Size of sheet
259.3 x 126.4 cm

E.1203-2000. Given by the artist

THE RELIGIOUS ICONOGRAPHY of Wagstaff's *Shroud* is unmistakable: the Shroud of Turin, believed by many to bear the imprint of Christ's wounded body. Wagstaff encourages this association through his choice of title. But the religious imagery goes deeper. Wagstaff uses tattooing as an art genre and says:

The imagery for my tattoos draws strongly on my religious upbringing and consists of symbols and patterns that are found in almost every culture in the world (circles, squares, stars, swastikas, triangles, etc). I am interested in the migration and spontaneous generation of geometric forms, how the same shapes and patterns can be found in diverse cultures over vast geographic areas.[111]

The tattoos on the shroud show up like the wounds on the body on the Turin shroud. Indeed tattoos are wounds; they represent a form of stigmata that Wagstaff has inflicted upon himself.

When Wagstaff first began to get his body tattooed he realized how much blood was created. As the tattooist works, he uses tissues to soak up the excess blood by pressing them over the wound.

Seeing the imprint on the tissue gave Wagstaff the idea of using his fresh tattoos as a source for print-making. After experimenting with small prints taken directly from his new tattoos, Wagstaff decided to embark on a more ambitious project. This involved creating a screen from a negative photograph of his whole body and drawing a pint of his own blood. One pint was sufficient to print two life-size 'shrouds'.

Wagstaff's work at the Royal College of Art, where he recently completed his MA in printmaking, was concerned with the relationship and similarities between tattooing and printmaking. He carefully selects the designs for his tattoos and has them executed by a chosen tattooist who is very much a part of the process of the creation of the work. Wagstaff initially had a tattoo done as the result of a creative decision. He views his own heavily tattooed body as a piece of artwork, displaying himself alongside screenprints and lithographs of images of his body and tattoo symbols.

SC

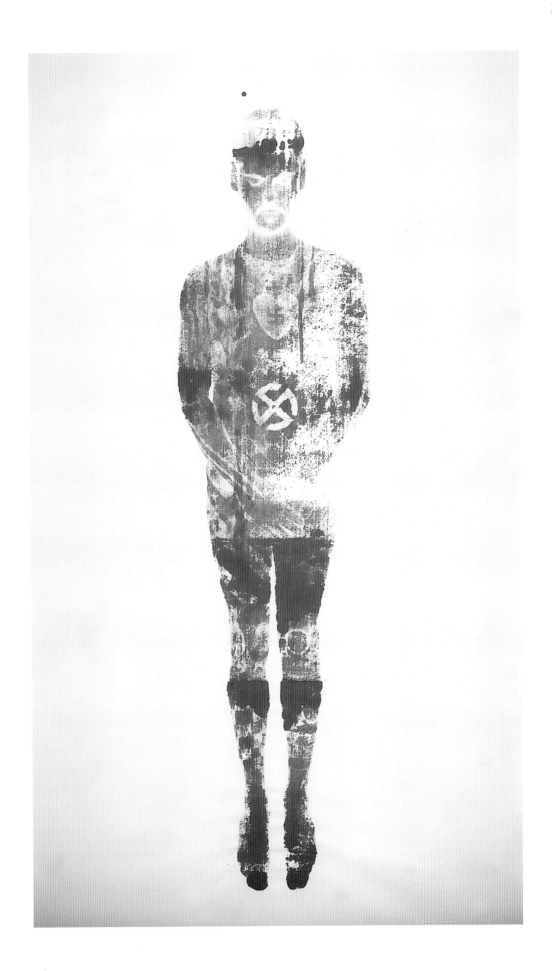

Notes

1 Anne Hammond (ed.), *Frederick H. Evans: Selected Texts and Bibliography,* Oxford 1992, p.58.

2 Ibid., p.1.

3 *Photographer's Journal*, vol. XXXIV, 30 April 1900, pp.236–41.

4 Jack B. Yeats, *Sligo*, London 1930, p.22.

5 Translation from Bente Torjusen, *Words and Images of Edvard Munch,* London 1989, p.86.

6 Quoted in *Käthe Kollwitz, 1867–1945: The Graphic Works*, Kettle's Yard, Cambridge 1981, p.8.

7 Ibid, p.12.

8 Ibid.

9 Cited in Mark Evans (ed.), *Themes and Variations: The Drawings of Augustus John, 1901–1931*, London 1996, p.13.

10 Campbell Dodgson, *A Catalogue of Etchings by Augustus John 1901–1914*, London 1920, p.xi.

11 Cited in Mark Evans, *Portraits by Augustus John: Family, Friends and the Famous*, Cardiff 1988, p.29.

12 Marguerite Duthuit-Matisse and Claude Duthuit, *Henri Matisse: Catalogue raisonné de l'oeuvre gravé; établi avec la collaboration de Françoise Garnaud; préface de Jean Guichard-Meili, D.317*, Paris 1983.

13 Walter Sickert, 'The New Life of Whistler', *Fortnightly Review* 84, December 1908, p.1021, cited in Aimée Troyen, *Walter Sickert as Printmaker*, exh. cat., Yale Center for British Art, 1979, p.iv.

14 Billie Burke, with Cameron Shipp, *With a Feather on My Nose*, New York 1949, cited in Margaret Dunwoody Hausberg, *The Prints of Theodore Roussel – A Catalogue Raisonné*, New York 1991, p.8.

15 *Der Sturm*, Berlin, May 1913, vol. IV, no. 160/161, p.25; Kraus Reprint, Nendeln/Liechtenstein 1970

16 *Der Sturm*, Berlin, April 1916, vol. VI, no. 23/24, p.137; Kraus Reprint, Nendeln/Liechtenstein 1970

17 F.L. Griggs, 16 January 1903, cited in Jerrold Northrop Moore, *F.L. Griggs 1876–1938: The Architecture of Dreams,* Oxford 1999, p. 40.

18 Edward Wadsworth to John Quinn, 1917, cited in Barbara Wadsworth, *Edward Wadsworth: A Painter's Life*, Wilton, Salisbury 1989, p.73.

19 Henri Gaudier-Brzeska to Edward Wadsworth, 18 November 1914, cited in Wadsworth, op. cit., pp. 57–8.

20 C.R.W. Nevinson, *Paint and Prejudice*, London 1937, p.96.

21 Ibid.

22 Cited in *C.R.W. Nevinson: The Twentieth Century*, exh. cat., Imperial War Museum, London 1999.

23 Translation of *Verächter des Todes*, the title Dix gave to a print and a watercolour of 1922, showing two circus artists.

24 Cited in Camilla Gray, *The Russian Experiment in Art 1863–1922*, rev. edn, London 1986, p.253.

25 Marguerite Duthuit-Matisse and Claude Duthuit, op. cit., D. 466.

26 G. Apollinaire, 'Médaillon: un fauve', quoted from A.H. Barr, *Matisse, his Art and his Public*, New York 1951, p.553.

27 H. Matisse, *Notes d'un peintre*, originally published in *La Grande Revue*, 25 December 1908; translated from *Henri-Matisse Retrospective Exhibition*, exh. cat., Museum of Modern Art, New York 1931, p.10.

28 Ibid., p.30.

29 Ibid., p.33.

30 Quoted in Malcolm Yorke, *Eric Gill: Man of Flesh and Spirit*, London 1981, p.157.

31 Bryan Rhys, 'Introduction', to Nicholas Breton, *The Twelve Moneths*, ed. Brian Rhys, Waltham Saint Lawrence, Berkshire 1927.

32 'Life and opinions of an English Modern', *The Sunday Times*, 28 April 1963, quoted in Carol Hogben, *Ben Nicholson: The Graphic Art*, exh. cat., Victoria and Albert Museum, London 1975.

33 Cited in Roberto Tassi, *Graham Sutherland: Complete Graphic Work*, London 1978, pp.10–11.

34 Cited in Peter Fuller, 'Graham Sutherland, The Early Years 1921–40', *Burlington Magazine*, vol.129, p.44.

35 Werner Hofmann, *Georges Braque: His Graphic Work*, London 1962, p.xii, cited in Jennifer Mundy, *Georges Braque Printmaker*, exh. cat., Tate Gallery, London 1993, p.19.

36 Claude Flight, *The Art and Craft of Lino Cutting and Printing*, London 1934, p.6.

37 From *The Times*, 24 May 1933, p.14, cited in Stephen Coppel, *Linocuts of the Machine Age: Claude Flight and The Grosvenor School*, Aldershot 1995, p.64 n.26.

38 Oliver Bernard, 'Introduction', in *Apollinaire: Selected Poems*, trans. Oliver Bernard, Penguin Modern European Poets Series, Harmondsworth 1965, p.14.

39 Judy Russell (ed.), *The Wood-Engravings of Gertrude Hermes*, Aldershot 1993, p.17.

40 Ibid., p.9.

41 Ibid., p.15.

42 Claude Roger-Marx, *Vuillard: His Life and Work*, trans. E.B. D'Auvergne, London 1946, p.24.

43 Translated from Claude Roger-Marx, *L'Oeuvre gravé de Vuillard*, Monte Carlo 1948, p.21.

44 Ibid.

45 From *Original Prints by Living Artists*, London c.1938, cited in Antony Griffiths, 'Contemporary Lithographs Ltd.' in *Print Quarterly*, vol.VIII, no.4, December 1991, p.399.

46 Ibid.

47 Quoted in Paul McCarron, *The Prints of Martin Lewis: A Catalogue Raisonné*, New York 1995, p.216.

48 Giorgio de Chirico, 'Perché ho illustrato l'Apocalisse', *Stile* 1, January 1941.

49 Leon Underwood, *Art for Heaven's Sake*, London 1934, p.i.

50 Jean Dubuffet, 'A Talking Dog', in *Notes for the Well Read* (trans. Joachim Neugroschel), 1945, cited in Mildred Glimcher and Jean Dubuffet, *Jean Dubuffet: Towards an Alternative Reality*, New York 1987, p.80.

51 James Laver 'Art for Everyman', in *A*

Collection of Forty Colour Lithographs, J. Lyons & Co., London n.d.

52 Man Ray, *Opera Grafica*, Turin 1973, p.5.

53 Keith Vaughan, letter to Norman Towne, 29 December 1949, cited in Malcolm Yorke, *Keith Vaughan: His Life and Work*, London 1990, p.127.

54 Dated 2 December 1985, in Tate Gallery Archive.

55 John Berger in the *New Statesman*, 15 March 1952, cited in Tom Cross, *Painting The Warmth of the Sun: St Ives Artists, 1939–1975*, Penzance 1984, p.126.

56 Una Johnson, *Ambroise Vollard, Éditeur*, exh. cat., Museum of Modern Art, New York 1977, p.32.

57 S.R.T., 'Hommage à Tériade', introduction to *The Sale Catalogue of the Complete Published Editions Belonging to Madame Alice Tériade…*, Christie's, London 30 June 1995, pp.8–9.

58 Ambroise Vollard quoted in *Marc Chagall et Les Fables de la Fontaine*, exh. cat., Musée du Pays de Sarrebourg, 1992, p.8.

59 Frances Spalding, *Dance till the Stars Come Down: A Biography of John Minton*, London 1991, p.136.

60 Radio broadcast on William Blake, transmitted 22 May 1947, cited in Spalding, op. cit., p.132.

61 From Ben Shahn, *Love and Joy About Letters*, New York 1963, cited in John D. Morse (ed.), *Ben Shahn*, New York 1972, p.143.

62 Ibid., p.146.

63 Quoted from N. Gabo, letter to Thomas Hess, 21 December 1950, cited in Graham Williams (ed.), *Naum Gabo: Monoprints from Engraved Wood Blocks and Stencils*, Biddenden, Kent 1987, p.11.

64 Eric Newton, 'Round the London Galleries', *The Listener*, 19 July 1956, p.96.

65 Edward Bawden, 'A Note on Lino Cutting', in Ruari McLean, *Edward Bawden: A Book of Cuts*, London 1979, p.9.

66 Roland Penrose, *Miró*, London 1970, p.162.

67 Ibid., p.164.

68 Stephen Coppel, *Printmaking in Paris: Picasso and his Contemporaries*, London 1997, p.55.

69 Dawn Ades, *André Masson*, London 1994, p.14.

70 Peter Selz, *Sam Francis*, New York 1982, p.269, cited in Connie W. Lembark, *The Prints of Sam Francis: A Catalogue Raisonné 1960–1990*, New York 1992, p.15.

71 Andrew Brighton, in *David Hockney Prints 1954–77*, London 1979, p.2.

72 Cited in Nikos Stangos (ed.), *David Hockney by David Hockney*, London 1976, p.65.

73 Extract from a telephone conversation between Mary Lee Corlett and Ivan Karp, 8 July 1993, quoted in Mary Lee Corlett, *The Prints of Roy Lichtenstein: A Catalogue Raisonné, 1948–1993*, New York 1994, p.253.

74 Quoted in Esther Sparks, *Universal Limited Art Editions: A History and Catalogue, the First Twenty-Five years*, exh. cat., Art Institute of Chicago, New York 1989, p.61.

75 Victor Vasarely, *Vasarely*, New York 1978, section X.

76 *Jeunes Peintres d'Aujourd'hui*, Paris 1954.

77 Vasarely, op. cit., p.8.

78 Ibid., p.13.

79 BBC television series, *The Shock of the New*, 1980, cited in *Richard Hamilton*, exh. cat., Tate Gallery, London 1992, p.172.

80 Richard Hamilton, 'Photography and Painting', in *Studio International*, March 1969, p.120.

81 Walter Benjamin, 'Unpacking My Library: a talk about book collecting', in *Illuminations*, trans. Harry Zohn, London 1970, p.60.

82 Robert C. Morgan, *Art into Ideas: Essays on Conceptual Art*, Cambridge 1996, p.158.

83 Bridget Riley, 'The Pleasures of Sight', in Robert Kudielka (ed.), *The Eye's Mind: Bridget Riley, Collected Writings 1965–1999*, London 1999, p.32.

84 Ibid., p.33.

85 Quoted in Richard H. Axsom and David Platzker, *Printed Stuff: Prints, Posters and Ephemera by Claes Oldenburg: A Catalogue Raisonné, 1958–1996*, New York 1997, p.21.

86 Quoted in ibid., p.24.

87 *Gavin Jantjes: Graphic Work 1974/1978*, exh. cat. (exhibition for International Anti-Apartheid Year 1978), Kulturhuset, Stockholm 1978, p.7.

88 From 'Installation Instructions', part of the Print Information issued to accompany the work by Crown Point Press, Oakland, California 1979.

89 Cited in *Baselitz: Paintings 1960–83*, exh. cat., Whitechapel Art Gallery, London 1983, p.82.

90 Cited in ibid., p.9.

91 Cited in ibid., p.10.

92 Anthony Hartley, *Mallarmé*, Harmondsworth 1965, p.29.

93 Ibid., p.ix.

94 Quoted in Patrick Elliott (ed.), *Contemporary British Art in Print: The Publications of Charles Booth-Clibborn and his Imprint the Paragon Press 1986–95*, Scottish National Gallery of Modern Art, Edinburgh 1995, p.86.

95 Quoted in Carol di Grappa (ed.), *Landscape, Theory: Photographs and Essays*, New York 1980, p.84.

96 Quoted in Brian Coe and Mark Haworth-Booth, *A Guide to Early Photographic Processes*, London 1983, p.100.

97 Quoted in Kathan Brown, *Ink, Paper, Metal, Wood: Painters and Sculptors at Crown Point Press*, San Francisco 1996, p.114.

98 Quoted in Elliott, op. cit., p.150.

99 Kapoor interview with Marianne Brouwer cited in *Rhizome*, exh. cat., Haags Gemeente Museum, The Hague; Rijksdienst Beeldende Kunst, Amsterdam 1991, pp.63–73.

100 Extract from a conversation between Paula Rego and the poet Alberto de Lacerda published in the Portuguese newspaper *Diário de Noticias* on Christmas Day 1965.

101 Quoted in Elliott, op. cit., p.104.

102 Cited in Ekaterina Ford, 'Ruslan Kotev', in *Printmaking Today,* vol. 5, no. 3, Autumn 1996, p.9.

103 Lisa G. Corrin, 'Confounding the Stereotype', in *Chris Ofili,* exh. cat., Serpentine Gallery, London; City Art Gallery, Southampton; Whitworth Art Gallery, Manchester 1998, p.16.

104 Chike Okeke, 'The Quest from Zaria to Nsukka' in *Seven Stories about Modern Art in Africa,* exh. cat., Whitechapel Art Gallery, London 1995, pp.41–2.

105 Cited in Christopher Frayling, 'Tim Mara: "A slightly obsessional printmaker"', in *Tim Mara,* exh. cat., Flowers East, London 1996, p.4.

106 Ibid., p.2.

107 Extract from transcript of 'Postmodern Wallpapers', a lecture given by Gill Saunders to the Wallpaper History Society Conference, London 1996.

108 Andrea MacKean interview with Sonia Boyce and Christine Woods, 'Wallpaper', in Mark Crinson (ed.), *Annotations 2: Sonia Boyce: Performance,* London 1998, p.38.

109 Mark Crinson, 'Telling Lyrics', in ibid., p.26.

110 Quoted from the artists' own statement, 1999.

111 Quoted from an e-mail from the artist to Shaun Cole, 14 July 2000.

Bibliography

To help with further reading as well as identify sources, titles are grouped under the relevant artist's name (in alphabetical order) and then listed chronologically with the most recent publication first, apart from those in the printmaking techniques section at the end which are arranged alphabetically by author.

Albers, Josef
Eugen Gomringer, *Josef Albers: His Work as Contribution to Visual Articulation in the Twentieth Century,* G. Wittenborn, New York 1968
Josef Albers and François Bucher, *Despite Straight Lines,* Yale University Press, New Haven, Connecticut; London 1961

Ardizzone, Edward
Nicholas Ardizzone, *Edward Ardizzone's World: The Etchings and Lithographs: An Introduction and Catalogue Raisonné,* Unicorn Press/Wolseley Fine Arts, London 2000
Antony Griffiths, 'Contemporary Lithographs Ltd.', *Print Quarterly,* December 1991, vol. VIII, no.4, pp.388–402
Edward Ardizzone: A Retrospective Exhibition, introduction by Gabriel White, exh. cat., Victoria and Albert Museum, London 1973

Atkinson, Conrad
Sandy Nairne and Caroline Tisdall (eds), *Picturing the System,* Pluto Press and ICA, London 1981

Auerbach, Frank
Michael Podro (introduction) and Frank Auerbach (commentaries), *Frank Auerbach: The Complete Etchings 1954–1990,* exh. cat., Marlborough Graphics Ltd, London 1990
Catherine Lampert and Frank Auerbach, 'A Conversation with Frank Auerbach', in *Frank Auerbach,* exh. cat., Hayward Gallery, London; Fruit Market Gallery, Edinburgh 1978

Baselitz, Georg
Fred Jahn, *Baselitz: Peintre-graveur, Werkverzeichnis der Druckgraphik 1974–1982,* 2 vols, Gachnang & Springer, Berne/Berlin 1983 and 1987
Baselitz: Paintings 1960–83, exh. cat., Whitechapel Art Gallery, London 1983

Bawden, Edward
Nigel Vaux Halliday, *More than a Bookshop: Zwemmer's and Art in the 20th Century,* P. Wilson, London 1991
Justin Howes, *Edward Bawden: A Retrospective Survey,* Combined Arts, Bath 1988
Douglas Percy Bliss *Edward Bawden,* The Pendomer Press, Godalming 1979
Ruari McLean, *Edward Bawden: A Book of Cuts* (includes 'A Note on Lino Cutting' by Edward Bawden), Scolar Press, London 1979

Beuys, Joseph
Jörg Schellmann, *Joseph Beuys Multiples: Catalogue Raisonné of Multiples and Prints 1965–1985,* Editions Schellmann, Munich and New York, 6th edn 1985, 8th (English language) edn 1997
Robert C. Morgan, 'Who was Joseph Beuys', in *Art into Ideas: Essays on Conceptual Art,* Cambridge University Press, Cambridge 1996, pp.158–9

Boyce, Sonia
Mark Crinson (ed.), *Annotations 2: Sonia Boyce: Performance,* Institute of International Visual Arts, London 1998
Gill Saunders, 'Postmodern Wallpapers', transcript of a lecture to the Wallpaper History Society Conference, London 1996

Braque, Georges
Jennifer Mundy, *Georges Braque: Printmaker,* exh. cat., Tate Gallery, London 1993
Dora Vallier, *Braque: L'Oeuvre gravé,* Flammarion, Paris 1982
Una Johnson, *Ambroise Vollard, Éditeur: Prints, Books, Bronzes,* Museum of Modern Art, New York 1977

Broodthaers, Marcel
Michael Compton, *Marcel Broodthaers,* exh. cat., Tate Gallery, London 1980

Buren, Daniel
Kathan Brown, *Ink, Paper, Metal, Wood: Painters and Sculptors at Crown Point Press,* Chronicle Books, San Francisco 1996, pp.100–102, ill. p.101
View, vol.1, no.9, 1979, interview with Robin White, pp.16–20

Caulfield, Patrick
Patrick Caulfield: The Complete Prints, 1964–1999 (foreword by Alan Cristea, essay by Mel Gooding, compiled by Kathleen Dempsey), Alan Cristea Gallery, London 1999
Marco Livingstone, essay in *Patrick Caulfield,* exh. cat., Hayward Gallery, London 1999

Chadwick, Helen
Michael Newman, *The Mirror + The Lamp,* exh. cat., The Fruitmarket Gallery, Edinburgh 1986

Chagall, Marc
Charles Sorlier, *Chagall: Le Livre des livres*, Éditions André Sauret and Éditions Michel Trinckvel, France 1990

Chirico, Giorgio de
Margaret Crosland, *The Enigma of Giorgio de Chirico*, Peter Owen, London and Chester Springs, PA 1999
Antonio Vastano, *Giorgio de Chirico: Catalogo dell'opera grafica 1921–1969*, Edizioni Bora, Bologna 1996 (cat. no. 111a, illus. p.165)
De Chirico (foreword by William Rubin, essays by M.F. Dell'Arco et al.), Museum of Modern Art, New York; Tate Gallery, London 1982
The Memoirs of Giorgio de Chirico, trans. Margaret Crosland, Peter Owen, London 1971

Clemente, Francesco
Kathan Brown, *Ink, Paper, Metal, Wood: Painters and Sculptors at Crown Point Press*, Chronicle Books, San Francisco 1996, pp.193–6, ill. p.195

Dine, Jim
Esther Sparks, *Universal Limited Art Editions: A History and Catalogue, the First Twenty-Five Years*, exh. cat., Art Institute of Chicago/Harry N. Abrams, New York 1989, pp.57–69, ill. p.60

Dix, Otto
Hans Kinkel, *Otto Dix, das graphische Werk*, Fackelträger-Verlag Schmidt-Küster, Hanover 1971

Dubuffet, Jean
Sophie Webel, *L'Oeuvre gravé et les livres illustrés par Jean Dubuffet: catalogue raisonné*, Baudoin Lebon, Paris 1991 (no.29)
Dubuffet: Prints from the Museum of Modern Art (with essays by Audrey Isselbacher, Susan J. Cooke and James L. Fisher), Modern Art Museum, Fort Worth, and Museum of Modern Art, New York 1989
Mildred Glimcher, with writings by Jean Dubuffet, *Jean Dubuffet: Towards an Alternative Reality*, Pace Publications, Abbeville Press, New York 1987

Evans, Frederick H.
Anne Hammond (ed.), *Frederick H. Evans: Selected Texts and Bibliography*, Clio Press, Oxford 1992

Francis, Sam
Connie W. Lembark, *The Prints of Sam Francis: A Catalogue Raisonné 1960–1990*, Hudson Hills Press, New York 1992

Freedman, Barnett
Ian Rogerson and Sue Hoskins, *Barnett Freedman: Painter, Draughtsman, Lithographer*, Manchester Polytechnic Library, Manchester 1990
Jonathan Mayne, *Barnett Freedman*, Art and Technics, London 1948

Fulton, Hamish
Patrick Elliott (ed.), *Contemporary British Art in Print: The Publications of Charles Booth-Clibborn and his Imprint the Paragon Press 1986–95*, Scottish National Gallery of Modern Art, Edinburgh 1995, pp.86–103
Print Collector's Newsletter XV, 2, 1984, p.64
Carol di Grappa (ed.), *Landscape, Theory: Photographs and Essays* (by ten artists including Hamish Fulton), Lustrum Press, New York 1980, pp.77–93

Gabo, Naum
Graham Williams (ed.), *Naum Gabo: Monoprints from Engraved Wood Blocks and Stencils*, The Florin Press, Biddenden, Kent 1987

Gibbings, Robert
Robert Gibbings, *Wood-Engravings, with some Recollections by the Artist*, ed. Patience Empson, J.M. Dent & Sons, London 1959

Gill, Eric
Fiona MacCarthy, *Eric Gill*, Faber, London 1989
John Physick, *The Engraved Work of Eric Gill*, Victoria and Albert Museum, London 1963

Gormley, Antony
Patrick Elliott (ed.), *Contemporary British Art in Print: The Publications of Charles Booth-Clibborn and his Imprint the Paragon Press 1986–95*, Scottish National Gallery of Modern Art, Edinburgh 1995, pp.104–9
John Hutchinson, E.H. Gombrich and Lela B. Njatin, *Antony Gormley*, Phaidon, London 1995

Green, Renée
Press Release for *Taste Venue*, exhibition at Pat Hearn Gallery, New York 1994
C.L.R. James, *The Black Jacobins*, London 1938; reprinted by Allison & Busby, London 1994

Griggs, F.L.
Jerrold Northrop Moore, *F.L.Griggs 1876–1938: The Architecture of Dreams*, Oxford University Press, Oxford 1999
Francis Adams Comstock, *A Gothic Vision: F.L. Griggs and his Work*, Boston Public Library, 1966
Russell George Alexander, *The Engraved Work of F.L.Griggs, A.R.A., R.E.: Etchings & Drypoints 1912–1928*, Shakespeare Head Press, Stratford-upon-Avon 1928

Gross, Anthony
Mary Gross and Peter Gross (eds), *Anthony Gross*, Scolar Press, Aldershot 1992
Robin Herdman, *The Prints of Anthony Gross: A Catalogue Raisonné*, Scolar Press, Aldershot 1991
Graham Reynolds, *The Etchings of Anthony Gross*, Victoria and Albert Museum, HMSO, London 1968

Hamaguchi, Yozo
Yvonne Hagen, *Hamaguchi's Color Mezzotints*, Nantenshi Gallery, Tokyo 1976

Hamerschlag, Margarete
'Some Creative Children and What Became of Them. An exhibition of work by pupils of the Viennese pioneer art teacher Franz Cizek, with retrospectives of three pupils who later lived in England: Margarete Hamerschlag, Hilde Ascher and Lily Goddard', Press Release, Bethnal Green Museum of Childhood, London 1989

Hamilton, Richard
Richard Hamilton, exh. cat., Tate Gallery, London 1992
Dave and Reba Williams, 'The later history of Screenprint', *Print Quarterly*, vol. IV, no. 4, December 1987, pp.379–403
Kelpra Studio: An Exhibition to Commemorate the Rose and Chris Prater Gift, introduction by Pat Gilmour, Tate Gallery, London 1980
Richard Morphet, *Richard Hamilton*, Tate Gallery, London 1970

Hermes, Gertrude
Judy Russell (ed.), *The Wood-Engravings of Gertrude Hermes*, Scolar Press, Aldershot 1993

Hockney, David
David Hockney Prints 1954–77 (with introductory essay by Andrew Brighton), Petersburg Press for the Midland Group and the Scottish Arts Council, London 1979
Nikos Stangos (ed.), *David Hockney by David Hockney*, Thames and Hudson, London 1976

Hodgkin, Howard
Liesbeth Heenk, *Howard Hodgkin Prints*, Thames and Hudson, London (forthcoming)
Richard Morphet, *Howard Hodgkin Prints 1977 to 1983*, Tate Gallery, London 1985

Hopper, Edward
Gail Levin, *Edward Hopper: The Complete Prints*, Norton, New York 1979

173

Howson, Peter
Alan Jackson, *A Different Man: Peter Howson's Art from Bosnia and Beyond*, Mainstream, Edinburgh and London 1997
Robert Heller, *Peter Howson*, Mainstream, Edinburgh 1993

Jantjes, Gavin
Gavin Jantjes: Graphic Work 1974/1978, exh. cat., Kulturhuset, Stockholm 1978

John, Augustus
Mark Evans (ed.), *Themes and Variations: The Drawings of Augustus John, 1901–1931*, Lund Humphries, London 1996
Campbell Dodgson, *A Catalogue of Etchings by Augustus John 1901–1914*, C. Chenil, London 1920

Jones, David
Anne Price-Owen and Belinda Humfrey (eds), *David Jones: Diversity in Unity*, University of Wales Press, Cardiff 2000
Jonathan Miles and Derek Shiel, *David Jones: The Maker Unmade*, Seren, Bridgend 1995

Kapoor, Anish
Kapoor interview with Marianne Brouwer in *Rhizome*, exh. cat., Haags Gemeente Museum, The Hague; Rijksdienst Beeldende Kunst, Amsterdam 1991, pp.63–73
Jeremy Lewison, *Anish Kapoor: Drawings*, exh. cat., Tate Gallery, London 1990

Kitaj, R.B.
Jane Kinsman, *The Prints of R.B. Kitaj*, Scolar Press, Aldershot 1994
Rosemary Miles, *Kitaj: A Print Retrospective*, V&A/ Marlborough Graphics, London 1994
Kelpra Studio: An Exhibition to Commemorate the Rose and Chris Prater Gift, introduction by Pat Gilmour, Tate Gallery, London 1980

Klee, Paul
Paul Klee Foundation (ed.), *Paul Klee: Catalogue Raisonné*, vol. I, 1883–1912, Thames and Hudson, London and New York 1998
Armin Zweite, *The Blue Rider in the Lenbachhaus, Munich*, Prestel, Munich and New York, 1989
Betsy G. Fryberger, *In Celebration of Paul Klee, 1879–1940: Fifty Prints*, exh. cat., Stanford University Museum of Art, Stanford, California 1979
Museum of Modern Art, New York, *Paul Klee: Three Exhibitions*, reprinted (new preface by Monroe Wheeler) Arno Press, New York 1968
James Thrall Soby, *The Prints of Paul Klee*, Curt Valentin, New York 1945

Kollwitz, Käthe
Frances Carey and Antony Griffiths, *The Print in Germany 1880–1933: The Age of Expressionism*, British Museum Publications, London 1984, pp.21–45, 268
Käthe Kollwitz, 1867–1945: The Graphic Works, Kettle's Yard, Cambridge 1981
August Klipstein, *Käthe Kollwitz: Verzeichnis des Graphischen Werkes*, Bern 1955, pp.60–65

Kotev, Ruslan
Ekaterina Ford, 'Ruslan Kotev', *Printmaking Today*, vol. 5, no. 3, Autumn 1996

Kruger, Barbara
Love for Sale: The Words and Pictures of Barbara Kruger, text by Kate Linker, H.N. Abrams, New York 1990

Langlands & Bell
Germano Celant, 'The Transparency of Architecture', in *Langlands & Bell*, exh. cat., Serpentine Gallery, London 1996

Lanyon, Peter
Frances Carey and Antony Griffiths, *Avant-Garde British Printmaking 1914–1960*, British Museum Publications, London 1990, pp.179–183

Lewis, Martin
Paul McCarron, *The Prints of Martin Lewis: A Catalogue Raisonné*, M. Hausberg, New York 1995

Lichtenstein, Roy
A.D.B. Sylvester, *Some Kind of Reality: Roy Lichtenstein Interviewed by David Sylvester in 1966 and 1997*, Anthony d'Offay, London 1997
Mary Lee Corlett, *The Prints of Roy Lichtenstein: A Catalogue Raisonné, 1948–1993*, Hudson Hills Press in association with the National Gallery of Art, Washington, D.C.; New York 1994
Roy Lichtenstein Drawings and Prints, introduction by Diane Waldman, Thames and Hudson, London 1971

Lissitzky, El
Camilla Gray, *The Russian Experiment in Art 1863–1922*, Thames and Hudson, London 1962, rev. edn 1986
Sophie Lissitzky-Küppers, *El Lissitzky: Life, Letters, Texts*, Thames and Hudson, London 1968

Long, Richard
Patrick Elliott (ed.), *Contemporary British Art in Print: The Publications of Charles Booth-Clibborn and his Imprint the Paragon Press 1986–95*, Scottish National Gallery of Modern Art, Edinburgh 1995, pp.150–153

Richard Long: Walking in Circles, exh. cat., Hayward Gallery, London 1991

Mara, Tim
Christopher Frayling, 'Tim Mara: "A slightly obsessional printmaker"', exh. cat., Flowers East, London 1996

Marc, Franz
Erich Franz (ed.), *Franz Marc: Kräfte der Natur: Werke 1912–1915*, Hatje, Ostfildern 1993
Armin Zweite, *The Blue Rider in the Lenbachhaus, Munich*, Prestel, Munich and New York 1989
Barry Herbert, *German Expressionism: Die Brücke and Der Blaue Reiter*, Jupiter Books (London) Ltd, London 1983
Klaus Lankheit, *Franz Marc: Katalog der Werke*, Verlag M. DuMont Schauberg, Cologne 1970

Marcoussis, Louis
Solange Milet, *Louis Marcoussis: Catalogue raisonné de l'oeuvre gravé*, Forlaget Cordelia, Copenhagen 1991

Marden, Brice
Jeremy Lewison, *Brice Marden: Prints 1961–1991: A Catalogue Raisonné*, Tate Gallery, London 1992

Marti, Virgil
Donna De Salvo and Annetta Massie (with essay by Gill Saunders), *Apocalyptic Wallpaper: Robert Gober, Abigail Lane, Virgil Marti and Andy Warhol*, Wexner Center for the Visual Arts, Ohio State University, Columbus, Ohio 1997

Masson, André
Dawn Ades, *André Masson*, Academy Editions, London 1994
Lawrence Saphire and Patrick Cramer, *André Masson: Catalogue raisonné des livres illustrés*, Patrick Cramer, Éditeur, Geneva 1994
Silvie Turner, *Which Paper? A Review of Fine Papers for Artists, Craftspeople and Designers*, Estamp, London 1991
André Masson: Line Unleashed, a Retrospective Exhibition of Drawings at the Hayward Gallery, London (with contributions by David Sylvester, Dawn Ades and Michael Leiris), South Bank Centre, London 1987
Roger Passeron, *André Masson, Gravures 1924–1972*, Office du Livre, Fribourg 1973

Matisse, Henri
Marguerite Duthuit-Matisse and Claude Duthuit, *Henri Matisse: Catalogue raisonné de l'oeuvre gravé; établi avec la collaboration de Françoise Garnaud; préface de Jean Guichard-Meili*, Claude.

Duthuit, Paris 1983
Susan Lambert, *Matisse: Lithographs*,
HMSO, London 1972
Alfred Hamilton Barr, *Matisse: His Art and
his Public*, Museum of Modern Art, New
York 1951, reprinted 1966

Minton, John
Frances Spalding, *John Minton 1917–1957:
A Selective Retrospective*, exh. cat., Oriel
31, Newtown Powys 1993
Frances Spalding, *Dance till the Stars Come
down: A Biography of John Minton*,
Hodder & Stoughton, London 1991

Miró, Joan
Stephen Coppel, *Printmaking in Paris:
Picasso and his Contemporaries*, British
Museum, London 1997
Carolyn Lanchner, *Joan Miró*, Museum of
Modern Art, New York 1993
Roland Penrose, *Miró*, Thames and Hudson,
London 1970
Joan Miró: His Graphic Work, introduction
by Sam Hunter, H.N. Abrams, New York
1958

Morandi, Giorgio
Lou Klepac, *Giorgio Morandi: The
Dimension of Inner Space*, Art Gallery of
New South Wales, Sydney 1997
Giorgio Morandi: Etchings, exh. cat., Tate
Gallery, London 1991
Franco Basile, *Morandi Incisore*, La loggia
edizioni d'arte, Bologna 1985
Lamberto Vitali, *Morandi: Catalogo
Generale*, 2 vols, Electa, Milan 1983
Lamberto Vitali, *Giorgio Morandi: Opera
Grafica*, G. Einaudi, Turin 1957

Munch, Edvard
Elizabeth Prelinger and Michael Parke-Taylor,
The Symbolist Prints of Edvard Munch, Art
Gallery of Ontario, Toronto 1996

Nash, Paul
Jeremy Greenwood, *The Wood-Engravings
of Paul Nash*, The Wood Lea Press,
Woodbridge 1997
Alexander Postan, *The Complete Graphic
Works of Paul Nash*, Secker and Warburg,
London 1973

Nevinson, C.R.W.
Richard Ingleby, Jonathan Black *et al.*,
C.R.W. Nevinson: The Twentieth Century,
Merrell Holberton in association with the
Imperial War Museum, London 1999
Frances Carey and Antony Griffiths, *Avant-
Garde British Printmaking 1914–1960*,
British Museum Publications, London
1990, pp.50–61
C.R.W. Nevinson, *Paint and Prejudice*,
Methuen, London 1937

Nicholson, Ben
Jeremy Lewison, 'The Early Prints of Ben
Nicholson', *Print Quarterly*, vol. II, no. 2,
June 1985
Carol Hogben, *Ben Nicholson: The Graphic
Art*, exh. cat., Victoria and Albert
Museum, London 1975

Ofili, Chris
Chris Ofili, exh. cat., Serpentine Gallery,
London; City Art Gallery, Southampton;
Whitworth Art Gallery, Manchester 1998

Oldenburg, Claes
Richard H. Axsom and David Platzker,
*Printed Stuff: Prints, Posters and
Ephemera by Claes Oldenburg: A
Catalogue Raisonné, 1958–1996*, Hudson
Hills Press, New York 1997
Claes Oldenburg: An Anthology (with
essays by Germano Celant, Dieter
Koepplin, Mark Rosenthal), Solomon R.
Guggenheim Foundation, New York 1995

Paolozzi, Eduardo
Frances Carey and Antony Griffiths, *Avant-
Garde British Printmaking 1914–1960*,
British Museum Publications, London
1990, pp.232–5
Dave and Reba Williams, 'The Later History
of Screenprint', *Print Quarterly*, vol. IV, no.
4, December 1987, p.393
*Kelpra Studio: An Exhibition to
Commemorate the Rose and Chris Prater
Gift*, introduction by Pat Gilmour, Tate
Gallery, London 1980

Pennell, Joseph
Louis A. Wuerth, *Catalogue of the
Lithographs of Joseph Pennell* (with an
introduction by Elizabeth Robins Pennell),
Alan Wofsy Fine Arts, San Francisco 1991

Picasso, Pablo
LE REPAS FRUGAL
Stephen Coppel, *Picasso and Printmaking in
Paris*, Hayward Gallery National Touring
Exhibitions, South Bank Centre, London
1998
John Richardson (with the collaboration of
Marilyn McCully), *A Life of Picasso*, vol.1,
Jonathan Cape, London 1991
Bernhard Geiser, *Picasso Peintre-graveur:
Catalogue raisonné de l'oeuvre gravé et
des monotypes; corrections, refonte et
supplément par Brigitte Baer*, rev. edn of
vol. 1 (1899–1931), Editions Kornfeld,
Berne 1990
Georges Bloch, *Pablo Picasso: Catalogue de
l'oeuvre gravé et lithographié 1904–1967*,
Kornfeld et Klipstein, Berne 1968
Sir Roland Penrose, *Picasso: His Life and
Work*, Gollancz, London 1958
L'AUTRUCHE
Bernhard Geiser, *Picasso, Peintre-graveur:
Catalogue raisonné de l'oeuvre gravé et
des monotypes*, vol. 3, Editions Kornfeld,
Berne, 1933–1994; rev. edn written by
Brigitte Baer (building on and continuing
from Bernhard Geiser's research), Editions
Kornfeld, Berne 1986
Abraham Horodisch, *Picasso as a Book
Artist*, Faber and Faber, London 1962
Georges Louis Leclerc, Comte de Buffon, *Le
Buffon des Familles. Histoire et dés-
criptions des animaux extraites des oeuvres
de Buffon*, Garnier frères, Paris 1866

Piper, John
Orde Levinson, *John Piper: The Complete
Graphic Works: A Catalogue Raisonné
1923–1983*, Faber and Faber, London 1987

Power, Cyril
Stephen Coppel, *Linocuts of the Machine
Age: Claude Flight and the Grosvenor
School*, Scolar Press, Aldershot 1995
Frances Carey and Antony Griffiths, *Avant-
Garde British Printmaking 1914–1960*,
British Museum Publications, London
1990, pp.73–89
Gordon Samuel and Richard Gault, *The
Linocuts of Cyril Edward Power
1872–1951*, exh. cat., Redfern Gallery,
London 1989
*British Colour Linocuts of the 1920s &
1930s*, exh. cat., Redfern Gallery, London
1985

Pryse, Gerald Spencer
Anon., 'Gerald Spencer Pryse', in *Catalogue
58*, Spring 1994, Garton & Co., Devizes,
Wiltshire 1994, n.p. (follows no. 38)

Quaye, Tayo
Seven Stories about Modern Art in Africa
(with essays by Clementine Deliss, Everlyn
Nicodemus, Chika Okeke *et al.*), exh. cat.,
Whitechapel Art Gallery, 1995

Rauschenberg, Robert
Robert Rauschenberg, exh. cat., Tate Gallery
Publications, London 1980

Ravilious, Eric
Helen Binyon, *Eric Ravilious: Memoir of an
Artist*, Lutterworth, Guildford 1983

Ray, Man
Man Ray, *Opera Grafica*, Luciano
Anselmino, Turin 1973

Rego, Paula
John McEwan, *Paula Rego*, Phaidon,
London 1992
Nursery Rhymes, introduction by Marina
Warner, exh. cat., Marlborough Fine Art
(London) Ltd, Graphics Gallery, London
1989

Riley, Bridget
Robert Kudielka (ed.), *The Eye's Mind:*

175

Bridget Riley, Collected Writings 1965–1999, Thames and Hudson in association with the Serpentine Gallery and De Montfort University, London 1999
Robert Kudielka, *Bridget Riley: Silkscreen Prints 1965–78*, exh. cat., Arts Council of Great Britain, London 1980

Rothenstein, Michael
Tessa Sidey, *The Prints of Michael Rothenstein*, Scolar Press, Aldershot 1993

Roussel, Theodore
Margaret Dunwoody Hausberg, *The Prints of Theodore Roussel: A Catalogue Raisonné*, M.D. Hausberg, New York 1991

Schmidt-Rottluff, Karl
Frances Carey and Antony Griffiths, *The Print in Germany 1880–1933: The Age of Expressionism*, British Museum, London 1984, pp.123–9
Rosa Schapire, *Karl Schmidt-Rottluffs graphisches Werk bis 1923*, Euphorion Verlag, Berlin 1924

Schwitters, Kurt
Werner Schmalenbach, *Kurt Schwitters*, DuMont Schauberg, Cologne 1967

Shahn, Ben
John D. Morse (ed.), *Ben Shahn*, Praeger Publishers, New York 1972

Sickert, Walter
Ruth Bromberg, *Walter Sickert: Prints: A Catalogue Raisonné*, Yale University Press, New Haven and London 2000 (no. 131)
Aimée Troyen, *Walter Sickert as Printmaker*, exh. cat., Yale Center for British Art, 1979
Lillian Browse, *Sickert*, Hart-Davis, London 1960

Sutherland, Graham
Gordon Cooke, *Graham Sutherland: Early Etchings*, Scolar Press, Aldershot 1993
Roberto Tassi, *Graham Sutherland: Complete Graphic Work*, Thames and Hudson, London 1978

Tschudi, Lill
Stephen Coppel, *Linocuts of the Machine Age: Claude Flight and the Grosvenor School*, Scolar Press, Aldershot 1995

Underwood, Leon
Christopher Neve, *Leon Underwood*, Thames and Hudson, London 1974

Vasarely, Victor
Victor Vasarely, *Vasarely*, Alpine Fine Arts Collection, New York 1978

Vaughan, Keith
Malcolm Yorke, *Keith Vaughan: His Life and Work*, Constable, London 1990

Vuillard, Edouard
Claude Roger-Marx, *L'Oeuvre gravé de Vuillard*, André Sauret, Monte Carlo 1948
Claude Roger-Marx *Vuillard: His Life and Work*, trans. E.B. D'Auvergne, Paul Elek, London 1946

Wadsworth, Edward
Jeremy Lewison (ed.), *A Genius of Industrial England: Edward Wadsworth 1889–1949* (with essays by Andrew Causey, Richard Cork, Serge Fauchereau and Jeremy Lewison), exh. cat., Arkwright Arts Trust and Bradford Art Galleries and Museums, Bradford 1990
Barbara Wadsworth, *Edward Wadsworth: A Painter's Life*, Michael Russell, Wilton, Salisbury 1989

Warhol, Andy
Riva Castleman, essay in *The Prints of Andy Warhol*, exh. cat., Museum of Modern Art, New York, and Cartier Foundation for Contemporary Art, Jouy-en-Josas 1990
Kynaston McShine (ed.), *Andy Warhol: A Retrospective*, Museum of Modern Art, New York 1989
Frayda Feldman and Jörg Schellmann (eds), *Andy Warhol Prints: A Catalogue Raisonné*, Ronald Feldman Fine Arts Inc., New York/Editions Schellmann, Munich and New York/Abbeville Press, New York 1985

Yeats, Jack B.
Hilary Pyle and Zoë Reid, *From the Archive at the Yeats Museum*, National Gallery of Ireland, Dublin 2000
Images in Yeats: An Exhibition of the Works of Jack B. Yeats (text Hilary Pyle), National Gallery of Ireland, Dublin 1990
James White, *Jack B. Yeats: Drawings & Paintings*, Secker and Warburg, London 1971
Hilary Pyle, *Jack B. Yeats: A Biography*, Routledge & Kegan Paul, London 1970

Useful books on printmaking techniques
Bamber Gascoigne, *How to Identify Prints*, Thames and Hudson, London, 1986
Pat Gilmour, *Artists in Print: An Introduction to Prints and Printmaking*, British Broadcasting Corporation, London 1981
Antony Griffiths, *Prints and Printmaking: An Introduction to the History and Techniques*, British Museum Press, London, 2nd edn 1996
Susan Lambert, *Prints: Art and Techniques*, V&A Publications, London 2001

176

Acknowledgements

The authors acknowledge with gratitude the help and support that they have received from within and outside the Museum. The book's aim is to share the V&A's collection of twentieth-century prints with a wider public, and everybody involved has contributed in some way to that endeavour. The authors are indebted to Mary Butler, Miranda Harrison and Rosemary Amos in V&A Publications for their encouragement and support, and for bringing the book to fruition. They thank Colin Grant for his sympathetic and painstaking copy-editing and Roger Hammond for the imaginative design of the book. They are especially grateful to Sara Hodges and Ken Jackson in the V&A Photographic Studio for carrying out all photography of the prints to the highest standards.

The authors would like to thank Miss Mary Spencer Pryse, and Philip Dunn at the Museum of Labour History, for the knowledge they generously shared about Gerald Spencer Pryse. They are also grateful to Maria Gilissen for advice on Marcel Broodthaers, and to Liesbeth Heenk, the Alan Cristea Gallery and the artist himself for enlightening information about Howard Hodgkin's prints. The artists Ben Langlands and Nikki Bell gave every possible assistance. Zoë Reid of the National Gallery of Ireland, Stephen Powell and the London Ex-Boxers Association and Rosemary Taylor of the East London History Association helped with research into the Jack B. Yeats print. Hugh Tempest Radford of Unicorn Press kindly supplied information about Ardizzone. Pauline Webber of V&A Paper Conservation gave expert advice on paper identification and manufacturing techniques.

The editor is particularly grateful to all members of the Department of Prints, Drawings and Paintings for their spirit of enthusiasm and friendly co-operation. Not only have many contributed entries for the book, but everyone has helped the enterprise in some way or another. Frances Rankine played a leading role, getting through a heavy administrative workload with efficiency and grace. She was greatly helped by the assistance of Robin Brookes, Joyce Baston and Alex Hepburn. Ruth Walton offered crucial support at the proofreading stage of the book. Fiona Leslie ably translated Italian texts that informed the entry for De Chirico, and Guillaume Olive unravelled French texts relating to the Sickert and Vuillard works.